In This Garden

EXPLORATIONS IN MIXED-MEDIA NARRATIVE

Angela Cartwright and Sarah Fishburn

Illustrations by Alice Scott-Morris

QUARRY BOOKS

Debbie:
Have fun *Make Art*

Angela Cartwright

First published in the United States of America by
Quarry Books, a member of
Quayside Publishing Group
100 Cummings Center
Suite 406-L
Beverly, Massachusetts 01915-6101
Telephone: (978) 282-9590
Fax: (978) 283-2742
www.quarrybooks.com

Library of Congress Cataloging-in-Publication Data
Cartwright, Angela, 1952-
 In this garden : explorations in mixed-media narrative / Angela Cartwright and Sarah Fishburn ;
illustrations by Alice Scott-Morris.
 p. cm.
 ISBN-13: 978-1 59253-516-3
 ISBN-10: 1-59253-516-X
 1. Handicraft. 2. Gardening. 3. Gardens in art. I. Fishburn, Sarah. II. Scott-Morris, Alice. III.
Title.
 TT157.C29 2009
 635--dc22

 2008040051
 CIP

ISBN-13: 978-1-59253-516-3
ISBN-10: 1-59253-516-X

10 9 8 7 6 5 4 3 2 1

Design: Visible Logic, Inc.
Photography: Lightstream
Illustrations: Alice Scott-Morris

Printed in Singapore

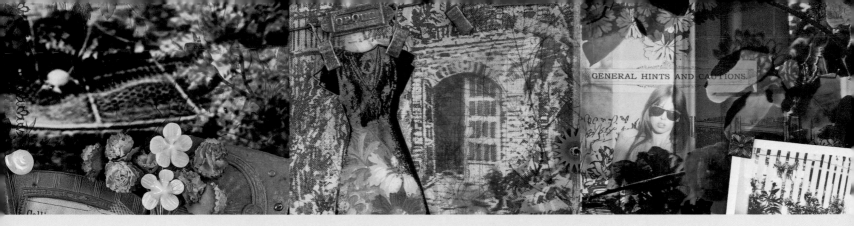

WE COME TO THE EARTH, WE RETURN TO THE EARTH, AND IN BETWEEN, WE GARDEN

To Angela—A charming English rose who is always up at the crack of dawn
to water her flora and fauna. Any afternoon squandered in your little backyard-
garden sanctuary feels like home to me—sunburn, berry stains, and all!
S.F.

To Sarah—My friend who helps my art garden grow with a plethora
of words, humor, and imagination.
A.C.

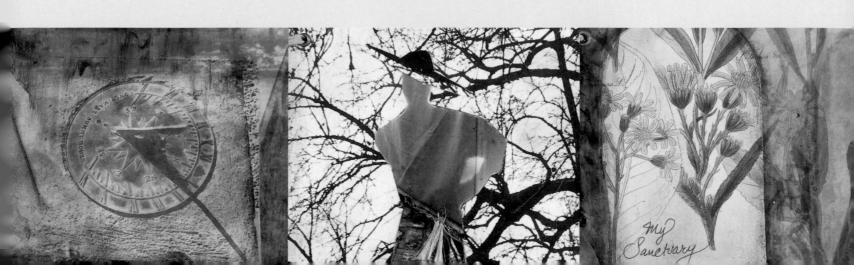

OAK

GINKGO

PINECONE

Down the Garden Path

INTRODUCTION

Plant the seeds, and tend the garden ...

Some men like
to make a little garden out of life
and walk down a path.

JEAN ANOUILH

So many of us lead hectic lives. We find ourselves rushing from work to meetings and back home again, and then running out the door to the market five minutes before our next meal to grab a jar of this, a container of that— only to catch a quick breath and start all over again.

The artful gardens found within these pages celebrate the insouciant spirit we each feel as we step into our own real-life outdoor spaces. We close our eyes and breathe in the mingled scents of earth and verdant plant life. We listen to irresistible birdsong and insect buzz as our imagination roams, and the cares of the world fall away.

Nearly every culture across every continent shares a universal inclination to nurture some form of plant life. Some- times it's an imperative—a garden filled with life-sustaining fruits and vegetables; other times, an impassioned pastime— a few herbs for adding flavor to the fruits

of other's gardens. Perhaps more often, our gardens are kept simply for the exquisite and wild beauty of their flowers and the tranquility achieved from time spent in quiet contemplation or dedicated care. In rural, suburban, and urban settings alike, one finds lovingly cultivated plots. Those of us who have no bit of land to call our own satisfy that gardening need with houseplants, window boxes, junk-shop teacup gardens on our windowsills, or if we're lucky, in community gardens.

The mixed-media and fine artists and photographers who created the lush and captivating landscapes of *In This Garden* each began with the tiniest seed of an idea that soon sent forth tentative yet eager shoots and finally blossomed full force into the breathtaking, seductive, and occasionally thought-provoking miniature scenes before you. Pen-and-ink drawings further illustrate and pay homage to each artist's garden concept.

From the down-to-earth yet fantastic flora and fauna flourishing in Australia to the elegant fairy-tale garden of Marie Antoinette, from the shadows seen in a traditional English garden as dawn fades to twilight, to a cowgirl's barn surrounded by sagebrush and roses, come follow us down quaint paths and landscaped walkways. As we wander, explore with us the four corners of a haphazard courtyard in New Orleans, the colors of a wildflower extravaganza, things that grow above and below, and exotic tropical terraces cooled by a zephyr gust. Discover the pleasures of community gardening and witness the gentle passing of the seasons. Experience a garden story remembered and retold, and a sanctuary from the weariness of wanderlust...all of these run the gamut from wild to whimsical, and romantic to visionary. Please enter through our garden gates— and don't forget to breathe!

Sarah & Angela

SHORTCUT THROUGH THE GARDENS

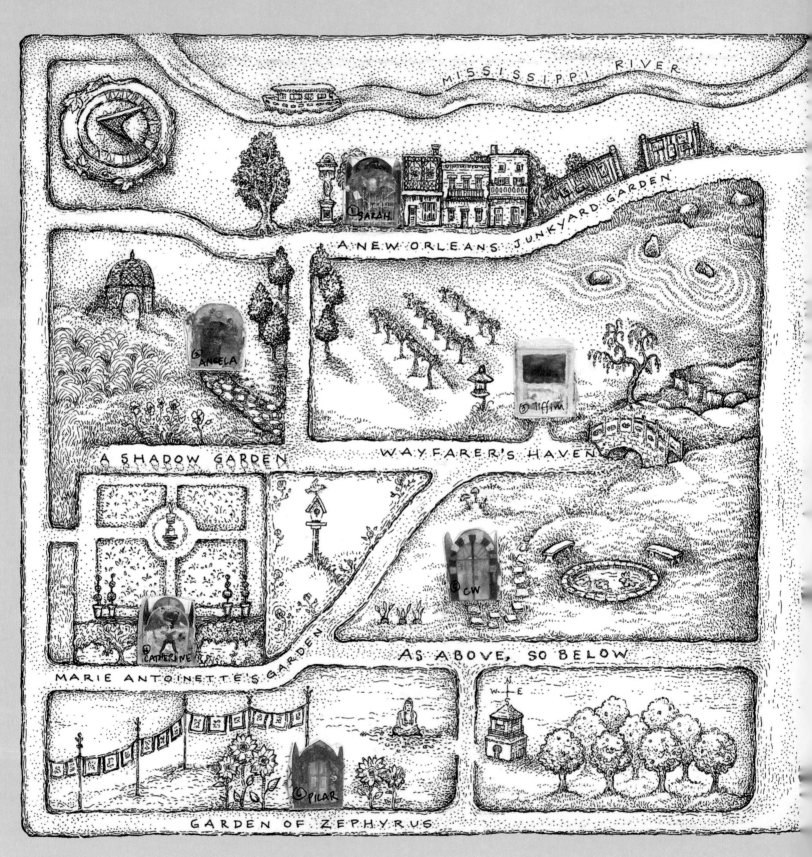

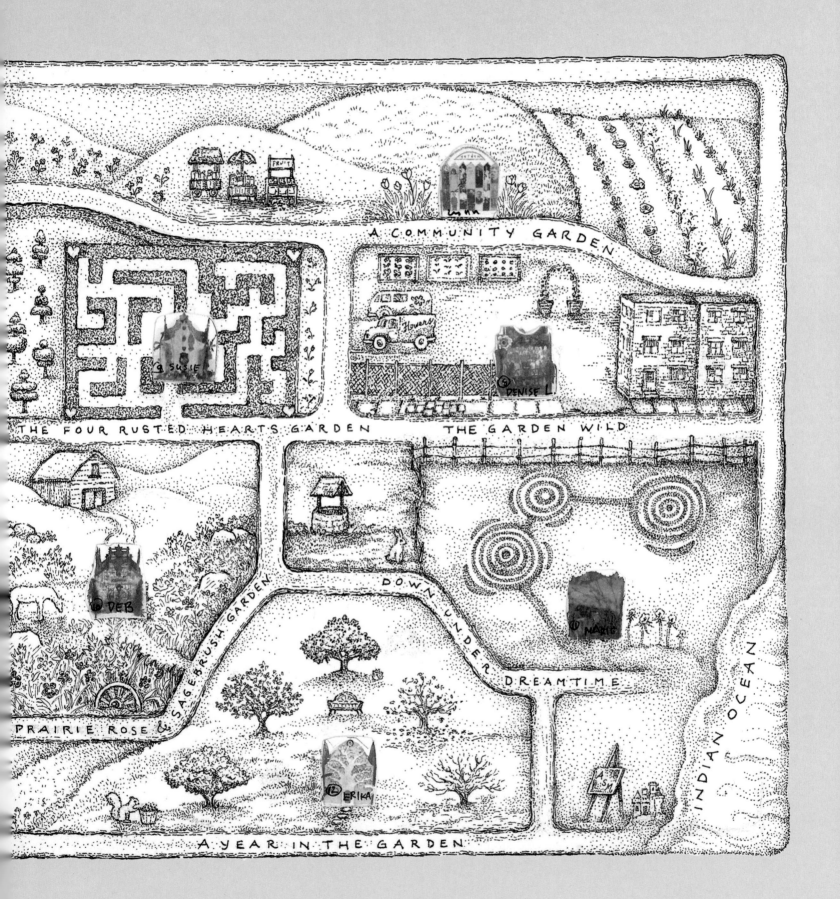

CHAPTER 1

A New Orleans Junkyard Garden

I t's a pretty, albeit ramshackle, courtyard in the deep heat of summer, but here catch a glimpse of the true shabby-chic character of Sarah Fishburn's New Orleans junkyard garden in late winter. Even in the sultry south, a garden needs a brief season of intermission.

French mulberry, iris, lantana, bougainvillea, and sunflower, imports from Mexico and France, mix easily with the native flowers and plants of the Gulf. Lush foliage and other elements work together to make this garden a love letter to New Orleans. From the front gate to the back, dichotomies of a crazy yet beloved southern town nicknamed "The Big Easy" are explored. In its slightly crumbling decadence, tempered with a dash of Bohemian elegance, we see visions of the past and present captured in the painted mural in the South Corner and in the multicolored glass of the bottle tree on an outside wall. Gaze at the heap of junk metal strewn about the North Corner, collected by the artist at "The World's Longest Yard Sale," and wonder what the future holds.

A garden doesn't always need a studied color scheme or inherent order. Like Mardi Gras itself, the corners of this vaguely dilapidated junkyard are lavish with both concealed layers and aggressive color overlays. Spray-painted graffiti frames delicate drawings, paintings, and photographs of flowers. Sure, razor wire to discourage intruders wraps the top of the garden gate, yet studded with rhinestones it still seems to proclaim that old New Orleans sentiment: *Laissez les bons temps rouler!*

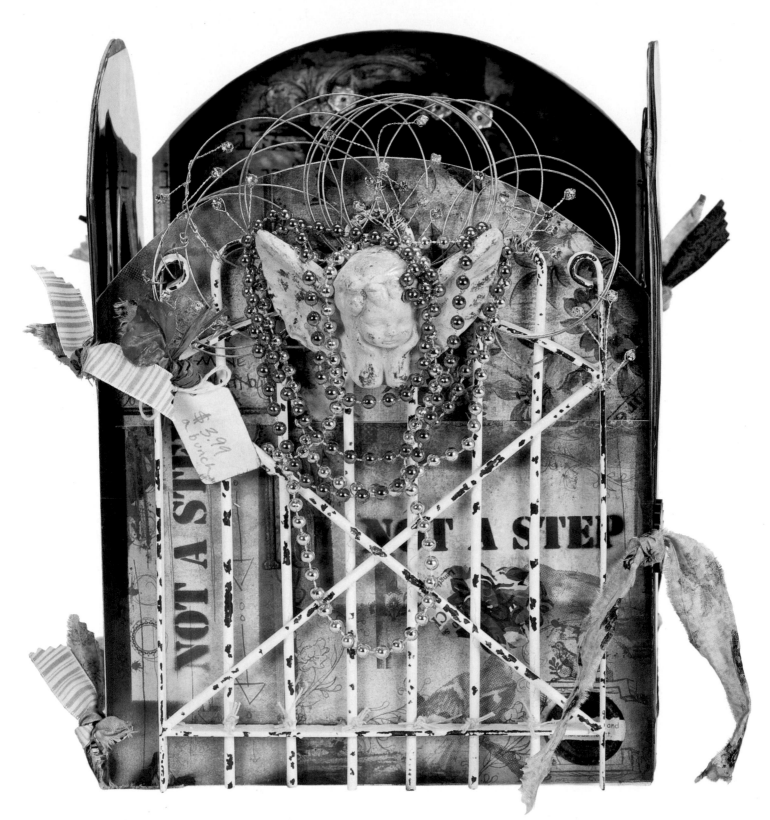

A New Orleans Junkyard Garden

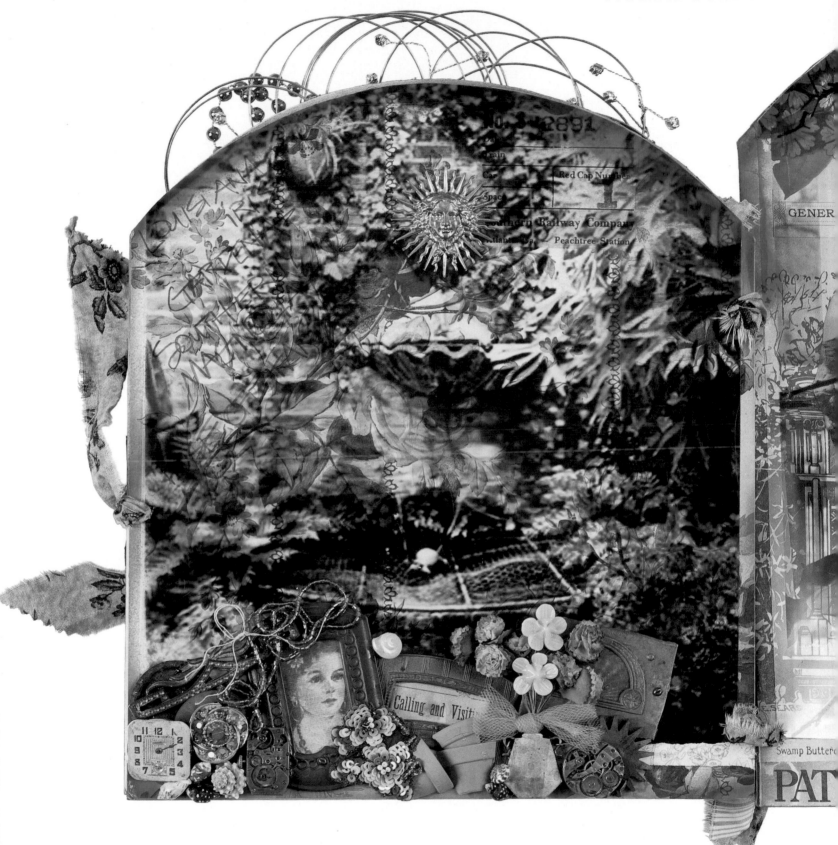

Gardening is not a rational act.
MARGARET ATWOOD

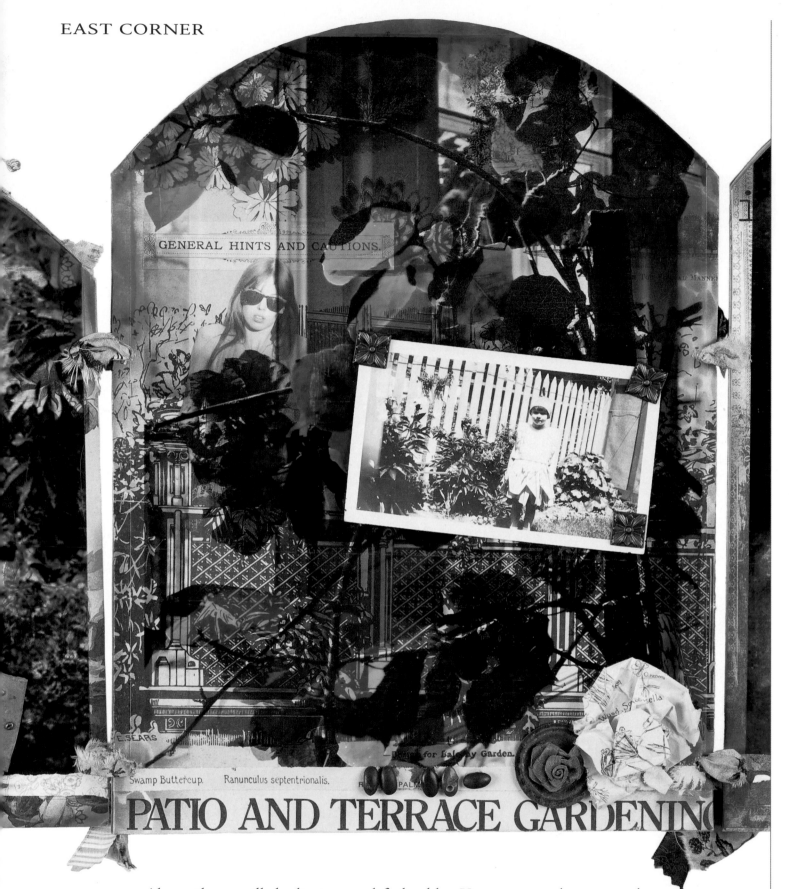

GENERAL HINTS AND CAUTIONS.

Swamp Buttercup. Ranunculus septentrionalis.

PATIO AND TERRACE GARDENING

Always throw spilled salt over your left shoulder. Keep rosemary by your garden gate.
Add pepper to your mashed potatoes. Plant roses and lavender, for luck. Fall in love whenever you can.
ALICE HOFFMAN

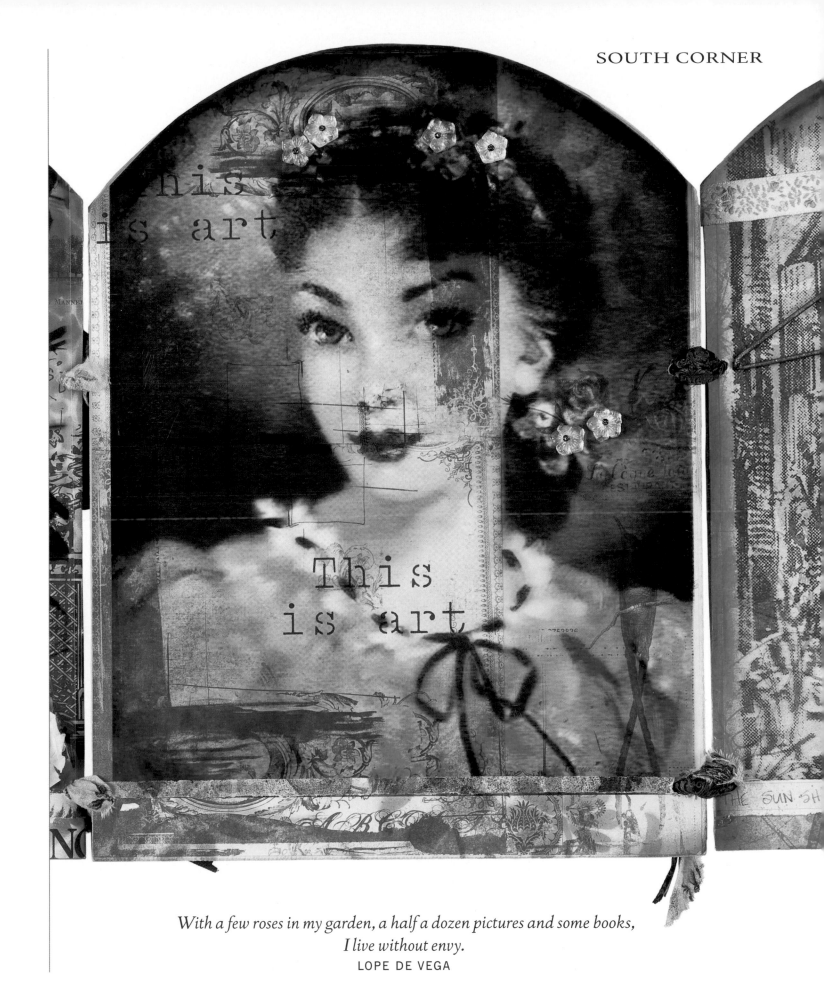

*With a few roses in my garden, a half a dozen pictures and some books,
I live without envy.*
LOPE DE VEGA

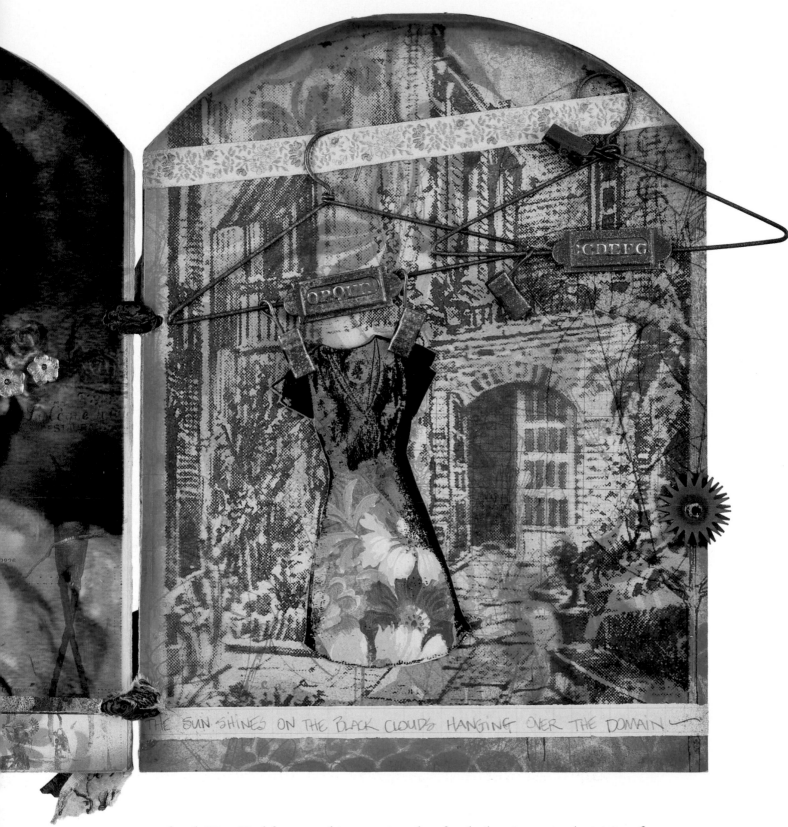

i thank You God for most this amazing day:for the leaping greenly spirits of trees
and a blue true dream of sky;and for everything which is natural which is infinite which is yes
E. E. CUMMINGS

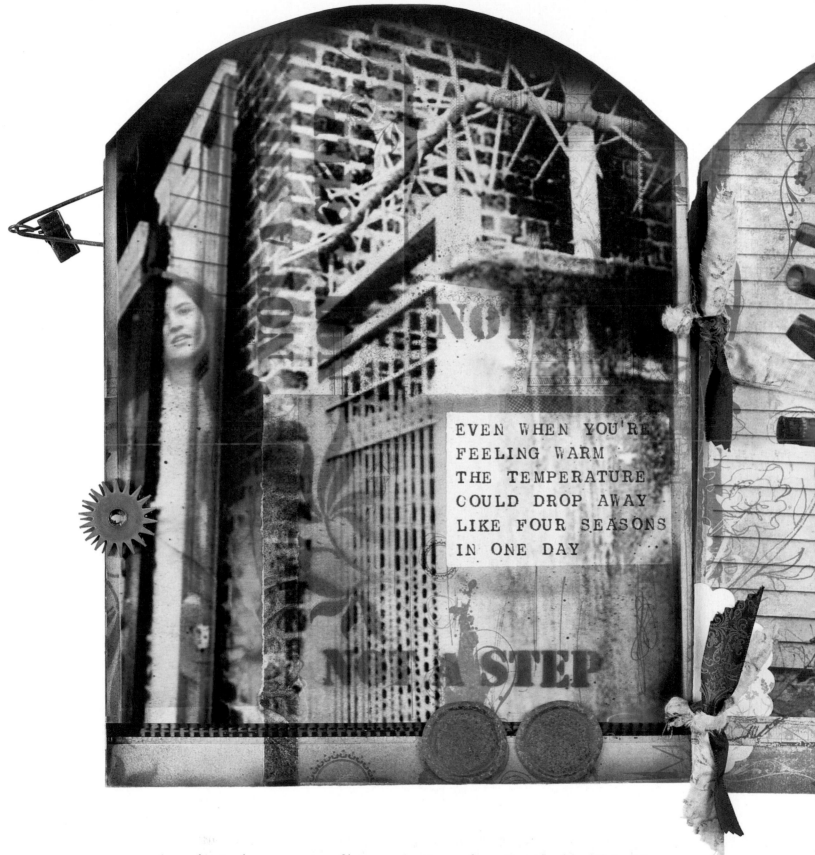

EVEN WHEN YOU'RE
FEELING WARM
THE TEMPERATURE
COULD DROP AWAY
LIKE FOUR SEASONS
IN ONE DAY

A garden is always a series of losses set against a few triumphs, like life itself.
MAY SARTON

How Does Your Garden Grow?

Stencils + Spray Paint = Spellbinding Backgrounds

Looking for a kicky, provocative way to add depth to your art? Follow Sarah into her backyard—go ahead and let that screen door slam—and get ready to fashion some bewitching backgrounds with spray paint and stencils. Browse the array of stencils this artist has hung with clothespins, in no particular order, across the outside wall of her kitchen. She favors floral stencils, words, and found items such as retro plastic place mats and old doilies, which when sprayed through have pleasing regular patterns and designs. Those net bags from produce markets? Perfect. Real leaves, grasses, and blossoms also work. Use them as reverse stencils, sometimes called masks. The result? A blank area the shape of the object surrounded by spray paint. It's a knockout graphic look.

Commercial stencils can be found in home-improvement stores, hobby shops, online, in scrapbook stores, or you can cut your own. Mylar provides an excellent stencil material; it is neither too stiff nor too flexible. Though many people are happy using 4-mm film, Sarah passes on a solid piece of advice: use 5-mm if you can find it, it's thicker and will last longer! Draw designs directly onto the Mylar or run the sheet through an inkjet or laser printer, or copy machine. Additional transfer techniques can be found in the books *Mixed Emulsions* and *The Complete Guide to Altered Imagery*. Many stencil artists cut their stencils freehand with a utility knife or a sturdy, economical box cutter.

When it comes to spray paint, Sarah recommends Krylon X Metals for lasting brilliance. Developed for use on skateboards and bikes, their anodized color allows for a single shade to manifest a layer-upon-layer effect, excellent for building a cool background similar to airbrushing. Fast drying, the paint is dynamite for using on transparency acetate. Don't hold back—just make sure the wind is blowing away from you when spraying!

Spray a light mist of paint through your stencil. Rotate the stencil slightly and spray again; repeat. Your design will pop with multiple layered images and impart a lovely three-dimensional effect. Remove the stencil and spray a fine mist directly onto a few areas of the image for striking results—what fun! Spray an irregular line down the edges of your art pieces as a delicious finishing touch.

Field Notes

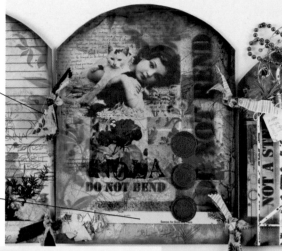

Selvage scraps torn from fabric provide a sturdy method for connecting panels.

Song lyrics contribute a graphic punch and define the ambience.

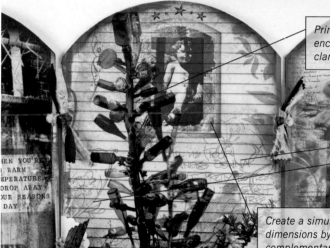

Print an image onto transparency acetate to intensify its clarity and color.

Penciled words and drawings establish a grunge appeal.

Create a simulated 3-D nicho in two dimensions by stenciling and layering complementary papers and including photographs with shadows.

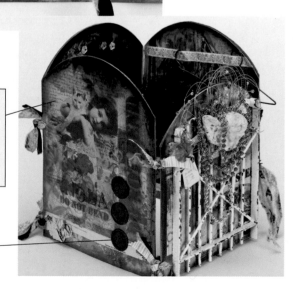

Use photographs and sketches from your travels and daily life, not just in journals but in all of your art. The images will remind you of your adventures, and a big plus is they are copyright free.

Rusty bottle caps add an inexpensive 3-D accent.

Iris: faith, hope, wisdom, valor

Zen Garden

the balconies and courtyard gardens of New Orleans

blackberries just picked and eaten warm

Coriandre, the perfume

the perfect creamy ivory color of a gardenia

pink and red hues of window-box geraniums, summer after summer

the rich and pungent smell of green chile during roasting season

the whisper of aspen leaves In the wind

a whip-poor-will's evocative call just before sunset

Dig It!

When making copies or prints of an image to include in your art, try duplicating it in various sizes and colors. You may feel sure of the exact size or shade you want to use in a piece, but by experimenting with a less obvious option, you might find the image's impact in a composition can dramatically increase. Also, be sure to make your copies and prints at a high resolution—high resolution equals good quality. For printing, 300 dots per inch (dpi) is the accepted standard.

Angela Cartwright

My
Sanctuary

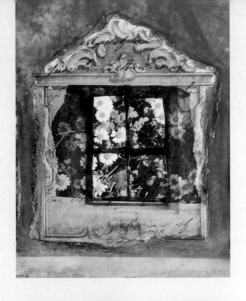

CHAPTER 2
A Shadow Garden

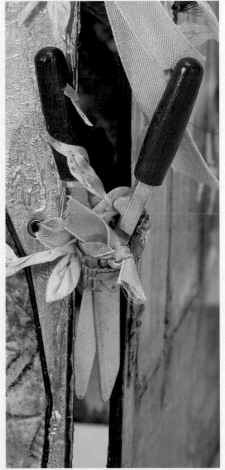

Venture down the cobbled pathway and open the gate to reveal a delightful interplay of light and dark in Angela Cartwright's shadow garden. Her homage to positive and negative space captures light filtered through the trees in a remarkable display of puzzle pieces.

At dawn, Angela's shadow is long and lean as she listens to the music of water cascading into a massive fountain seen in her photographic image of the North Corner. The mingled fragrance of scented herbs and lavender draws us to various paths leading further into her garden sanctuary.

As the artist explores the variations of light at high noon, her shadow-self is found perched playfully on a bench amid an array of yellow roses. An altered shadow puddles under a long, flowered ranunculus skirt as unruly thoughts spur her imagination.

At teatime, a sundial marks where the shadows fall behind our silhouetted artist as friends settle in the sparkling sunlight to enjoy colorful conversation and a spot of English tea. In the shade of an ancient oak tree, this corner lends itself to nurturing friendships, and enjoying the constant companionship of the garden's floral inhabitants.

As twilight approaches and the light balances precariously on the horizon, Angela's next photomontage brings us into dimness, as the shortening shadows grow dark and dense. The moments pass as one walks the thin shadowy line between dusk and the magic of nightfall. Stillness settles around us and we are comforted by the cooling air.

Truly, a garden can bring tranquility to one's world, no matter how large or small, how light or dark.

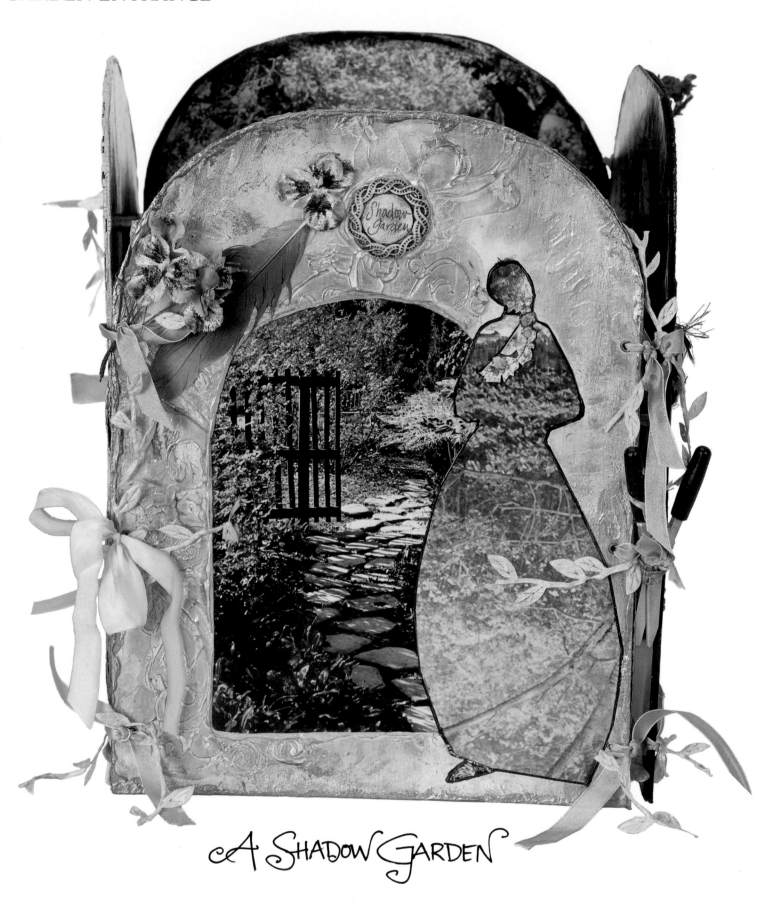

A SHADOW GARDEN

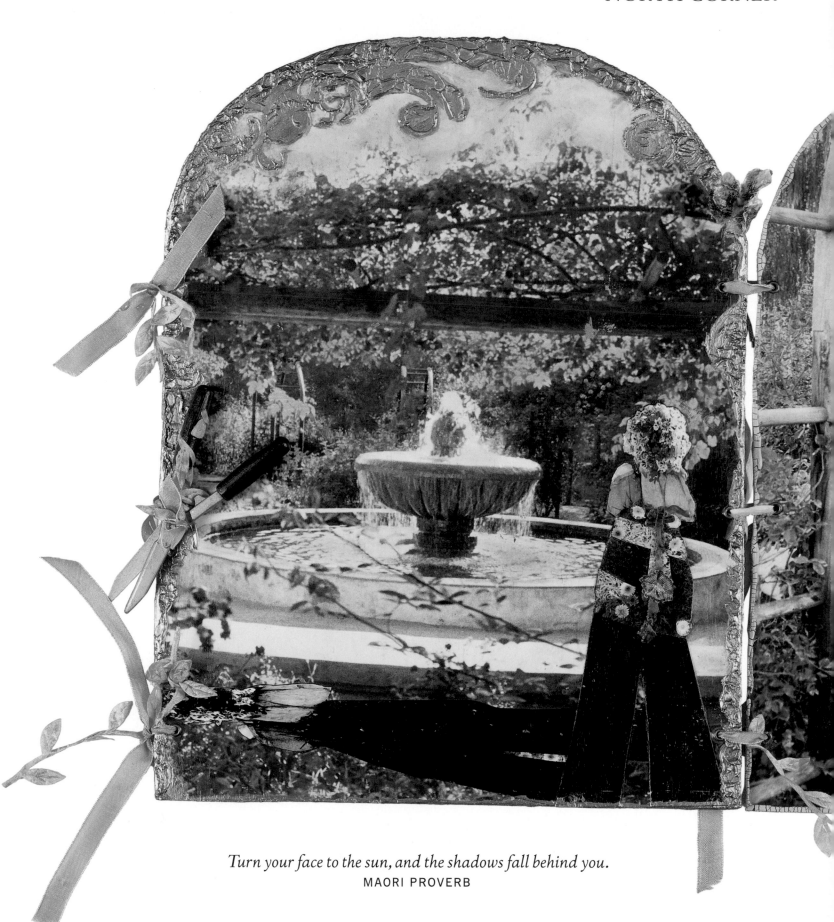

Turn your face to the sun, and the shadows fall behind you.
MAORI PROVERB

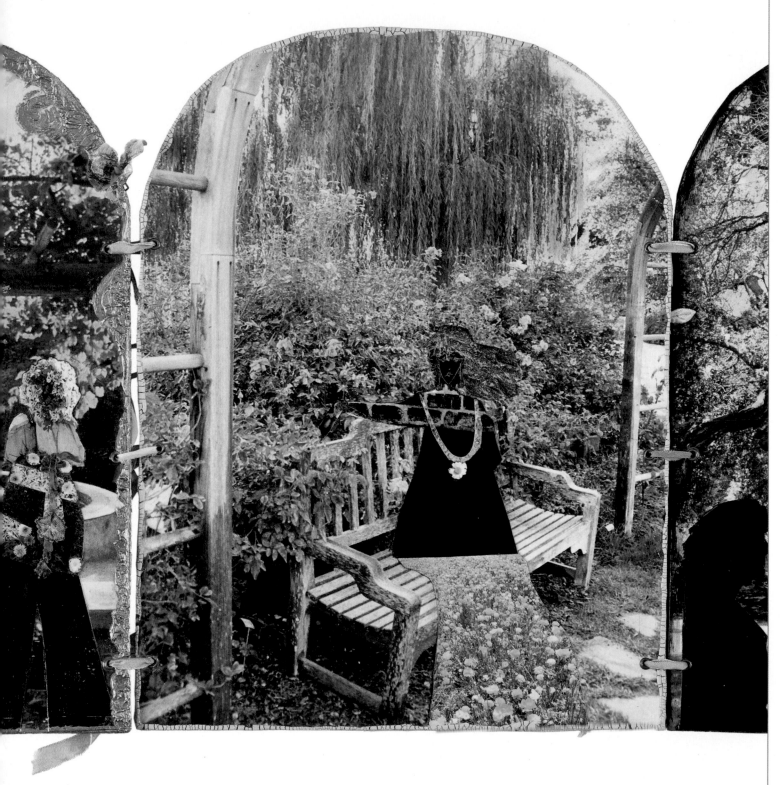

Every artist dips his brush in his own soul, and paints his own nature into his pictures.
HENRY WARD BEECHER

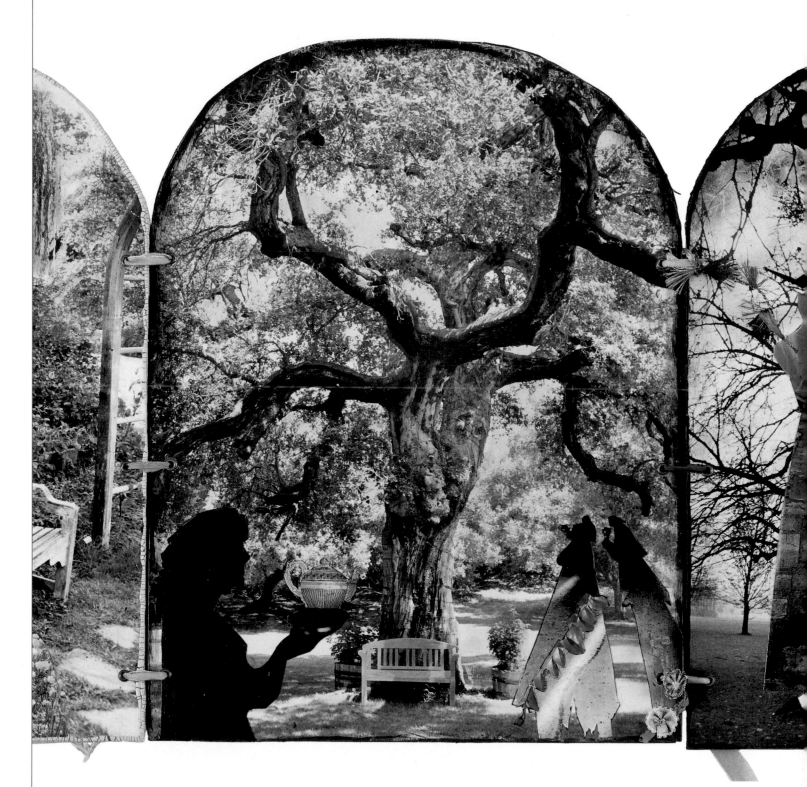

Nobody sees a flower—really—it is so small it takes time—we haven't time—
and to see takes time, like to have a friend takes time.
GEORGIA O'KEEFFE

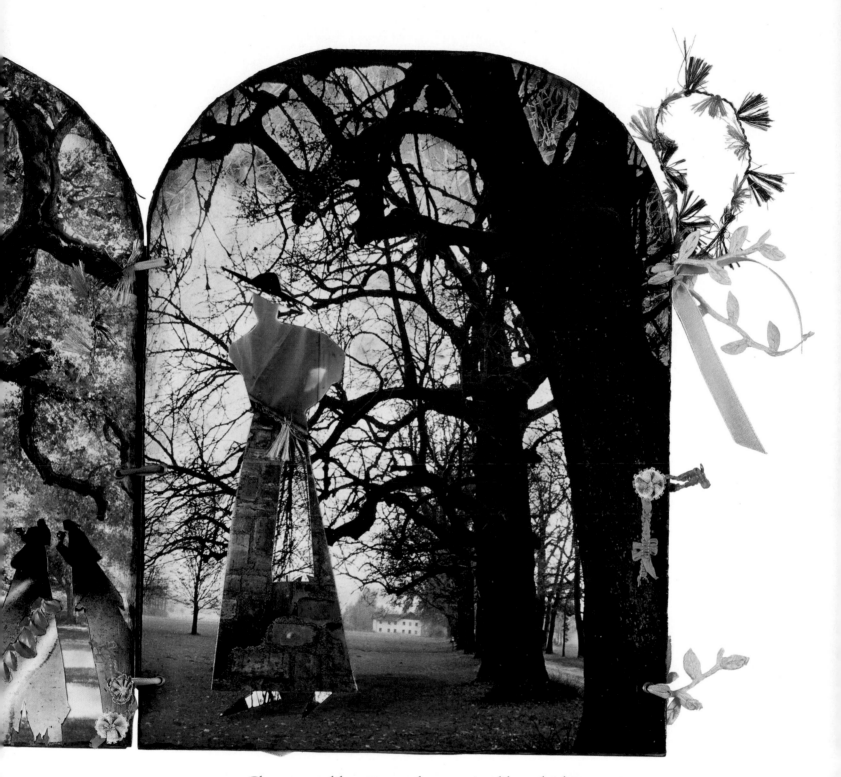

Character is like a tree and reputation like a shadow.
The shadow is what we think of it, the tree is the real thing.

ABRAHAM LINCOLN

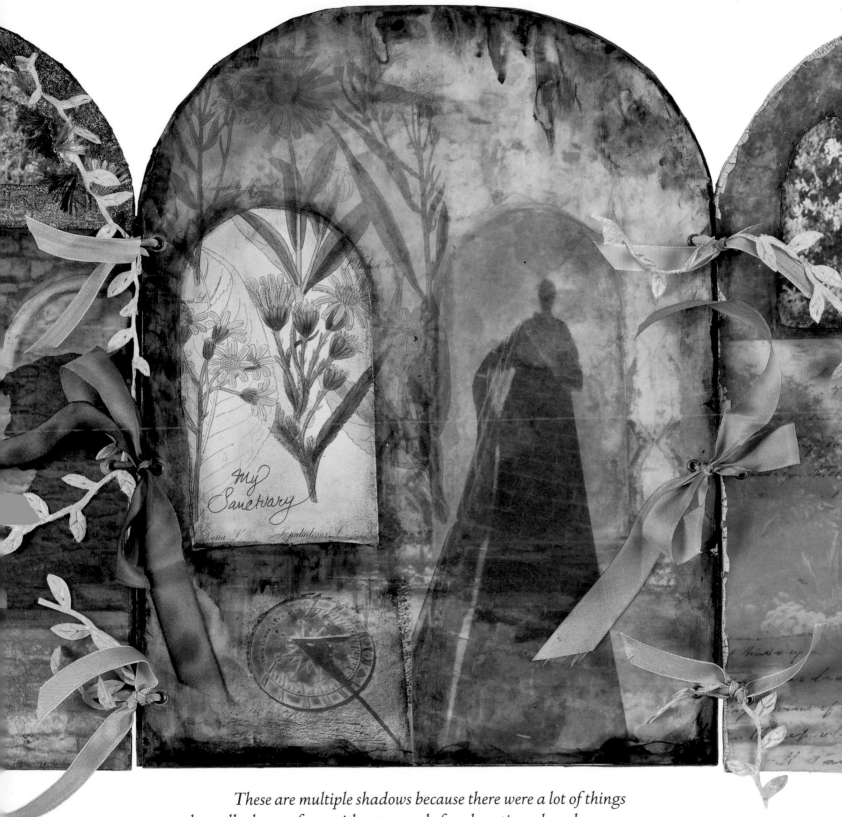

*These are multiple shadows because there were a lot of things
she walked away from without a word of explanation when she was younger
and she still thinks about them more than she needs to.*

BRIAN ANDREAS

Garden Notebook

Create a potager garden and cultivate homegrown produce. Growing herbs, spices, and vegetables in a small outside area can add delightful fresh flavors to your meals. Herbs and vegetables are easy to grow with good planning, frequent watering, good drainage, and at least four to five hours of sunlight daily. Regular pruning and use of your newly grown produce will encourage more growth. Plant mint, lavender, and edible nasturtiums, and you will quickly be rewarded with the sweet smell of success.

Cachepot

photographs, vellum, transparency, vintage Austrian botanical print, oil paint, acrylic paint, molding paste, crackle paint, oil sticks, Distress ink, embossing powder, markers, eyelets, rubber stamps, decorative ribbon, feather, faux-ivory disk, miniature garden shears, imported faux-flower embellishments

How Does Your Garden Grow?

Unruly Textures, Unruly Dimensions

Angela is passionate about her photography and brings that passion to her altered art. Her toolbox overflows with gels, pastes, and various textural paints. The versatility of these materials allows her to expand the personality and the impact of a one-dimensional photograph. By stamping into molding paste and painting it with a sparkling coat of pale gold paint, she evokes the feeling of sunshine pouring into her garden in the North Corner.

Just as a garden is laden with texture and dimension, you can add the same to your photographic art. Angela begins with a photograph printed onto a fiber-based paper, which she then colors with transparent oil paints. For this technique, you can also use an RC print (resin-coated photographic paper used when black-and-white film is developed commercially), or use a photograph printed from your computer onto a photo paper with tooth. Transparent oil paint spreads quite freely on a pearl-finish photographic paper and the definition in the original image will not be lost. Layer the paint thickly if you want to obscure particular areas.

Layering molding paste, crackle paints, and photographs adds dimension to your art. To embed a photograph or image, spread a layer of paste over the surface, position the image within the paste, and then press down until the paste oozes up over the sides. "There are a wide variety of pastes and gels that can breathe life into one's artwork ... if you are unruly enough to go for it."

Spread a layer of molding paste or gel medium onto your substrate, wait until it's tacky, and then use a rubber stamp to press an image into the paste or gel. Use stamps that aren't too detailed, as paste will fill in the fine grooves. You can stamp the image again to create a different impression with any molding paste remaining on the stamp. Use a notch tool and other implements to create additional patterns. Let the paste dry completely before adding color with paint or ink.

One-step crackle paint cracks when dry. The thicker you paint it on, the deeper it cracks. There is a clear crackle accent medium that when applied over images, gives them a nostalgic look. To enhance the cracks, fill in the fissures with a swipe of an ink pad, and then smudge the ink around with your fingers. Free-spirited experimentation is a great way to discover textural possibilities and dimension within your art.

Field Notes

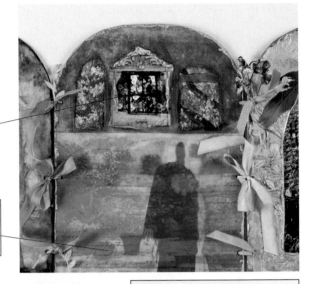

A transparency of a window frame with a photograph of flowers layered behind it draws your eye to this focal point.

Layers of text, photographs, and vellum instill a mystical feeling to these outside walls.

Stamping into melted embossing powders adds dimension on your photographs.

Rub oil sticks into edges of vellum to add depth and unify your layers.

The panels are attached with ribbons of leaves, which along with flower elements frame the garden scene.

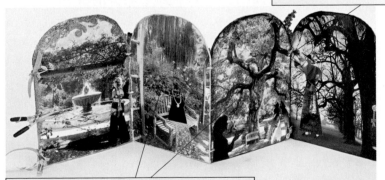

Shifting light and dark details from dawn through twilight create a thread of synchronicity throughout this shadow garden.

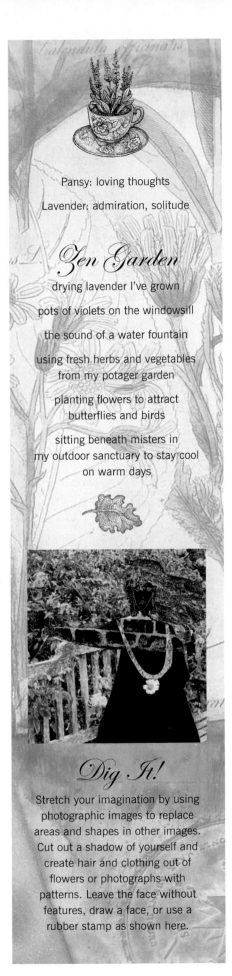

Pansy: loving thoughts

Lavender: admiration, solitude

Zen Garden

drying lavender I've grown

pots of violets on the windowsill

the sound of a water fountain

using fresh herbs and vegetables from my potager garden

planting flowers to attract butterflies and birds

sitting beneath misters in my outdoor sanctuary to stay cool on warm days

Dig It!

Stretch your imagination by using photographic images to replace areas and shapes in other images. Cut out a shadow of yourself and create hair and clothing out of flowers or photographs with patterns. Leave the face without features, draw a face, or use a rubber stamp as shown here.

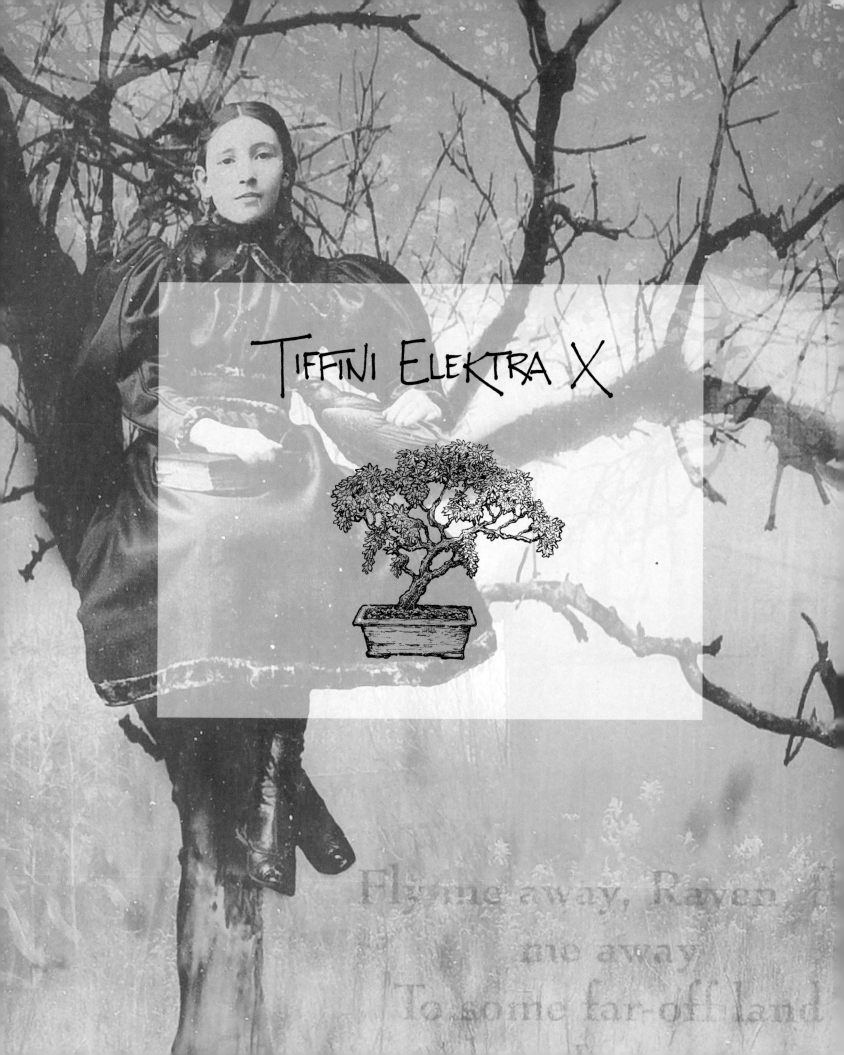

TIFFINI ELEKTRA X

Flying away, Raven
me away
To some far-off land

CHAPTER 3
WAYFARER'S HAVEN

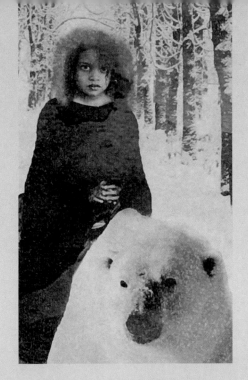

When Tiffini Elektra X conceived and built her *Wayfarer's Haven*, she took the concept of a structure that could be fashioned into a Japanese-lantern shape quite literally. All the rules went out the window. Could it function as a traditional accordion book incorporating translucent Plexiglas panels? Sure, but why not up the ante and make a stunning, luminous light-box out of each section? Once Tiffini started down the innovative path of artist/inventor, there was no stopping her.

The heaviness of the plaster framing belies the delicacy of this garden's corners and back walls. The notion of contrast is continually played with throughout the panels. Warm reds, oranges, and yellows fill the North Corner and give way to cool shades of purple, blue, and white in the south. A sumptuous Japanese garden scene in the east includes richly massed lily pads, cherry blossoms, a patterned kimono, and the intricately curled arms of an octopus. Compare that to the West Corner, which is desolate, stark, and windswept. The girl seen there, serious in manner and in her black dress and boots, perches on a bare branch with an equally somber crow.

Determined to achieve ethnic diversity within each garden corner and with each of the girls, the artist conveys different aspects of a vast imaginary world, yet the roots are firmly planted in the rich soil of reality. The *Wayfarer's Haven* gives new meaning to the phrase "illuminated manuscript"!

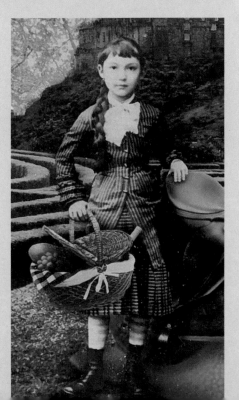

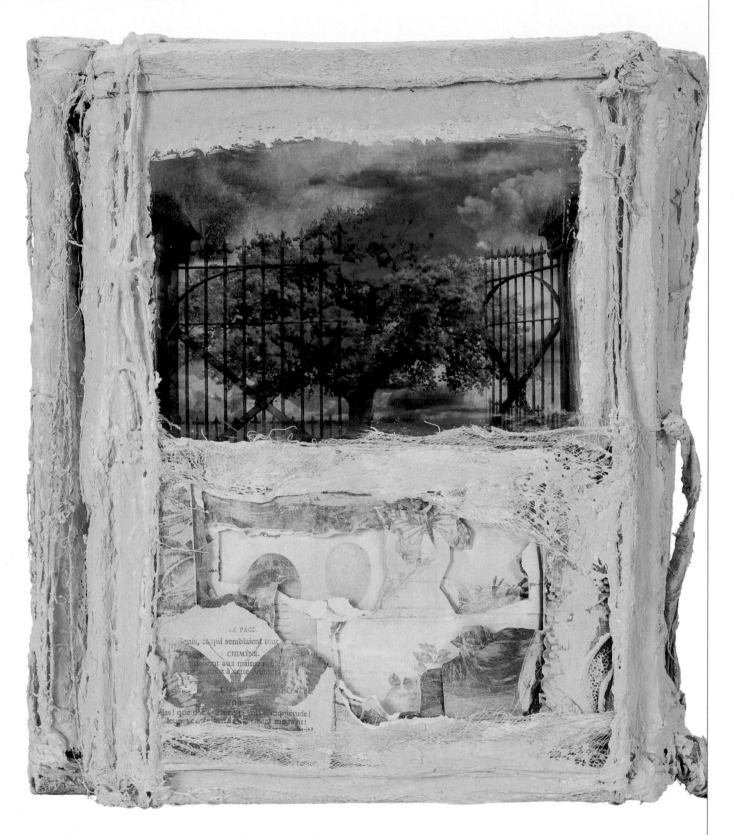

WAYFARER'S HAVEN

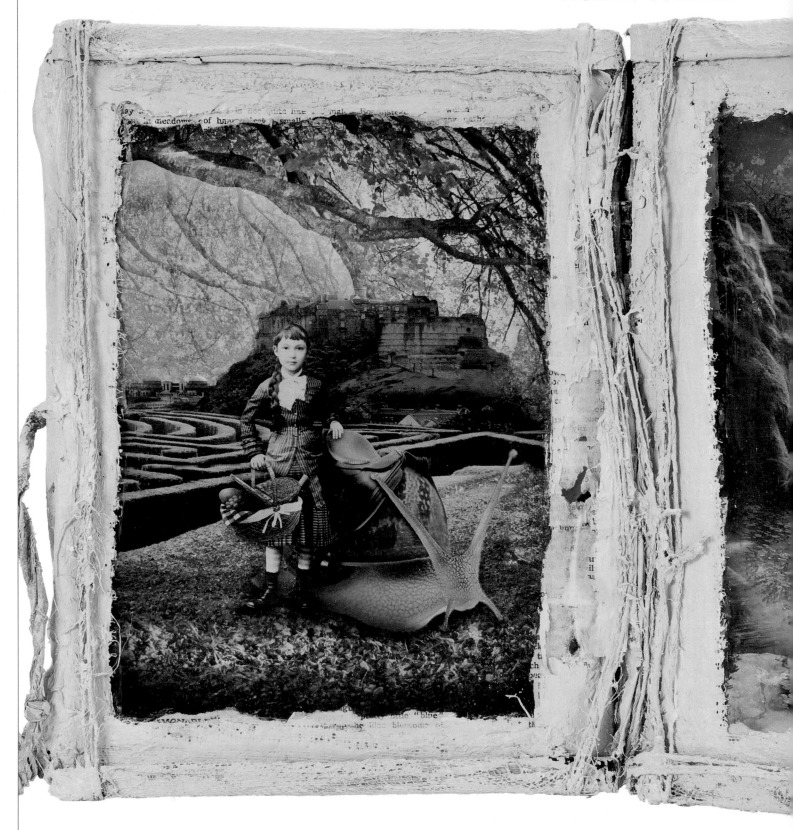

Nothing is more the child of art than a garden.
SIR WALTER SCOTT

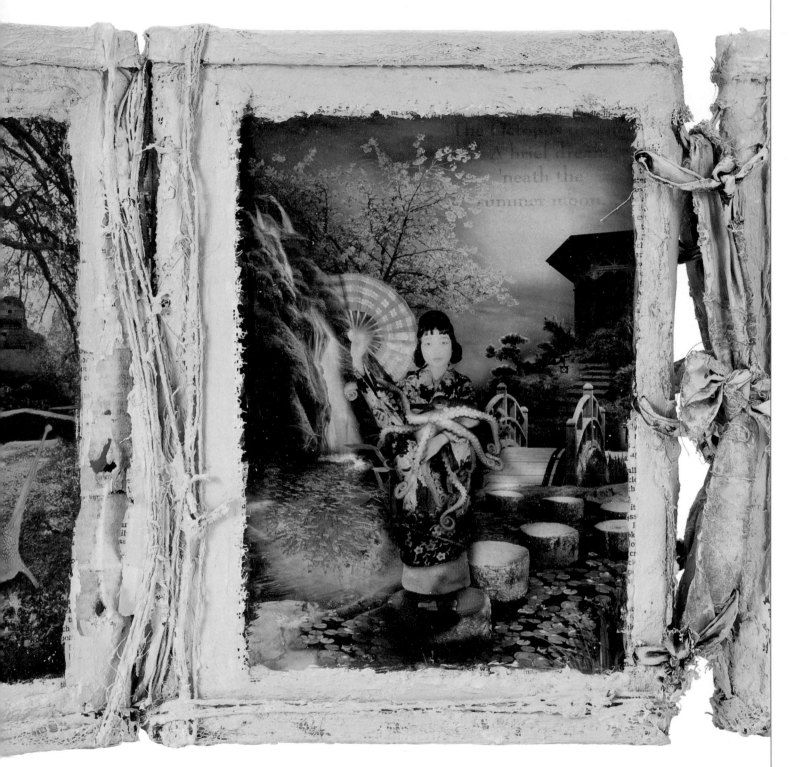

A little madness in the spring is wholesome even for a King.

EMILY DICKINSON

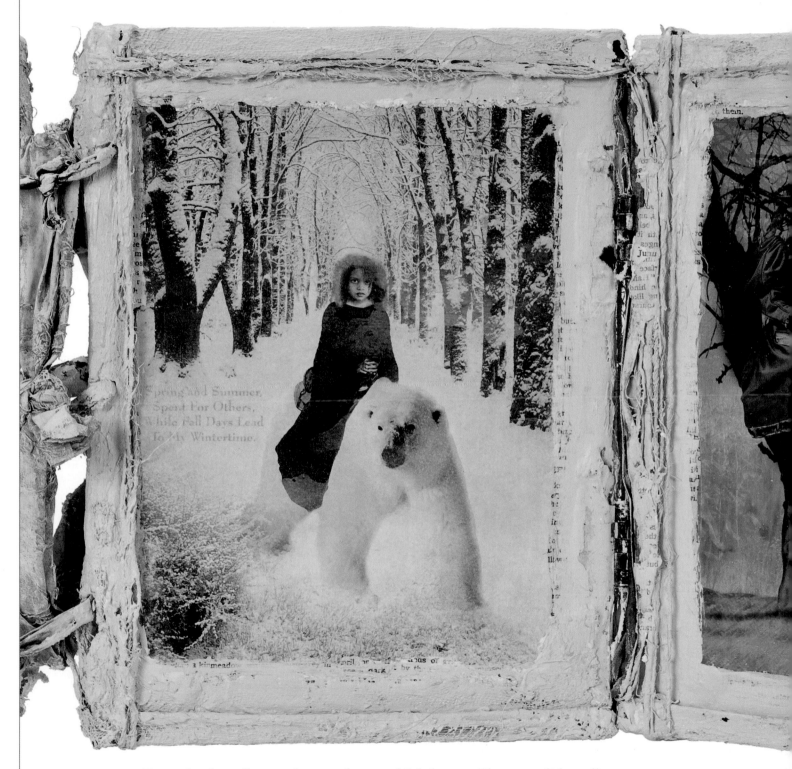

Down by the salley gardens my love and I did meet; She passed the salley gardens with little snow-white feet. She bid me take love easy, as the leaves grow on the tree; But I, being young and foolish, with her would not agree.

WILLIAM BUTLER YEATS

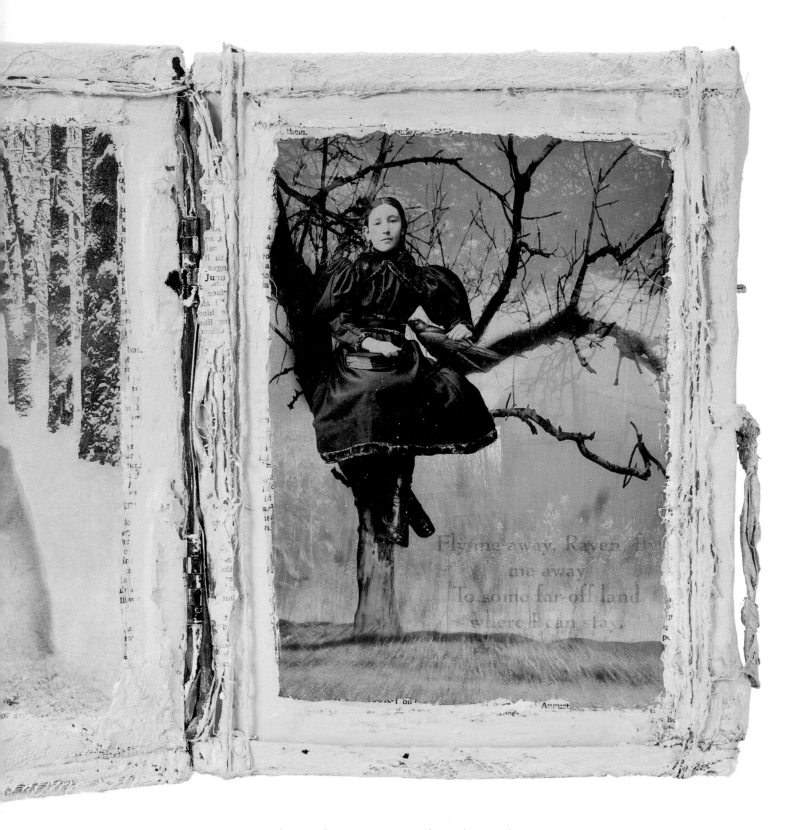

In the garden more grows than the gardener sows.
SPANISH PROVERB

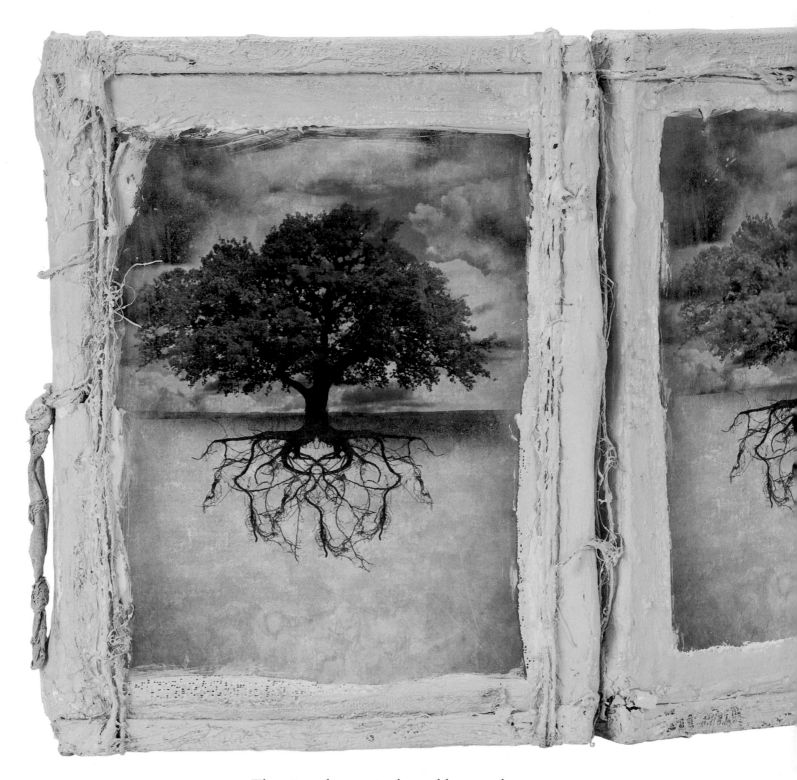

There is a pleasure in the pathless woods,
There is a rapture on the lonely shore ...
I love not Man the less, but Nature more.
LORD BYRON

Garden Notebook

Place a bonsai tree in a semi-sunny location; a wide windowsill is perfect to hold a decorative pot! Water the tree only when the soil is dry to the touch. Proper pruning is a critical factor in caring for bonsai—pinch the foliage to maintain the desired shape. In the spring, when the roots of your bonsai tree have become grounded in the pot, shake off the dirt, and use a bonsai pruner to get rid of any roots that look thin and scraggly. Branch pruning should also occur as spring begins. With a keen eye, choose the branches you wish to keep and carefully remove the others.

Cachepot

plaster of paris, cheesecloth, acrylic paint, acrylic caulk, transparencies, fabric, muslin, string, ribbon, string of thirty-five miniature Christmas lights, Plexiglas, wood, screws, varnish

How Does Your Garden Grow?

Let There Be Light

"I experimented and played around with the whole pop-up idea, but then started thinking; I make light-boxes! Maybe I can figure out how to translate my garden accordingly." And while Tiffini's light-box structure traveled miles from her original pop-up concept, it is still a technical marvel.

Beginning with a multitude of found images, which were then scanned, she digitally combined and refined each one. According to Tiffini, originally the little girl wearing the kimono in the East Corner was "nothing more than a face—black and white and badly damaged." The girl's entire body and the surrounding Japanese garden were digitally built and blended using drawing software.

The *Wayfarer's Haven* uses a basic-box construction: four two-sided frames made from lightweight wood and with removable upper and lower edges. Each frame holds two Plexiglas panels to which printed artwork is adhered. Small white string-lights are attached along the inside edges of each upper and lower frame section with the lights positioned between the Plexiglas panels. The removable sections allow for access to change the light bulbs in case they burn out.

To recreate the look of Tiffini's *Wayfarer's Haven*, glue bits of paper, fabric, string, and cheesecloth onto the frames. Lightly dip Rigid Wrap into a bowl of water and lay it over the sides and around the edges of each frame. If a bit gets onto the Plexiglas, don't stress, it will become part of the texture. Let the frame set for about twenty minutes, until the Rigid Wrap begins to harden. Mix a little plaster and paint it over the Rigid Wrap, paper, and fabric bits. After the plaster dries, apply some Red Devil Quick Paint—a white acrylic caulk—it's nontoxic, dries super fast, and adds great texture. The caulk lends stability to the Rigid Wrap and cheesecloth. Apply more plaster and some contrasting acrylic paint for highlights.

When the frames are completely dry, varnish them with a layer of Dorland's Wax. When lit the art will appear as if it was built on vellum even though it was printed on ordinary paper.

Field Notes

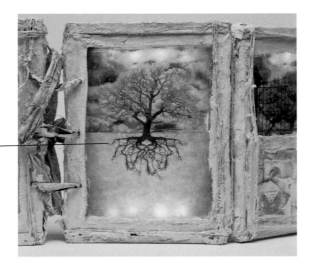

Changing seasons are expressed by showing the same tree with bare branches and then full of leaves.

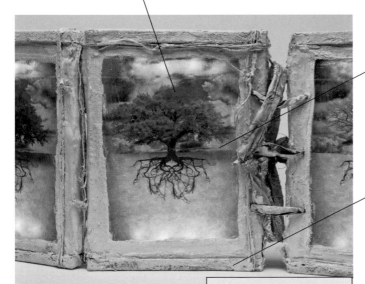

The tree's freeform structure mirrors the earthiness of the roots.

Don't be afraid to use contrasting elements like plaster of Paris and vellum.

Distinct colors vividly portray the change of seasons.

An accordion format can easily be transformed into a lantern.

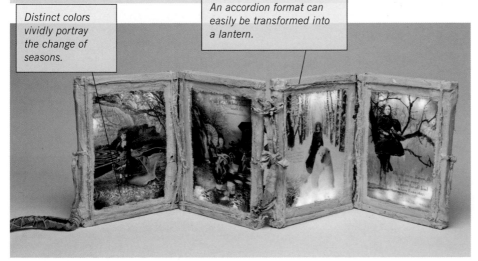

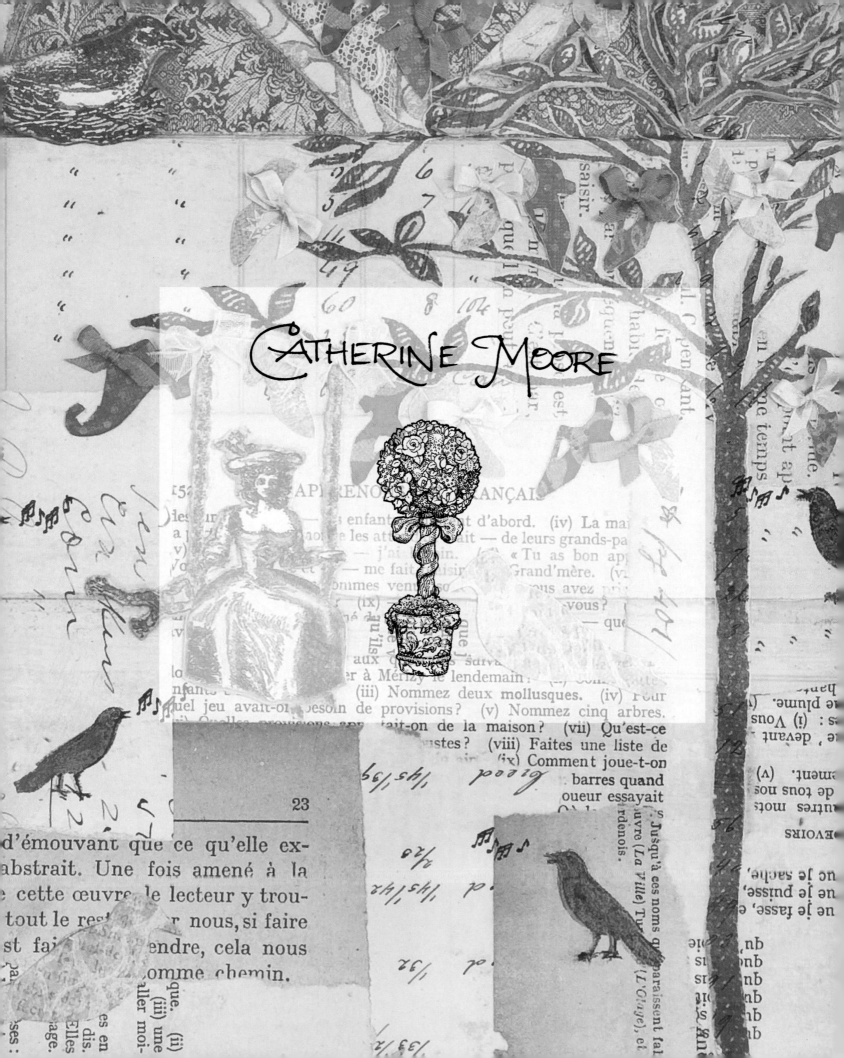

CHAPTER 2

Marie Antoinette's Garden

With a single glance at *Marie Antoinette's Garden* we are instantly swept away to eighteenth-century France. Catherine Moore visually transports us to a highly decorative and superbly imagined garden at the Royal Court in Versailles. Taking for her inspiration the grounds of the Petit Trianon, the small chateau that Louis XVl presented as a gift to his Viennese-born queen, Catherine has concocted a delicious confection of a garden with the rich pastel colors of a petit-four's icing.

Each façade of the Petit Trianon was specifically designed by its architect to complement that part of the larger estate it would face. Likewise, the four corners of this garden composition showcase a singular fundamental motif while sharing elements of color and visual symbols.

The entrance to the garden presents a spectacularly coiffed, pink-and-blue costumed figure of Marie. Her skirt forms the curtains of a small stage announcing exactly where we are, lest there be any doubt! In the North Corner we see an arcade, formed on one side by an arched and windowed wall, and on the other by a row of perfectly proportioned and symmetrical topiary trees. In the east, Catherine instills a bit of clever humor. Here Marie plays on a swing suspended from tree branches blossoming with pretty pumps! The West Corner is centered about a more formally divided garden. The south includes a gazebo complete with a marble tile dance floor.

Always there are birds flying, nesting, and perched. Birds settle on the walls, trees, and cobblestones. One carries a letter in her beak—perhaps a bit of news from Austria, perhaps an invitation to Marie's friends to come for a day of play in her garden.

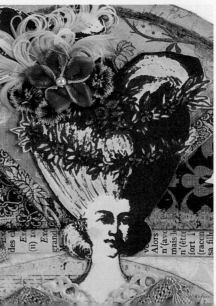

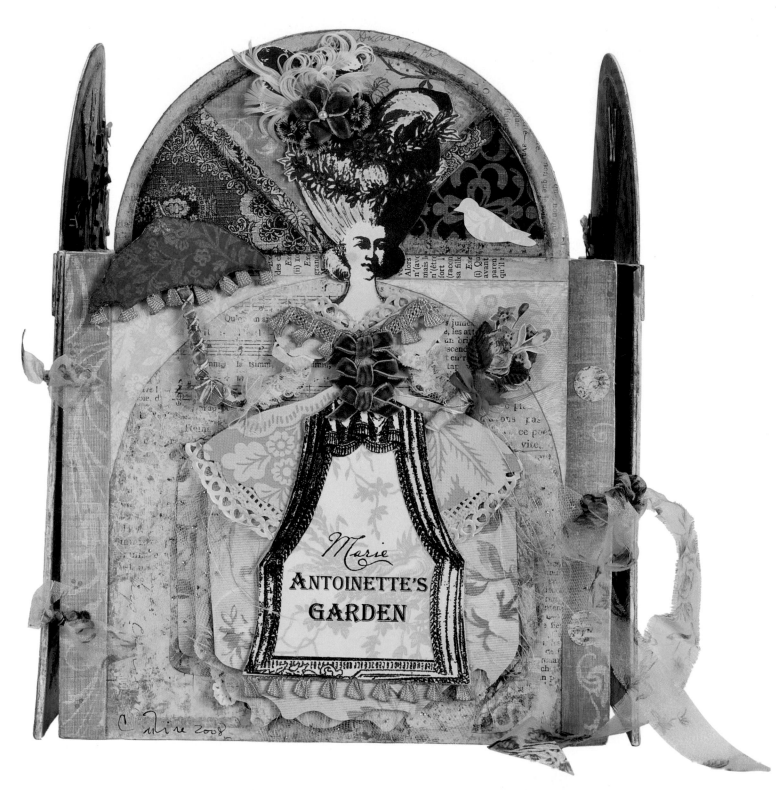

MARIE ANTOINETTE'S GARDEN

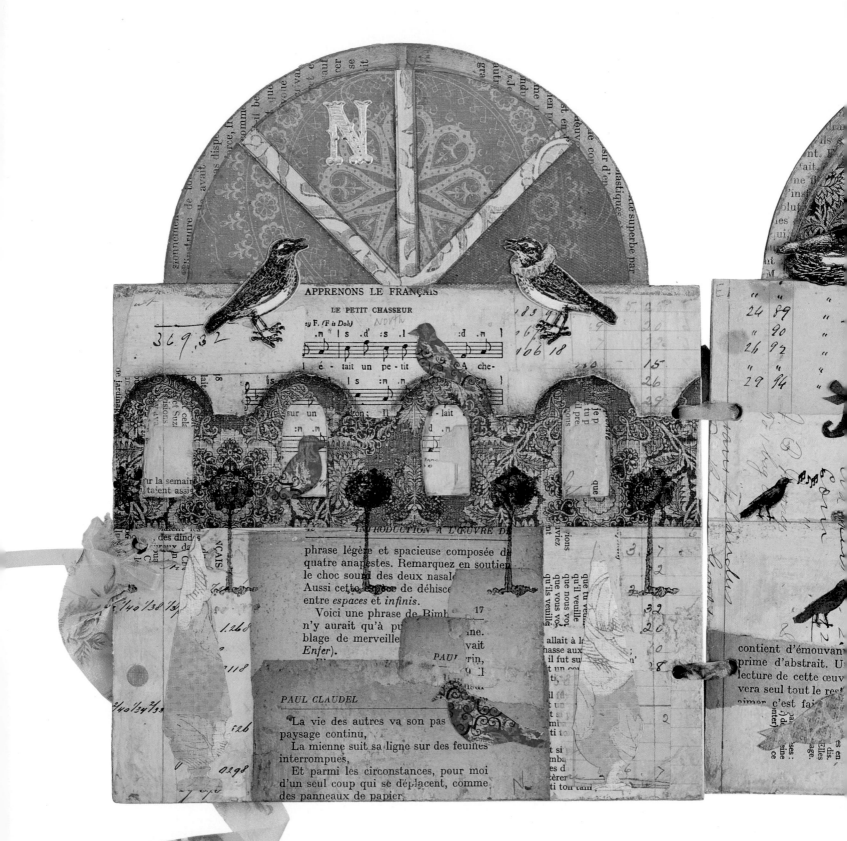

Won't you come into my garden? I would like my roses to see you.
RICHARD BRINSLEY SHERIDAN

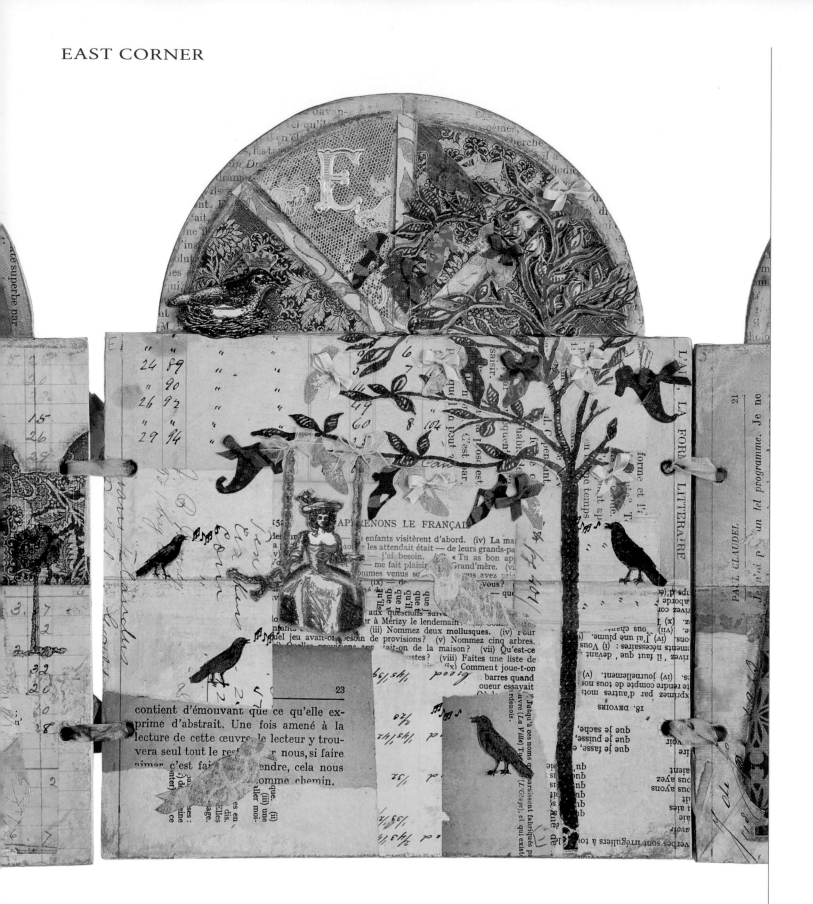

A profusion of pink roses bending ragged in the rain
speaks to me of all gentleness and its enduring.
WILLIAM CARLOS WILLIAMS

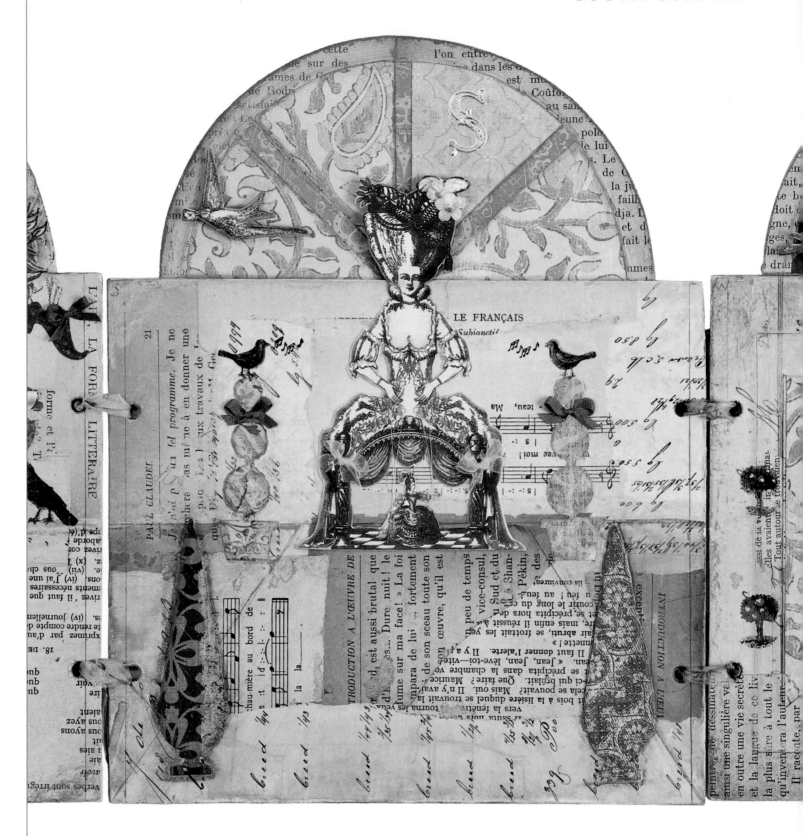

Flowers really do intoxicate me.
VITA SACKVILLE-WEST

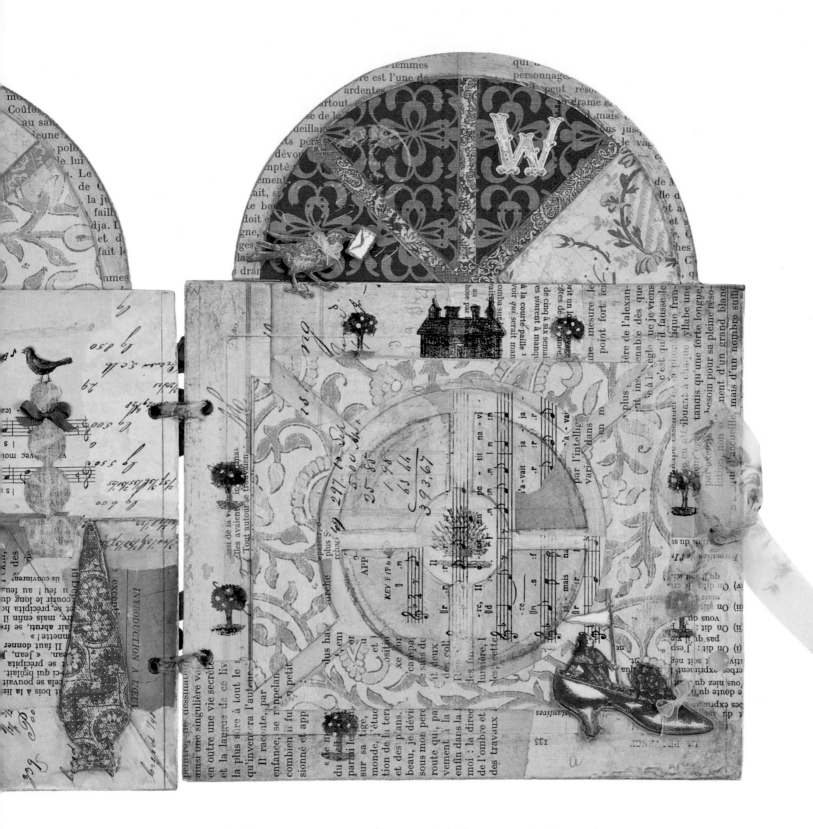

God gave us memories that we might have roses in December.
J. M. BARRIE

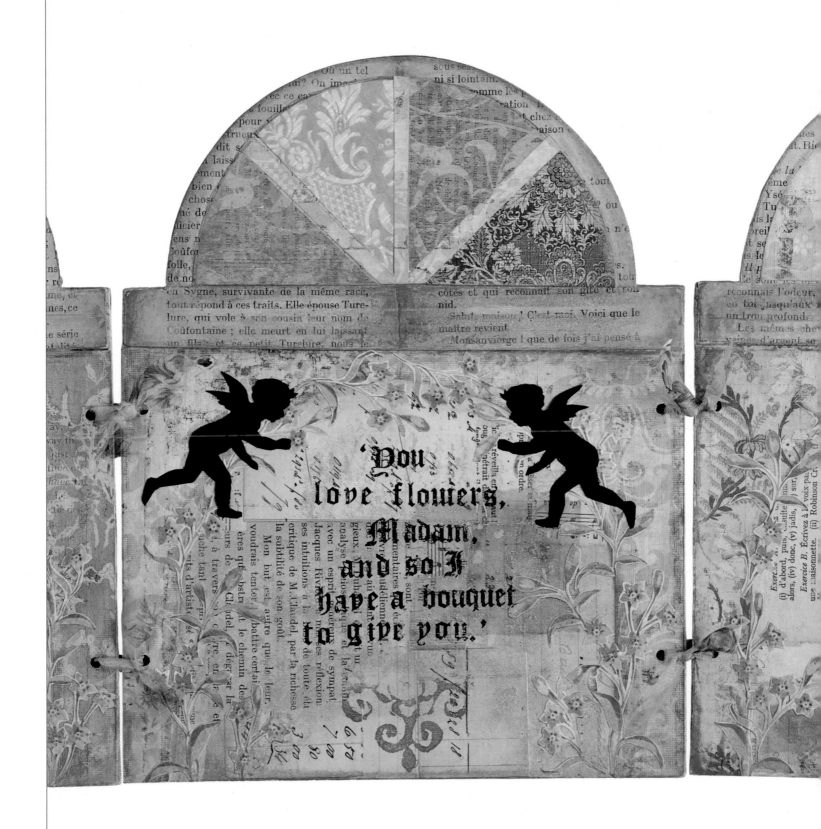

'You love flowers, Madam, and so I have a bouquet to give you.'

What's in a name? That which we call a rose by any other name would smell as sweet.
WILLIAM SHAKESPEARE

How Does Your Garden Grow?

The Stylish Art of the Silhouette

With a delicate and girlish pastel palette, Catherine has fashioned a cunning miniature garden stage set, one that would have done justice to any amateur theatrical or tableau performed in Marie Antoinette's Petit Trianon at Versailles.

Her silhouettes were cut out, painted black, and then collaged onto the garden walls. Catherine added a few cherubs cut from a blue floral paper. Set against ornately designed backdrops, these silhouetted figures and the courtly king and queen are actors in a tragic drama for the ages.

Catherine elaborates: "As a lover of language, I find the word silhouette quite appealing. It did not surprise me to learn that the word was adopted from the French and dates to the 1700s. As a figurative artist whose primary medium is paper, and as someone who is passionate about costume and fashion, I find silhouettes utterly charming. Not only do they reduce the figure to its simplest and most beautiful form, the black contrast adds a lot of visual impact."

Appearing quite early in classical art, including on Greek black-figure vase paintings, silhouetted figures reached new heights right before Louis XVI took the throne with his young queen, Marie. Louis XV employed Étienne de Silhouette as his minister of finance, who was so renowned for stinginess that cheap portraits done from the side and filled in with a solid color were labeled *à la Silhouette*. They became so popular in Europe during the late eighteenth century that the silhouettes replaced miniature paintings at the French and German courts. In England and the United States, profile portraitists flourished throughout the ninteenth century. Artists, such as Arthur Rackham, created hundreds of silhouettes for book and magazine illustrations. Although their popularity declined after the invention of the daguerreotype, periodically silhouettes experience a resurgence. A recent abundance of enormous silhouetted flowers printed on canvas, pop-art style, and the cutouts of designer Tord Boontje and illustrator Rob Ryan demonstrate that everything old is new again.

Field Notes

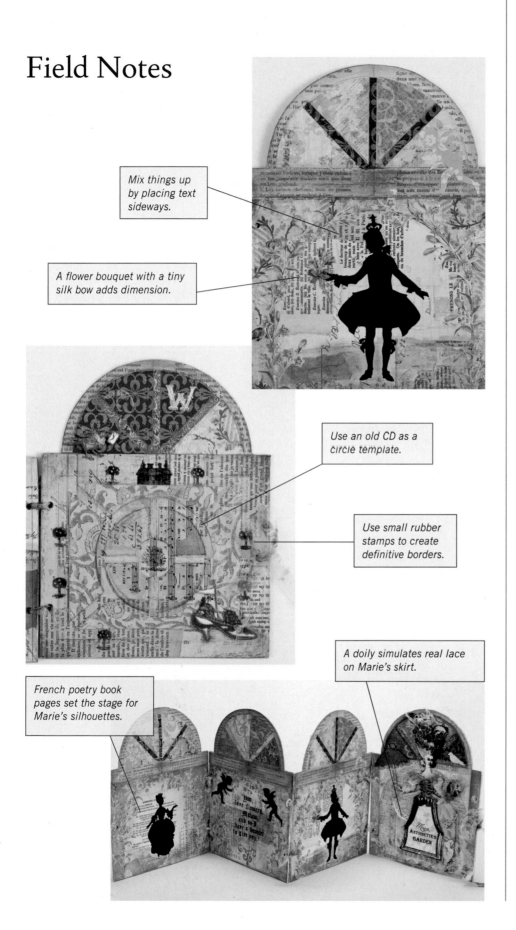

Mix things up by placing text sideways.

A flower bouquet with a tiny silk bow adds dimension.

Use an old CD as a circle template.

Use small rubber stamps to create definitive borders.

A doily simulates real lace on Marie's skirt.

French poetry book pages set the stage for Marie's silhouettes.

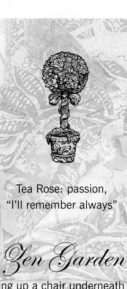

Tea Rose: passion, "I'll remember always"

Zen Garden

pulling up a chair underneath the canopy of oaks in my backyard

observing a family of thrashers splashing in the birdbath

warm tomatoes and basil fresh from my garden with a drizzle of olive oil

the sound of rain at night

basking in the sun as I listen to the ocean nearby

afternoon thunderstorms on Sanibel Island

Dig It!

To achieve clean edges when collaging paper onto a substrate, try this easy method that requires no measuring in advance. Simply cover the panels with assorted papers and allow them to extend beyond the edges about ¼" (6 mm). While the paper is still wet, use a sanding block to sand away the excess paper. Not only does this produce a clean edge, it presses the paper against the surface to provide better adhesion.

CHAPTER 5

As Above so Below

Minimalist, elegant, understated, subtle—any of these words accurately describe the serene ambiance of C. W. Slade's *As Above, So Below* garden. Endowed with a fine-art sensibility, the garden's soft colors seem to vibrate from somewhere within a hidden source—a wellspring of the clear essence of garden.

As we enter through the front gates, which seem to enclose the secrets of the rewarding life of a contemplative, we pass through each of the four elementals. Air, invisible yet omnipresent, swirls above, and cools us in the north. In the East Corner we find the quiet peacefulness of Buddha and the symbolic lotus blossom awash in the fabulous calm turquoise of sun-drenched water. Traveling on to the south in this beautifully kept Zen garden, we find expansive tree roots extending far, far below, almost reaching to the very core of the earth. At last, as we reach the westernmost corner, we feel as if we have just received an amazing gift as the element of fire welcomes us with its radiant warmth and heartfelt passion.

When we finally emerge on the other side, the outer walls are richly layered above and below with quiet patterns of infinite depth and vaguely iridescent colors. Refreshed, invigorated, and with our spirits renewed, we continue ever onward.

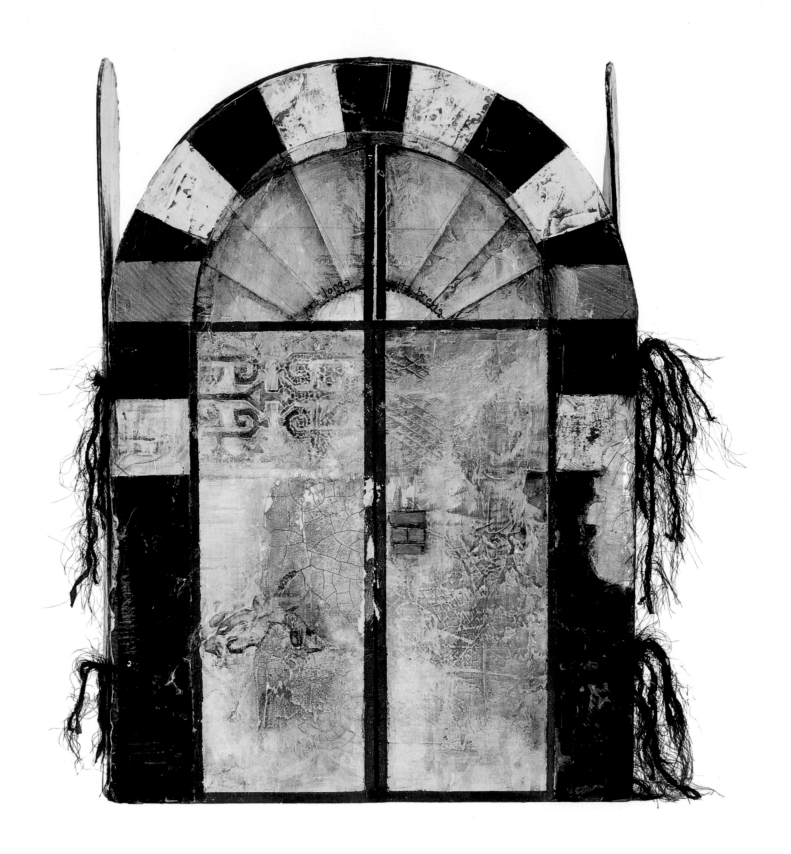

As Above so Below

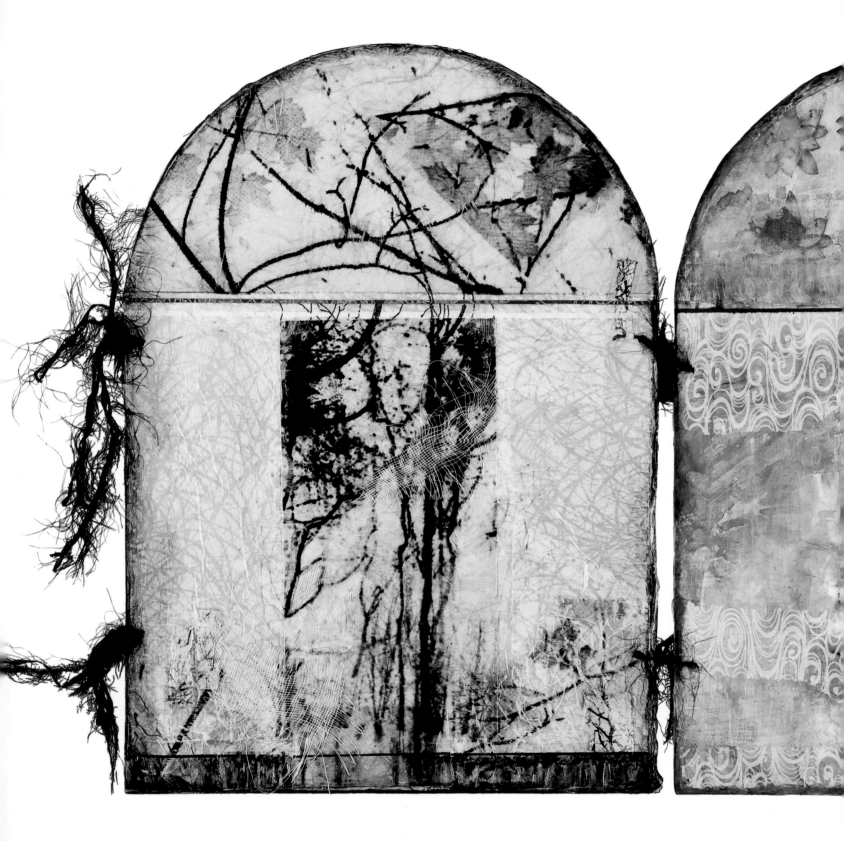

Now I see the secret of the making of the best persons.
It is to grow in the open air, and to eat and sleep with the earth.
WALT WHITMAN

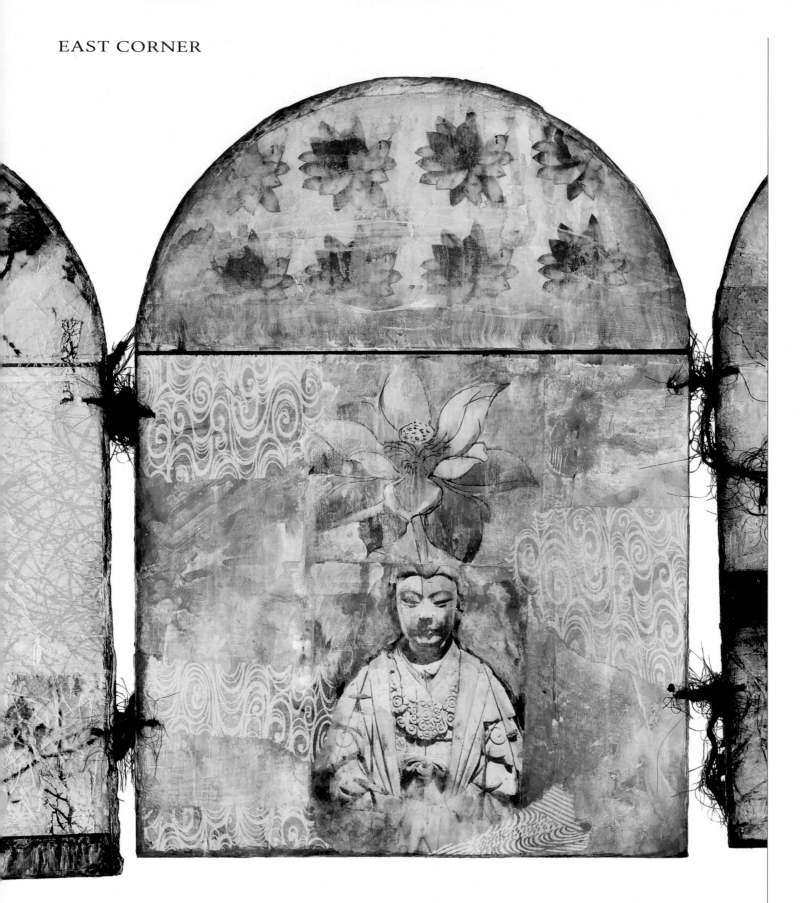

The trees reflected in the river—they are unconscious of a spiritual world so near to them. So are we.
NATHANIEL HAWTHORNE

My soul can find no staircase to heaven unless it be through earth's loveliness.
MICHELANGELO

WEST CORNER

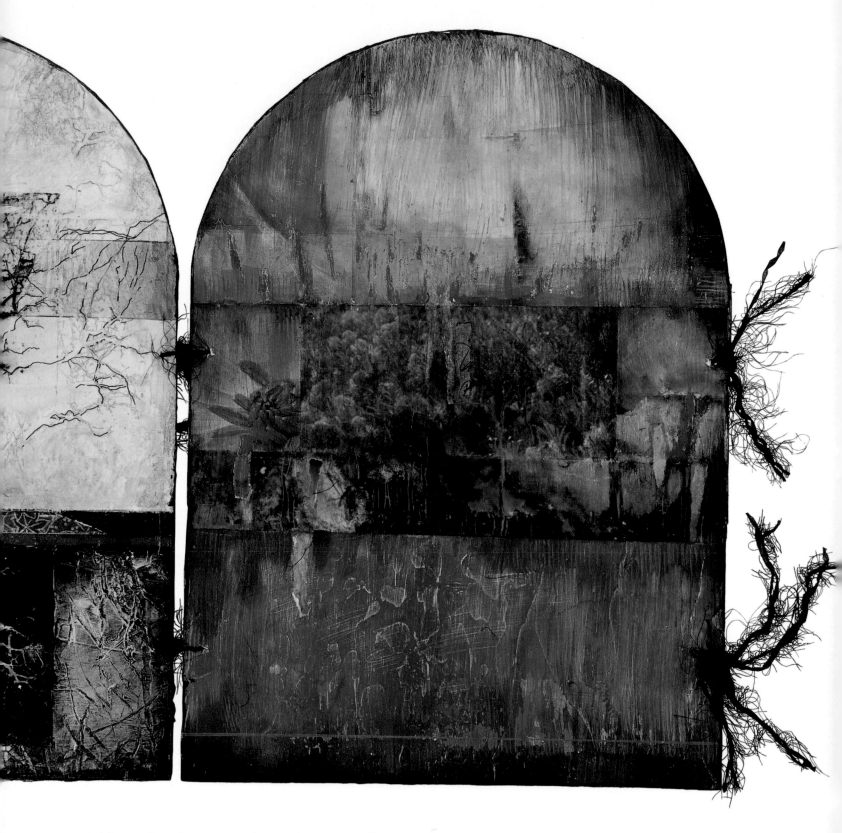

Hold your hands out over the earth as over a flame. To all who love her, who open to her the doors of their veins, she gives of her strength ...
HENRY BESTON

56 *In This Garden*

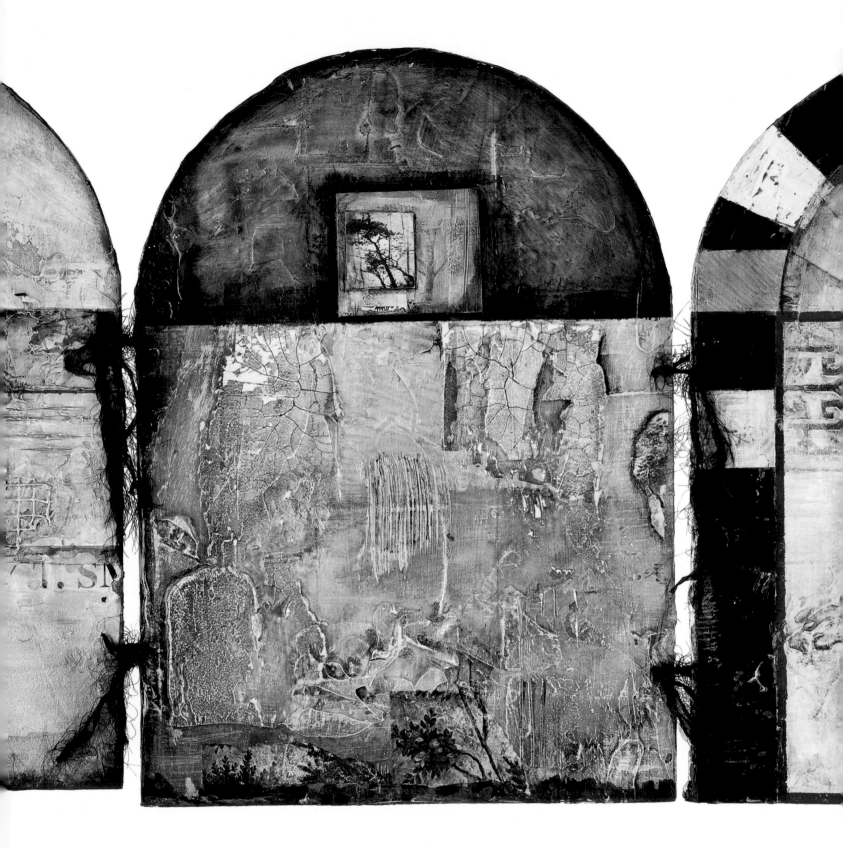

What lies behind us and what lies before us are tiny matters compared to what lies within us.
RALPH WALDO EMERSON

Garden Notebook

Most flower bulbs prefer a sunny location, but they will thrive in any climate! Plant bulbs deeper in sandy soils than in clay soils, and be sure there is adequate drainage to encourage large and full blooms. In colder climates some tender bulbs, such as dahlias and caladiums, produce blooms sooner if you start them indoors in containers, and then transplant them to the garden when danger of frost is past. Some bulbs, such as amaryllis, can be grown in containers year-round. Planted under a canopy of deciduous trees, early blooming bulbs are hopeful harbingers of spring.

Cachepot

texture paste, plaster, crackle paste, fluid acrylics, acrylic mediums, papers, magazine pages, rice paper, wire, cheesecloth, computer generated imagery, dental tools, sandpaper

How Does Your Garden Grow?

Tranquil, Diaphanous, Volatile, Gossamer

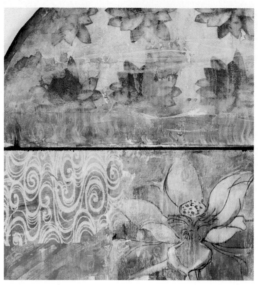

The untamed hues and color-drenched corners of the *As Above, So Below* garden are the perfect symbiosis of a fine artist's training and eye and C. W.'s willingness to experiment and play. For her base layer she used Arches 400 heavyweight watercolor paper that will withstand a multitude of materials and techniques. The artist built layers of paint and various papers over embedded cheesecloth and wire grid.

C. W. painted over sand-textured paste, and then tore away some layers to reveal threads of rice paper beneath. Many coats of gloss medium were applied for an overall glassy-smooth appearance and feel. The entrance gate to *As Above, So Below* was created with paints. For the rest of her garden C. W. relied largely on paper, with paint as an added element. She explains her approach: "When working with papers anything goes. Paper is just a tool and I don't worry about the image or pattern being lost. Whether I use a photo, digital image, or drawing, it's only meant to suggest something more subtle. I love to obscure areas of the image and play up other parts. I used digital images in the water wall, which was printed on standard copy paper. I like that the paper fades and tears so I can play with the images. First I use the computer to alter the images, and then continue altering with paint. Reusing photos of my previous work in new pieces creates continuity and a visual dialogue, and presents me with my own personal icons." C. W. first applies either matte or gloss medium, and then begins laying her papers down—manipulating, painting, sanding, and tearing as she goes.

C. W.'s abstract representation of each cardinal direction is as an element, and each element has a corresponding characteristic; earth, tranquil; air, diaphanous; fire, volatile; and water, gossamer. The digital and physical manipulation of paper and image work together in achieving the visual interpretation of these abstract qualities. There is a sense of wandering through the elements rather than viewing actual gardens.

Field Notes

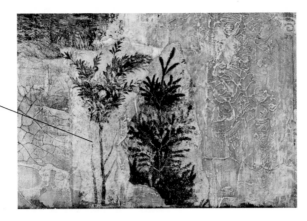

The shading of the tree grounds the image on this panel.

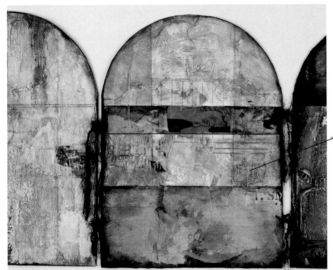

Wire grid was embedded in the texture paste.

Panels are unified by repeating suggestions of color.

Embossed patterns were made with paste and sandpaper.

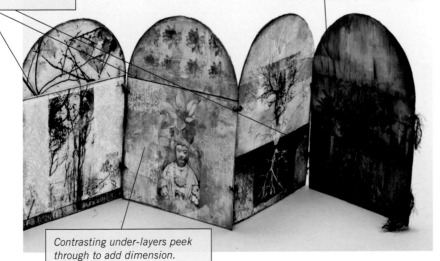

Contrasting under-layers peek through to add dimension.

Lotus: awakening to the
spiritual reality of life

Zen Garden

the smell of the earth after
a good rain

listening to the silence just
before sunrise

seeing the first signs of fruit

noticing something beautiful fighting
its way through the concrete

the smooth shiny skin of
peppers in my garden

reading outside my studio

watching the light play
with the shadows of leaves on
my studio wall

different shades of stones

Dig It!

Layer a prepared canvas or board
with collage material.
Cover larger areas with plaster or
texture paste, allowing portions
of the collage to show through.
When the plaster is dry, sand areas
to reveal the layers underneath.
Try working on two pieces of art
at the same time to allow for drying
time and mood changes.

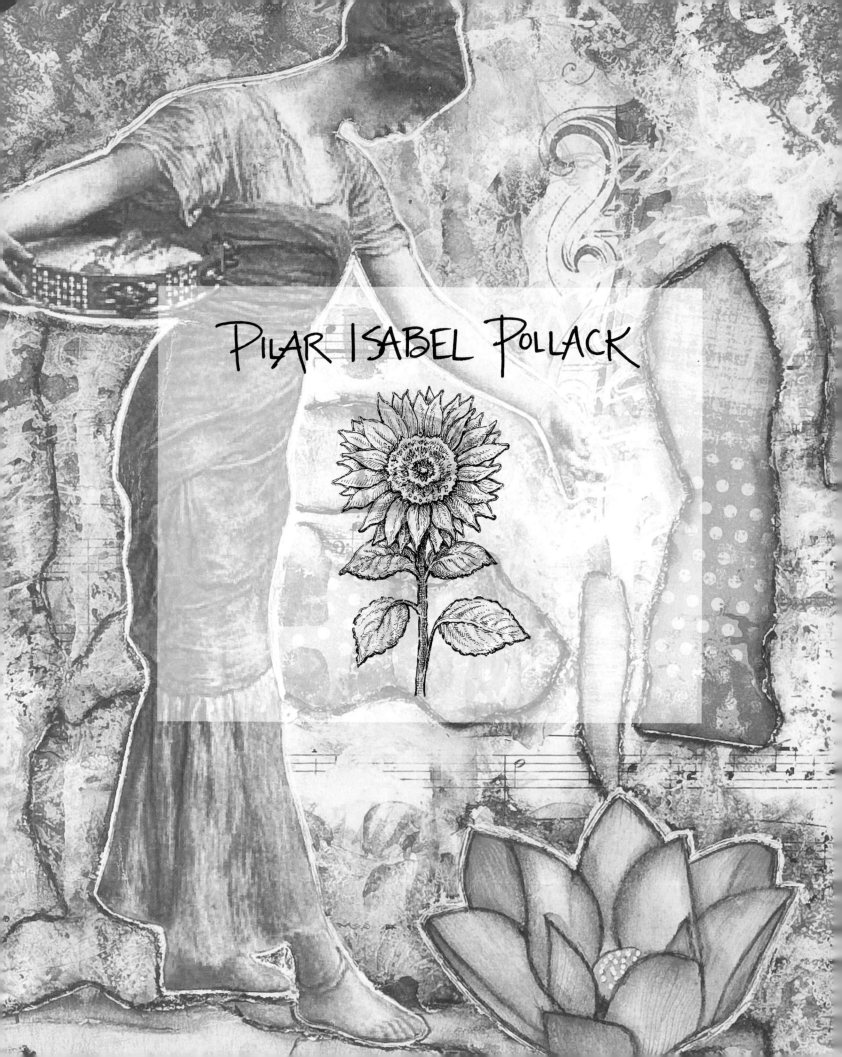

Pilar Isabel Pollack

CHAPTER 6

GARDEN OF ZEPHYRUS

Pilar Pollock's *Garden of Zephyrus* cleverly fuses the elegant icons of widely diverse floral, historical, and spiritual traditions with her personal grunge style and techniques. The result is a jewel box of a garden with treasures spilling forth from virtually every crevice and corner.

Pilar works facilely with freeform stitching, fusible interfacing, Lutradour, monoprints, fabric paper, water-soluble paper, paint, ink, and oil-color paintstiks to fabricate a spiritual garden resplendent with urban grunge. Medieval imagery easily coexists with Our Lady of Guadalupe within the inner corners of the garden. These images share an electric blue-violet accent color, a background filled with graffiti-style text, random numerals, dripped and rubbed pigments, and metallic highlights, which when combined exemplify her current far-ranging spiritual travels. Pilar's experiences with nature as a child are revisited in her choice of garden plantings on the outer walls—sunflowers, dandelions, and a fruit tree. Her drip-dry print technique adds an edgy effect to an otherwise static, repetitive grid on the dandelion wall; an effect duplicated by the juxtaposition of jarring elements with repetition throughout.

While urban grunge may evoke visions of an overt use of the color black, in the *Garden of Zephyrus* black plays only a peripheral accent role to the artist's distinctively grunged, yet bright highlights of fuchsia, orange, lime green, white, and bright blue.

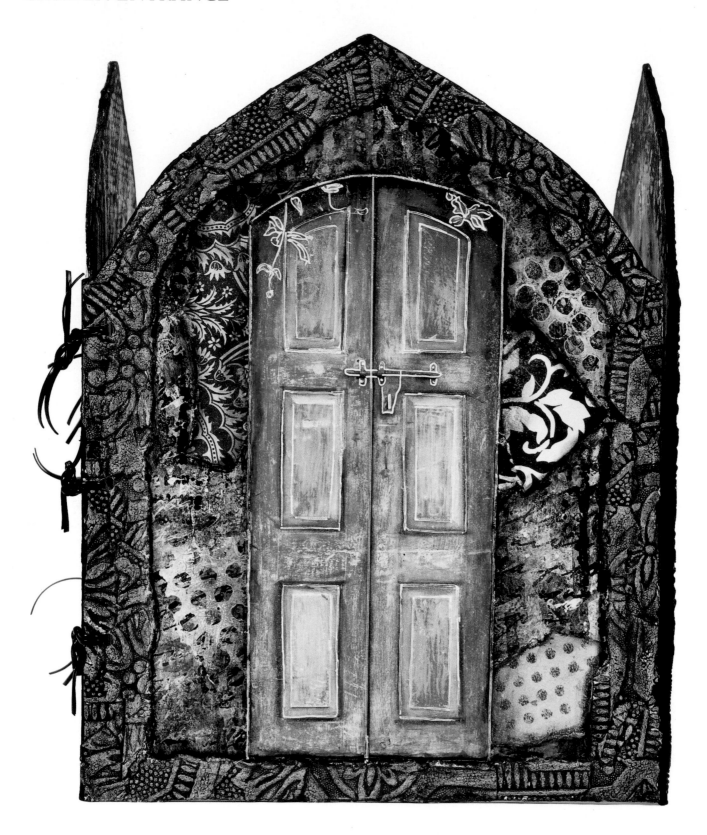

GARDEN OF ZEPHYRUS

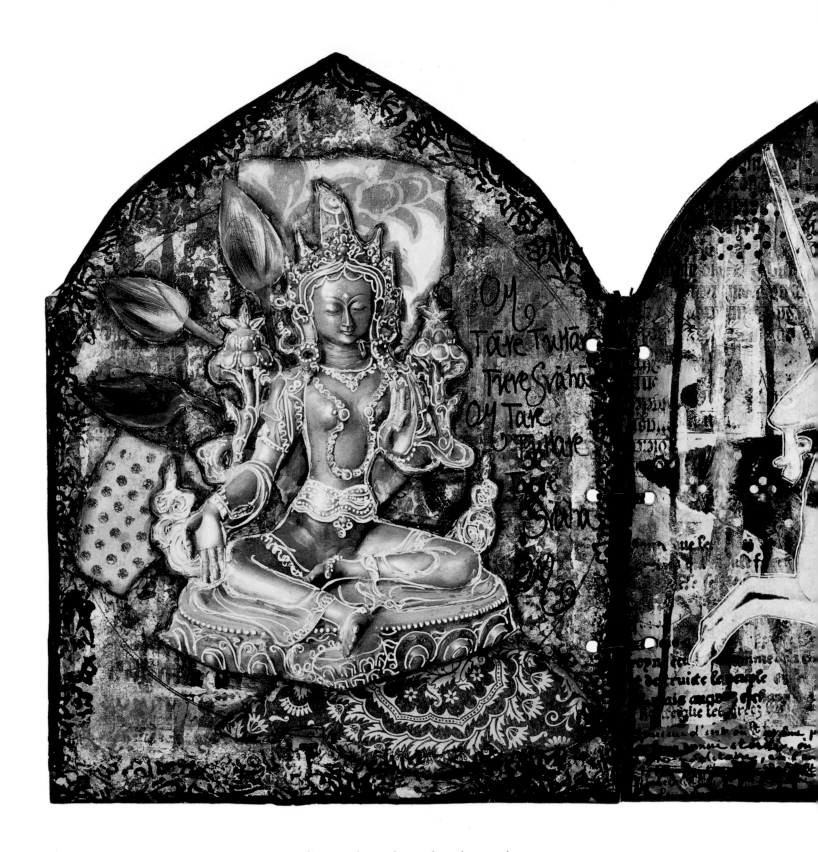

When seeds are buried in the earth,
their inward secrets become the flourishing garden.
RUMI

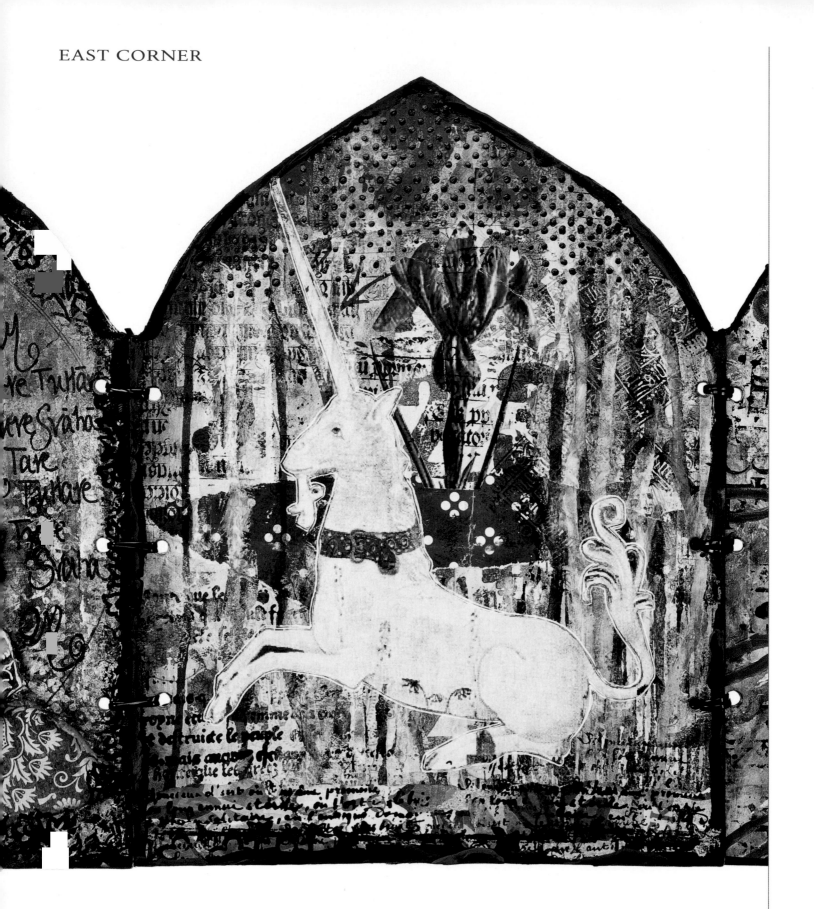

Connection with gardens, even small ones, even potted plants, can become windows to the inner life.
The simple act of stopping and looking at the beauty around us can be prayer.
PATRICIA R. BARRETT

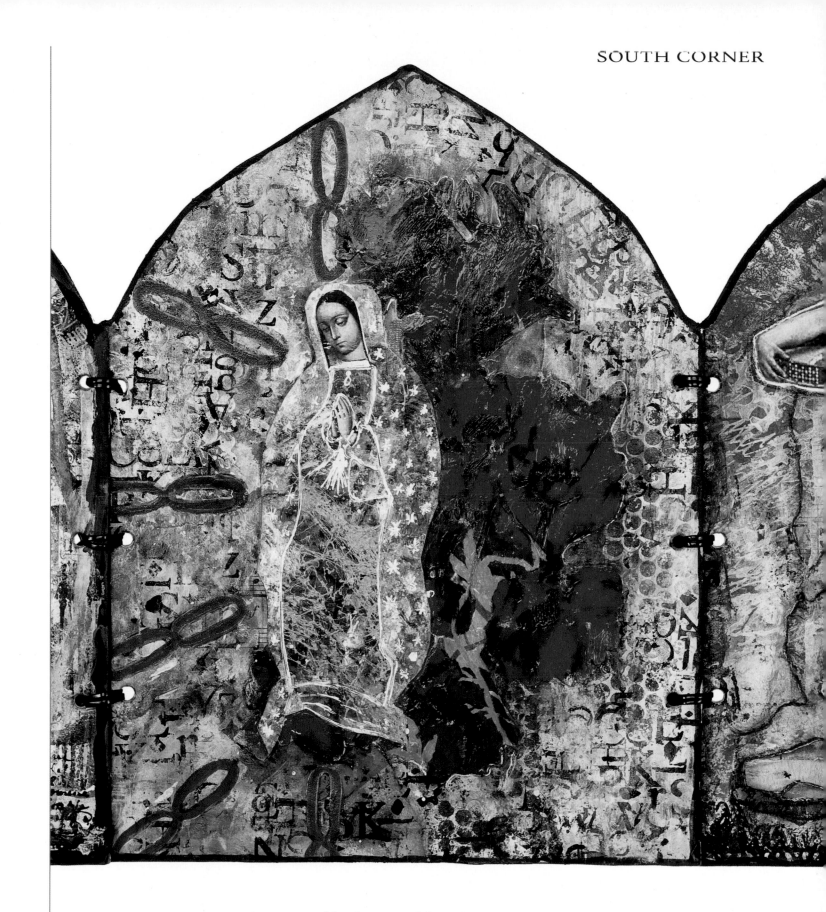

I was raised by the song of the murmuring grove
And loving I learned among flowers.
FRIEDRICH HOLDERLIN

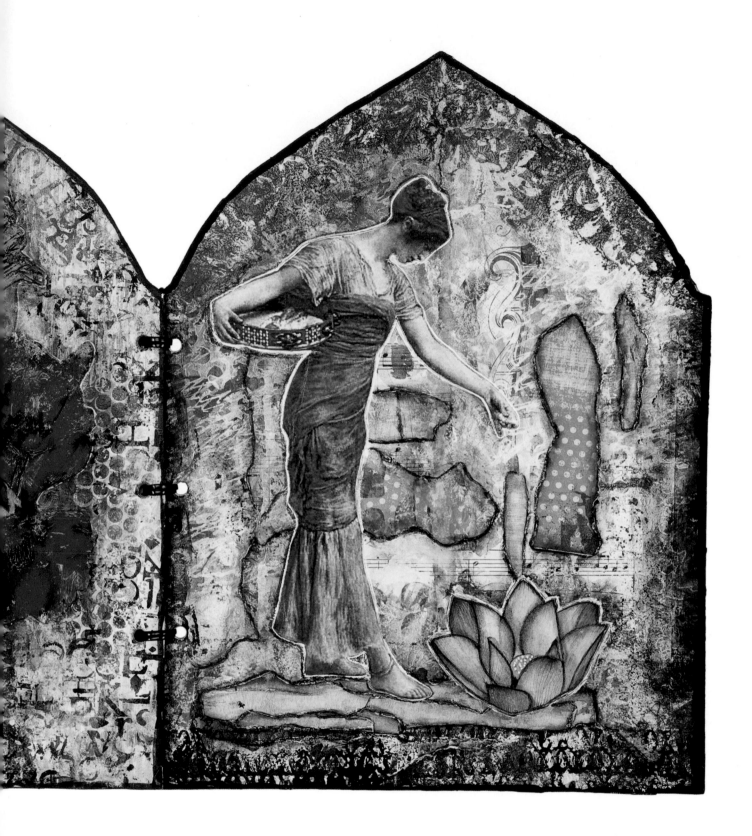

A pool is the eye of the garden in whose candid depths
is mirrored its advancing grace.
LOUISE BEBE WILDER

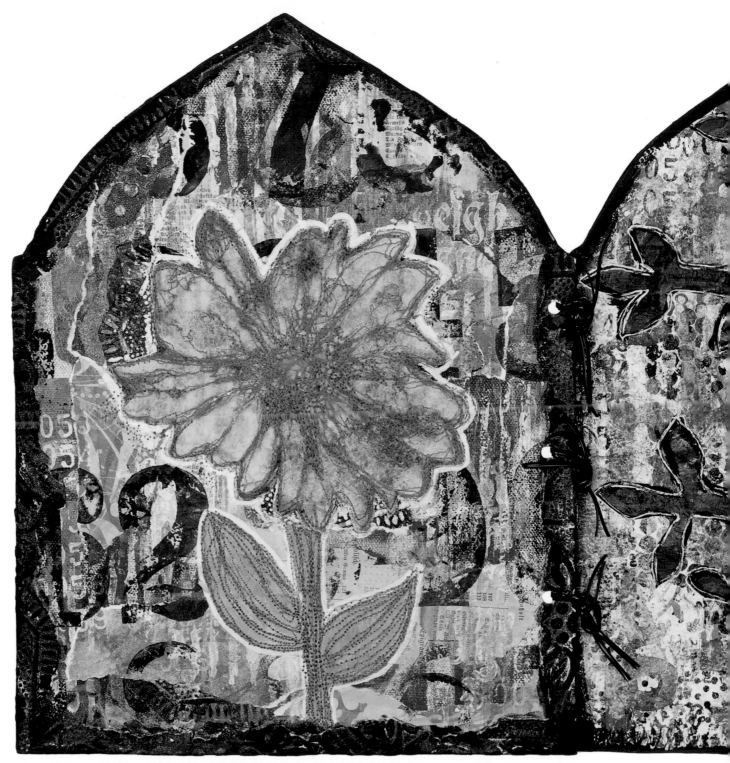

When time comes for us to again rejoin the infinite stream of water
flowing to and from the great timeless ocean,
our little droplet of soulful water will once again flow with the endless stream.

WILLIAM E. MARKS

How Does Your Garden Grow?

Drip Dry Painted Grunge

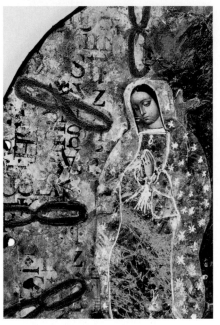

A quick glance at the seriously grunged color patterns and combinations in Pilar's *Garden of Zephyrus,* and we realize we are in the presence of a consummate tinge and tint experimenter.

She tells us, "The secret key to grunge is layering, or at least, in my little art world." Through layers of manipulated and altered scrap papers and paints, Pilar astutely conveys an illusion of mystery among the grit of everyday life.

Don't always feel constrained to using brushes and organized color placement when creating backgrounds! Consider dripping paint, ink, or dye randomly onto the page. Take it a step further—fold the page against itself to create unique patterns and new colors.

Try this version of monoprinting: Take a piece of drawing paper and apply two coats of gesso. As the paper dries, select two or three colors of fluid acrylic, ink, or watercolor fluid concentrate. You may wish to select color combinations that complement one another, or experiment with colors you would never consider using together!

When the paper is dry, place a drop or two of one color in the middle and at each corner of the paper. After a few seconds, fold the paper in half. Press down firmly on the paper as you smooth the layers together with your hand. Now open the paper. The ink or paint will have printed itself across the page. If necessary, or if desirable, repeat while the coloring agent is still wet.

Allow the ink/paint to dry for a minute, and repeat the process with additional colors. When you're pleased with the combinations and patterns, allow the paper to dry completely. Repeated folding will create peaks in the paper. Lightly emphasize those points with metallic wax, paint, or foil to pull the overall design together.

Field Notes

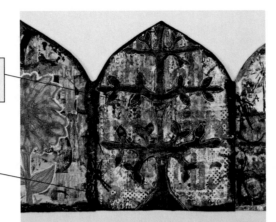

Outline with a white pen to pop the details.

Combine layers of paint, paper, and stamped images for a grungy effect.

Complement a photograph with a heavily stitched frame.

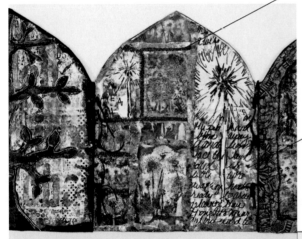

A black Sharpie stands out clearly against most backgrounds.

Free-form stitching creates additional patterns.

A 3-D effect is achieved by using embossed wallpaper as edging.

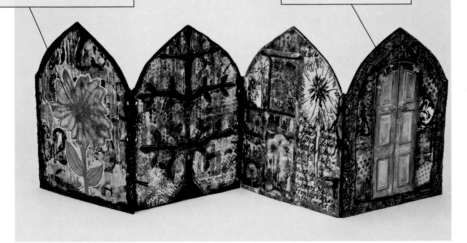

Sunflower: homage, devotion, adoration, longevity

Zen Garden

a jovial salutation from
a black phoebe

the bounce of grass beneath
my bare feet in the spring

the earthy bouquet after
the first spring rain

the smiling faces of sunflowers

natural alcoves and niches
shaped by bending branches

the soft coating of moss
on weathered rock

Dig It!

Never underestimate the power of paper. Search through your junk mail to find some great colors, fonts, and graphics. Coupons for local stores are printed on various weights of paper. Newspapers, phone books, take-out menus, receipts, and old letters can be a clever way to create dimension when using two or more elements—the fonts and contents play against each other. Dig into that stack of scrapbook paper sitting on your art table. If the preprinted design is too flat for you, rubber-stamp some text, drip a bit of paint, or add a wash to transform the appearance.

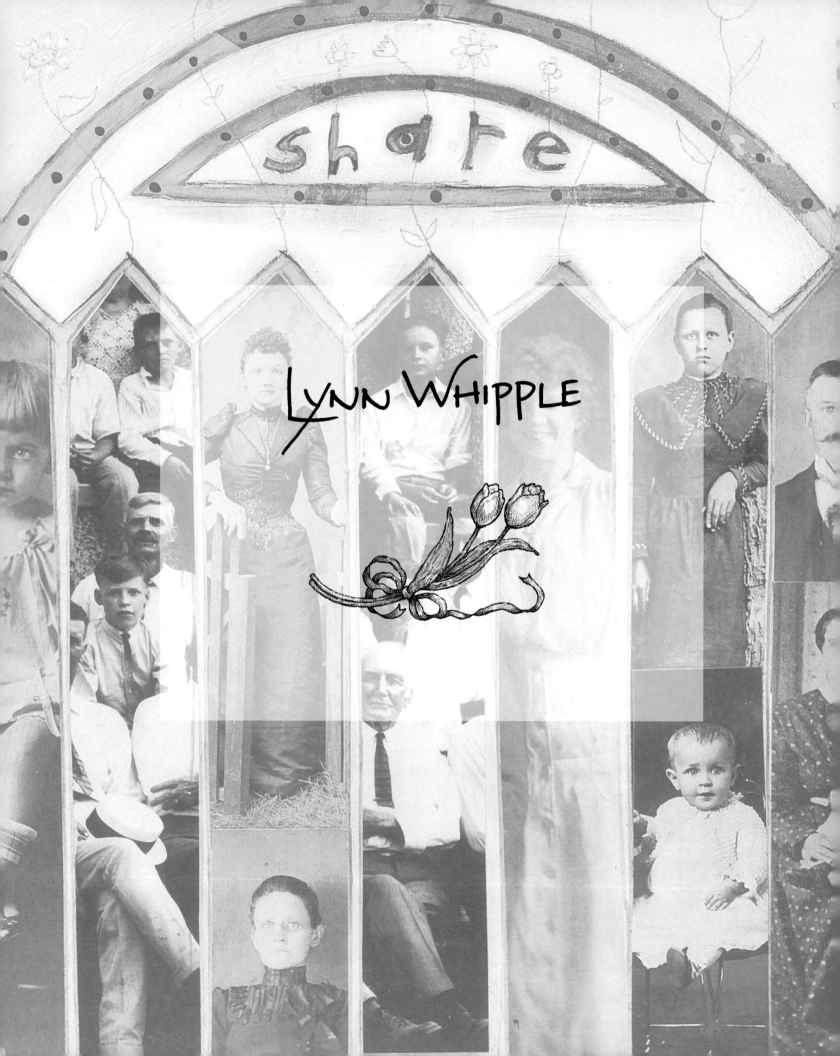

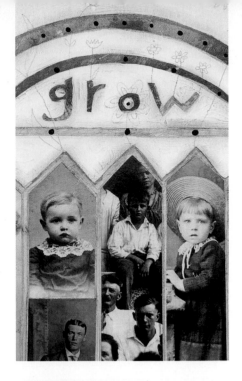

CHAPTER 7

A Community Garden

According to the American Community Gardening Association, whose mission is "to build community by increasing and enhancing community gardening and greening across the United States and Canada," a community garden can be urban, suburban, or rural, and can grow flowers, vegetables, or community. Lynn Whipple's community garden exemplifies the concept with grace, wit, and acres of visual appeal.

A sedate picket fence wraps all around the garden, holding a cacophony of collectively cultivated flowers that practically explode as they vie for the sun. Yet look again; this is a picket fence with a twist! It, too, almost explodes with life; each picket is constructed with copies of old studio photographs, or *cartes-de-visite*, cleverly stained with burnt umber paint imparting the quality of aged, stained wood. It's a gathering, a fellowship, and a community.

Catch a small glimpse of the secret life of plants within each garden corner. Every flower has a face peeking out from the heart of its petals at any passerby. If gardens represent the hearts and souls of those who plant and tend them, then this artist has cleverly captured the essence of what it means to be part of something so much larger than oneself in *A Community Garden*.

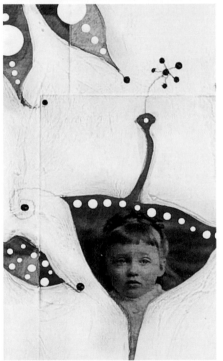

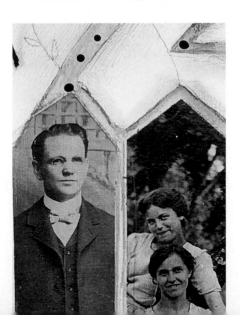

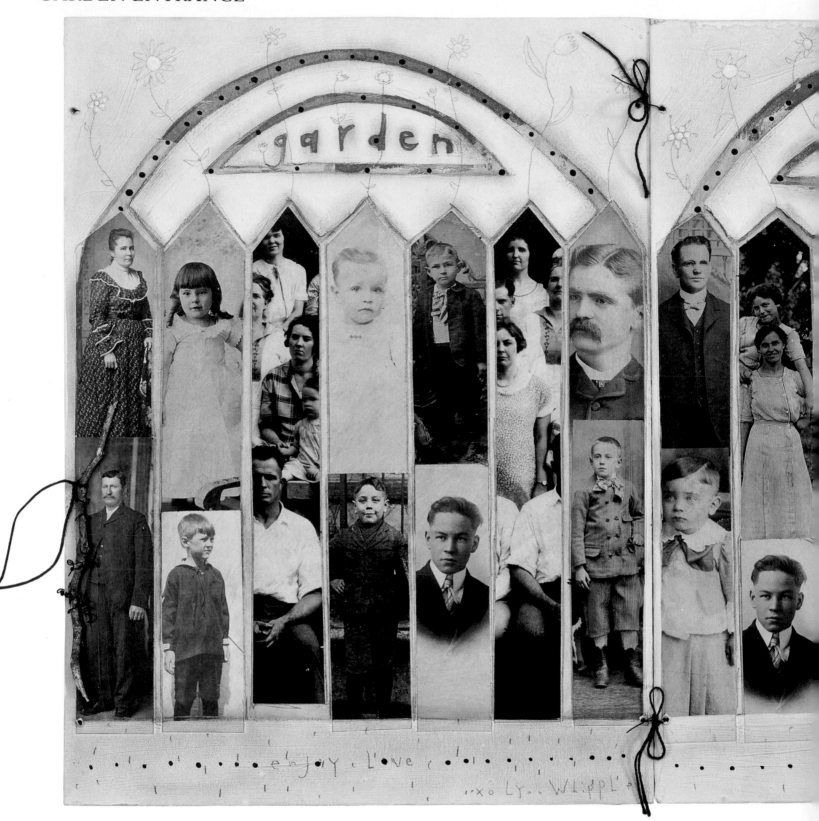

A Community Garden

In This Garden

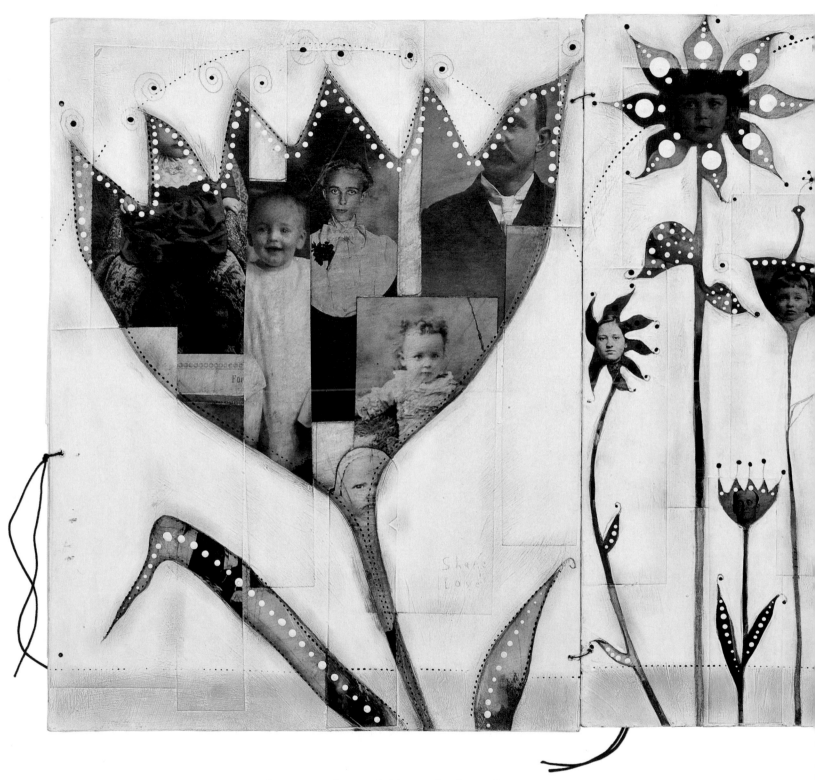

Flowers are beautiful hieroglyphics of nature,
with which she indicates how much she loves us.
WOLFGANG VON GOETHE

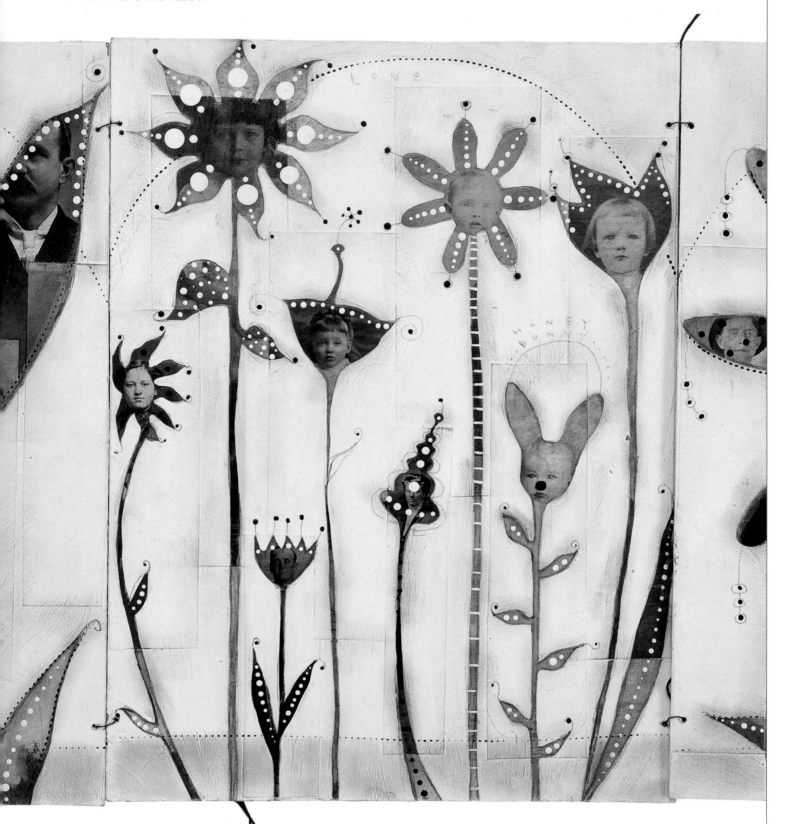

*Gardeners instinctively know that flowers and plants are a continuum and
that the wheel of garden history will always be coming full circle.*
FRANCIS CABOT LOWELL

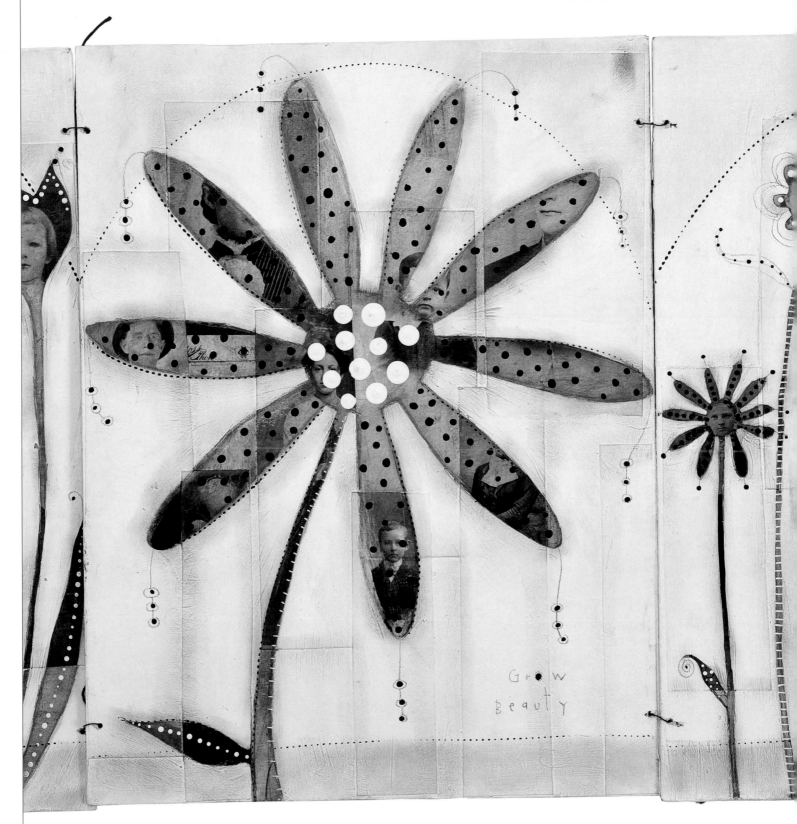

Out of gardens grow fleeting flowers but lasting friendships.
BEVERLY ROSE HOPPER

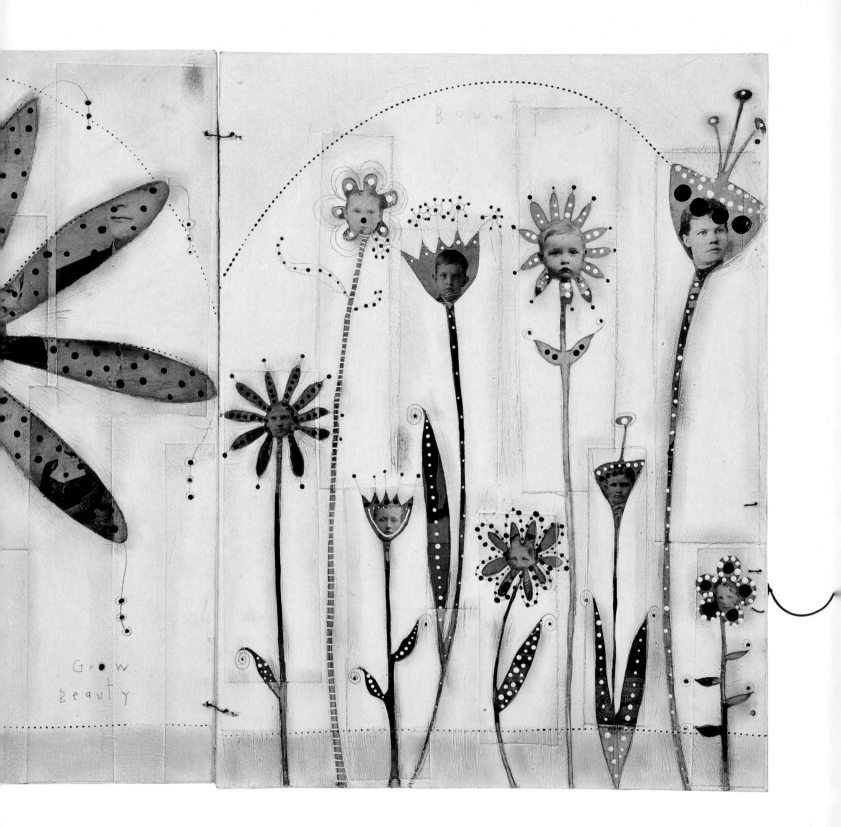

In all things of nature there is something of the marvelous.
ARISTOTLE

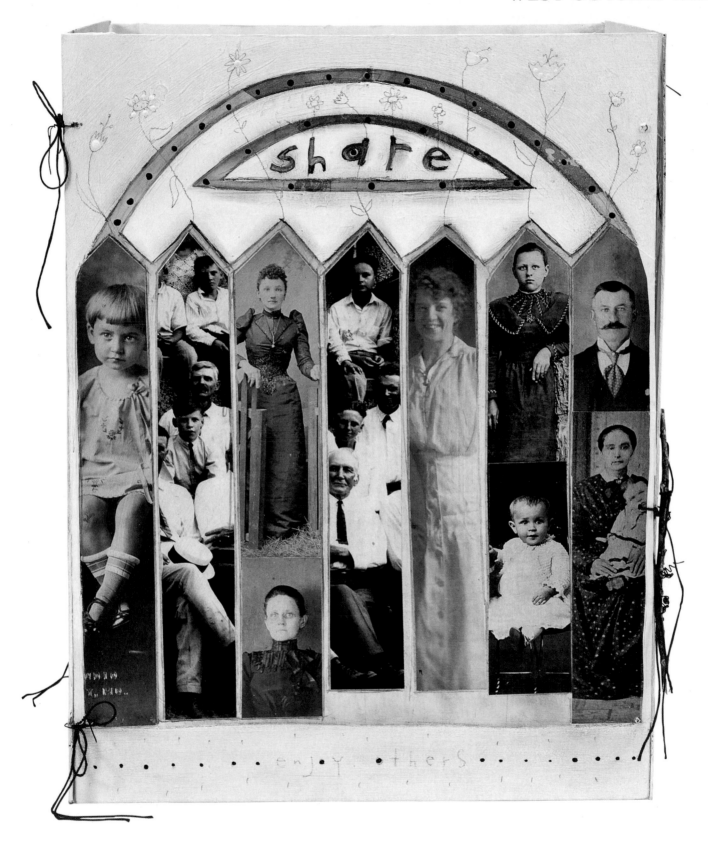

You don't have a garden just for yourself. You have it to share.
AUGUSTA CARTER

How Does Your Garden Grow?

Painted and Penciled, Posies and Pickets

Monochromatic hues of warm sepia unite the found images with which Lynn cleverly, unexpectedly, and whimsically composed an entire community garden.

Constructed from copies of antique photographs and cartes-de-visite of the late 1800s that the artist loves to collect, a picket fence is the epitome of community, and every flower is a member. Speaking as a collector, Lynn tells us, "I collect a lot of photos—I have several great antique markets locally. I rarely buy online, because I like to hold the photos and look at the back, you know, just to get the feel. I easily have over 10,000 images, and no stopping in sight—I think they are fascinating. When we travel for shows all over the country, we collect at flea markets, estate sales, antique markets, and malls. For several years people have sent photos to me or give them to me at shows, which is soooo nice. I have certain artist friends who always pick up photos for me in their travels as well; they know what I like. Of course, I pick up stuff for them too. So many of us are into mixed-media and found objects. Very often a group stays a day after a show just to hunt together, and then we have a big show and tell afterward."

Begin applying Lynn's nonpareil techniques by aging and darkening copies of photographs with a bit of burnt umber acrylic paint to infuse the whitewashed areas with warmth. Collage strips cut from photographs with gloss medium. Paint around them to create a shape (such as a tulip) with off-white acrylic. Once the paint is dry, outline the shape with pencil and smudge the graphite a little. Lynn says her 3B pencil is her best friend. She continues, "I love the back-to-basics feel of a pencil—it's so everyday and simple. In a way, pencil drawing feels a little fragile because you can always just erase!"

Add more simple line drawings. Use the same technique for lettering; draw the letters and paint around them. Outline the edges again, redefining the original lines, and finally smudge a little more.

To make flower stems that look similar to Lynn's is deceptively simple. Paint off-white acrylic onto images to draw a stem shape. Use a pen with white ink to divide the stem into rectangular segments. As a finishing touch, use cadmium red acrylic paint to add accent dots that literally pop off the background.

Field Notes

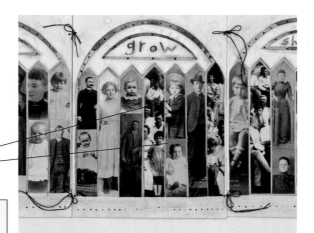

Cut sections from different photographs and piece them together to amplify their impact.

White-paint accents provide tone-on-tone interest inside the penciled flowers.

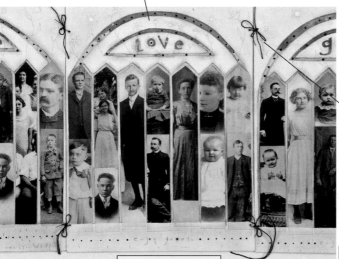

Simple red threads connect the garden walls.

Create a long thin stem and use a white gel pen to make divisions.

Red dots form additional flowers.

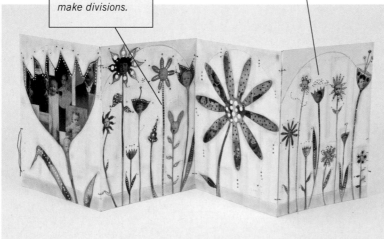

Tulip: international friendship, fame

Zen Garden

limitless shades of spring greens

sitting outside the river house watching the water roll by

seeing the first rare trilliums of the season

spying jack-in-the-pulpits as we slog along the spring run-off

sunlight creating magical fairy clearings in the forest

finding a cache of feathers beneath an eagle's nest

stars' unfettered brilliance in the wild sky

Dig It!

Devote a studio wall to things that strike your fancy. If you don't have wall space, hang the largest bulletin board you can find! It will become your 3-D journal—an idea laboratory. Hang unfinished sketches, found objects, notes from loved ones, and junk mail. The fragments may evolve into finished pieces, or even an actual wall shrine. The detritus and treasures of life will inspire you 24/7! If you experience artist block, take photos of the wall, clear it off, and start fresh.

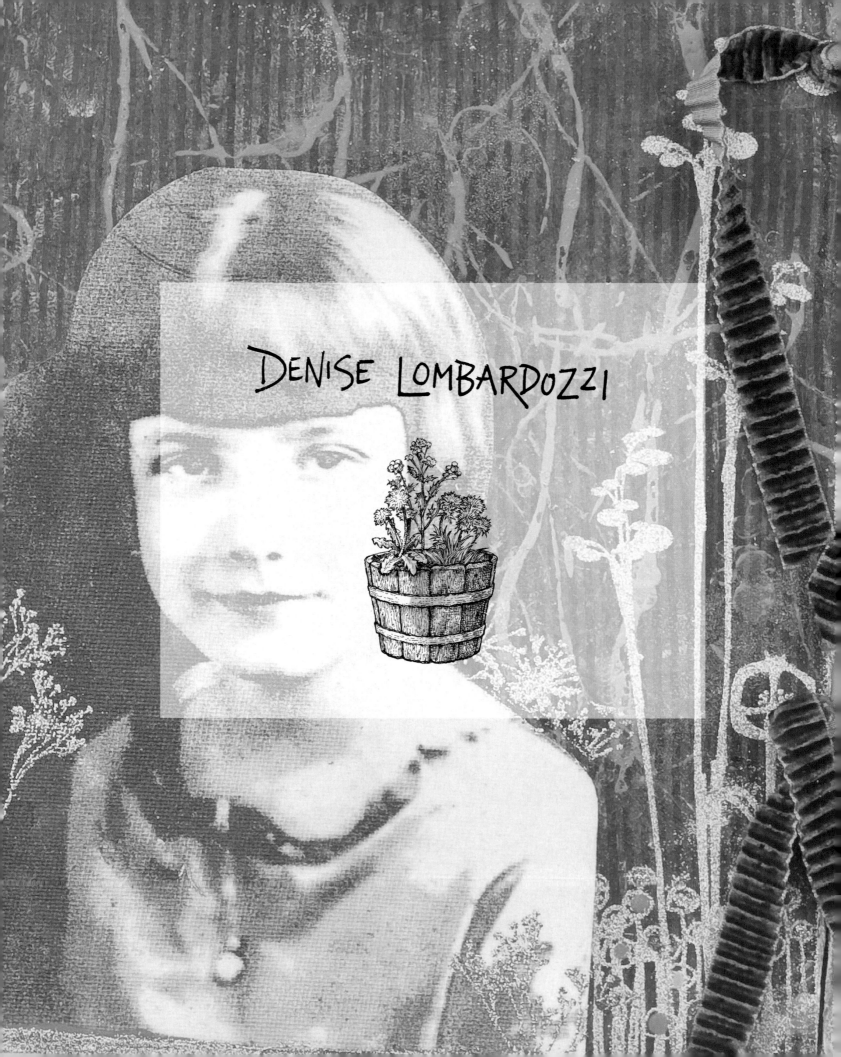

Denise Lombardozzi

CHAPTER 8

THE GARDEN WILD

Taking inspiration from her fearless ancestors, both as she imagines them and in reality, Denise Lombardozzi set about to design *The Garden Wild* as a loving tribute in honor of her family. Just as some family members have strayed at times, this artist emphatically believes that every tenaciously blooming wildflower is merely misunderstood and always has redeeming qualities, though we must travel a path full of twists and turns to discover them!

Dandelions, thistles, cohosh, flax, and wild violets run rampant along the outer walls and abundantly amok in every corner of *The Garden Wild*. The flowers twine among eye-catching photographs of the artist as a young girl and other women she holds dear.

The entrance gate, with beribboned and glittered letters proclaiming this sizeable family, is as wild as the garden contained within. Photographic blow-ups, à la *Alice in Wonderland*, have been magnified to a wonderfully large scale. We don't see just a single bird in the South Corner but an entire aviary. Where a lone butterfly might suggest the wildflowers here verge on becoming a real butterfly garden, we know for an irrevocable fact that butterflies are absolutely loving it here as dozens flit about the outside wall.

Giant blossoms bend and swirl throughout to create shady spots for tiny seedlings just showing their first petals. Color-infused blooms dazzle nearly every facet of this wild garden—it's out of control, but rather than try to contain those tricky weeds we are ever taken with their wild and rollicking ways.

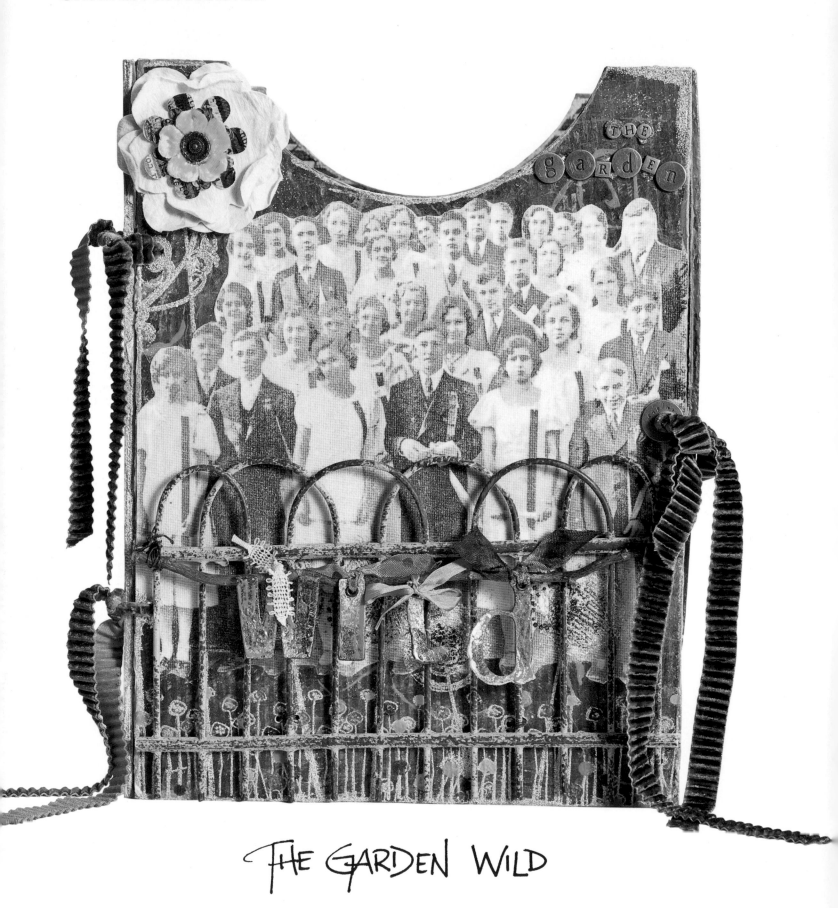

THE GARDEN WILD

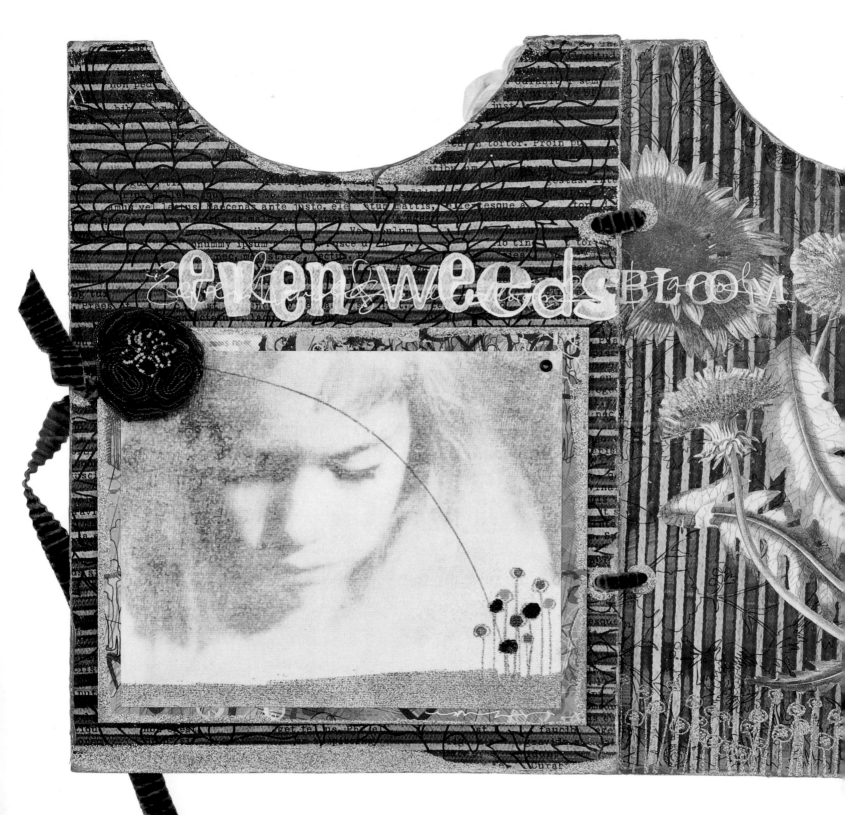

even weeds bloom

May all your weeds be wildflowers.
ANONYMOUS

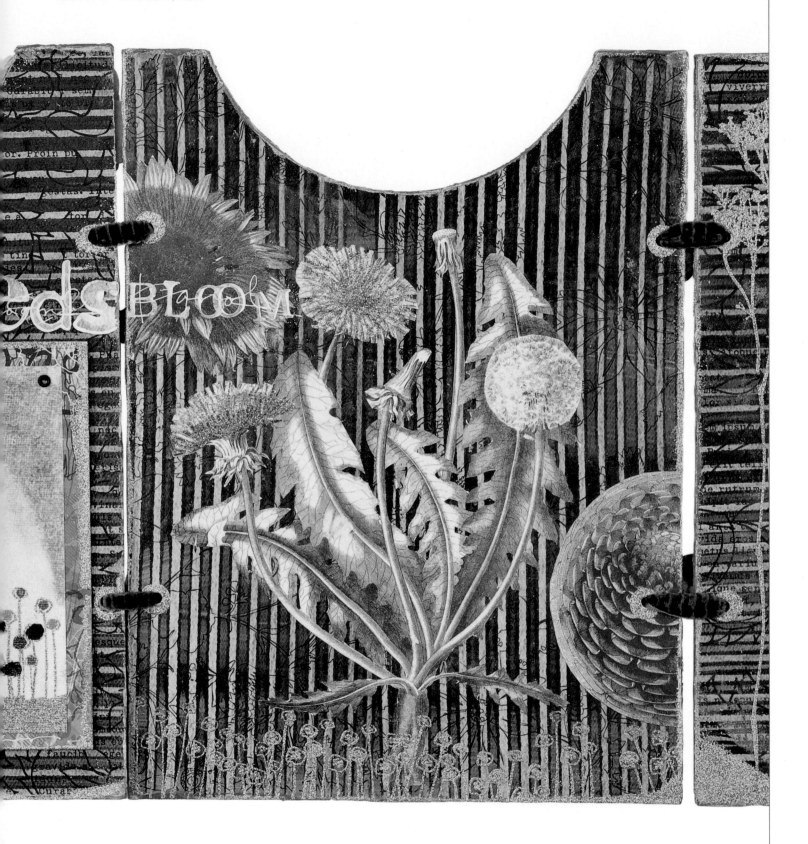

What is a weed? A weed is a plant whose virtues have not yet been discovered.
RALPH WALDO EMERSON

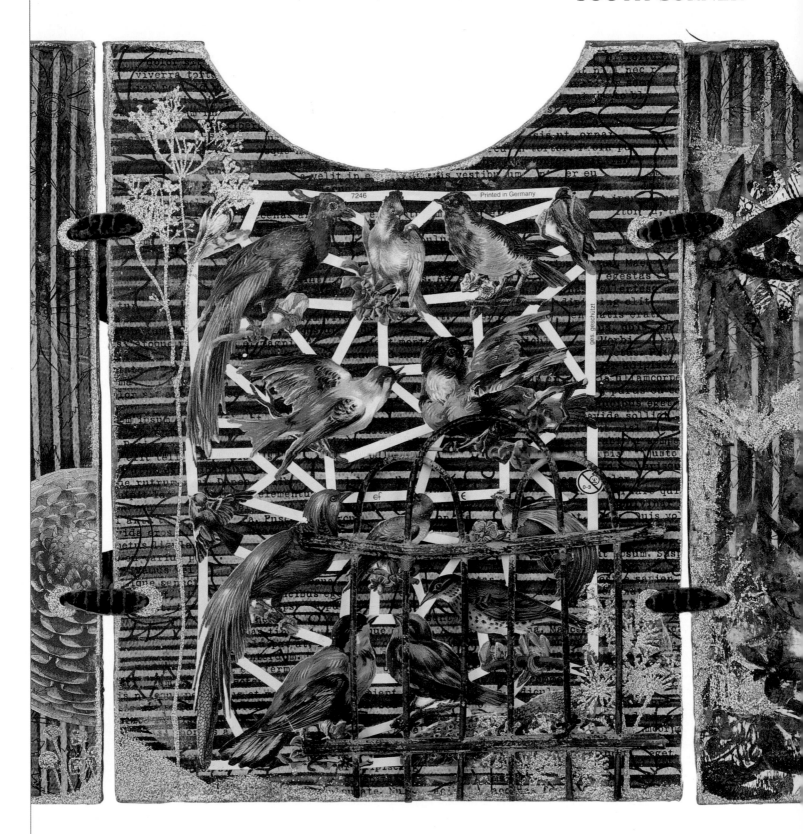

Weeds are flowers too, once you get to know them.
A. A. MILNE

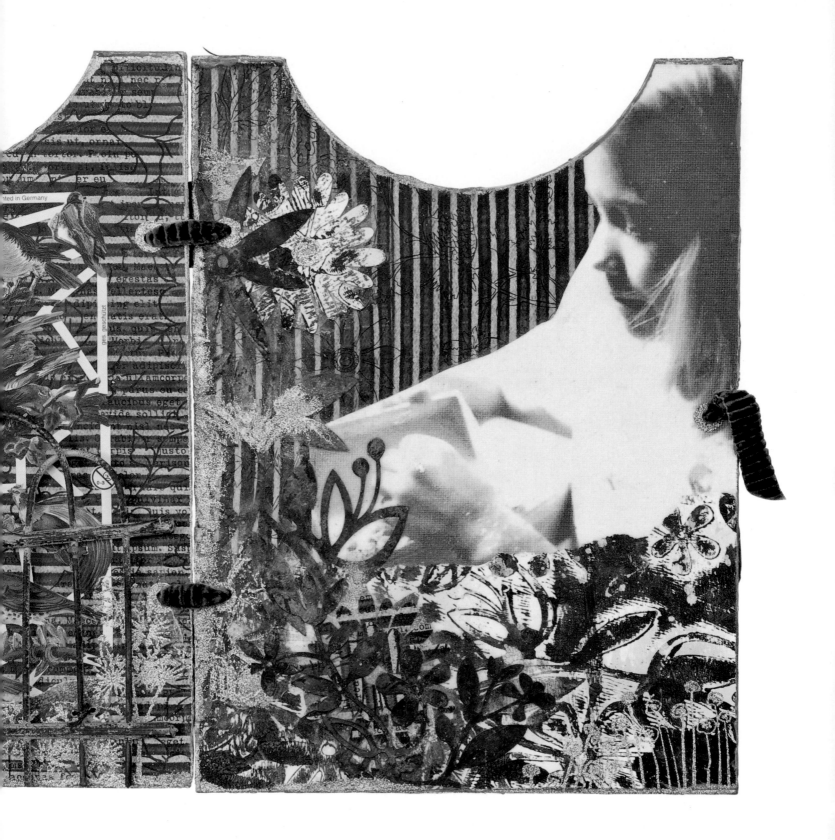

What is a weed? I have heard it said that there are sixty definitions.
For me, a weed is a plant out of place.
DONALD PEATTIE

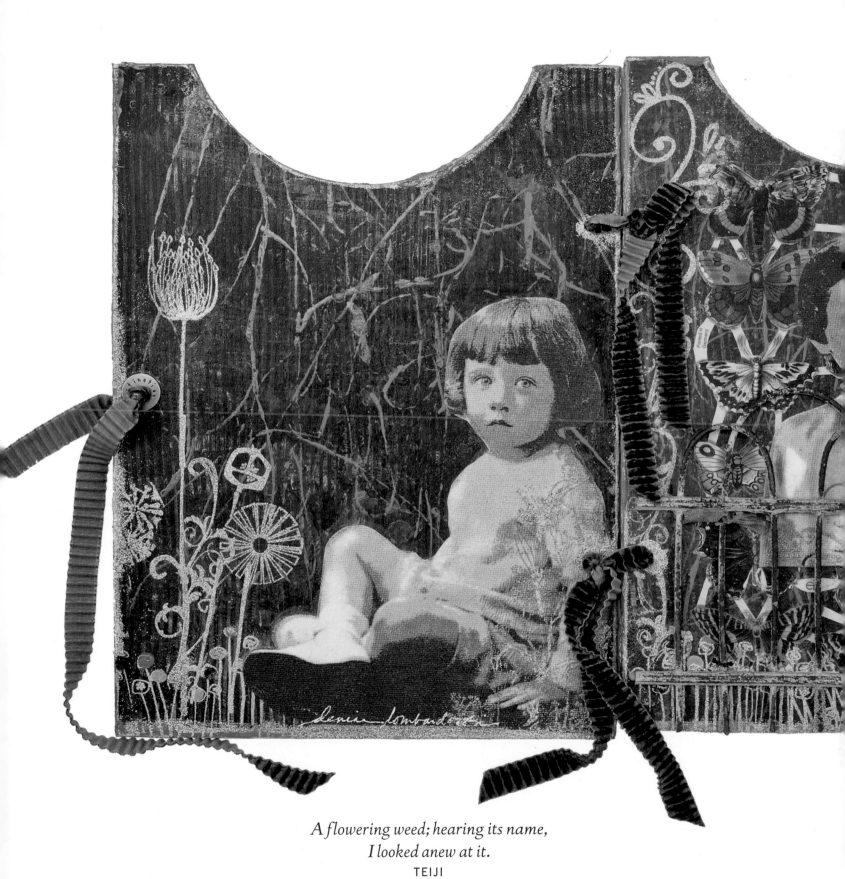

A flowering weed; hearing its name,
I looked anew at it.
TEIJI

There are several plants that are particularly fun when gardening with children. Impatiens bloom all summer and do well in shady spots. They come in colors from red and orange to hot pink and violet, even variegated! Touch a green seedpod, and the seeds come flying out at you—hence the nickname "poppers." Lady's mantle is a perennial with large leaves that hold drops of dew or rain on their surface. The droplets sparkle like diamonds in the sunlight. Nicknamed the diamond plant, it is perfect for planting in a fairy garden. Scented geraniums have pretty flowers, and they have scratch-and-sniff scents such as rose perfume, lemon, mint, chocolate, pine, and nutmeg.

Cachepot

acrylic paint, clear tar gel, art paste, book board, matte gel medium, gesso, canvas paper, paintable paper, embossing powder, pigment inks, rubber stamps, German scrap, botanical images, vintage family photographs, ribbon scraps, Grungeboard alphabet, art glitter, scrapbooking mask, white ink pen, combs, brushes, heat tool, sandpaper

How Does Your Garden Grow?

A Fresh Take on Paper and Paste

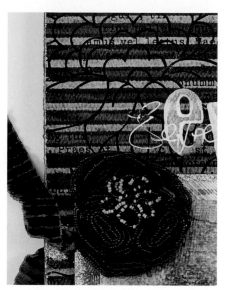

In a crafty quest for an irresistible and innovative background technique, a method that would do justice to her collaged and painted wildflower extravaganza, Denise turned to her updated version of paste paper.

Using a combination of acrylic paints, art paste, and tar gel over a paintable scrapbook wallpaper, Denise created garden walls that would not be lost behind her oversized photographs and voluptuous flowers. She completed the look by doing "a slight 'Jackson Pollack' to wild it up!"

Set aside a few hours to explore the possibilities of paste paper. The papers are fabulously versatile, and the tactile satisfaction of making your own paper is equal to the advantages of having one-of-a-kind materials close at hand.

Paintable papers are preprinted with designs that mimic traditional pen-and-ink techniques. The paper is a cold-pressed medium-rough watercolor paper that accepts paint easily, and the texture provides a bit of irregularity. The tar gel is combined with any acrylic paint (no oils!) and when dripped over a surface it creates finely detailed lines.

Create your own paintable paper by sketching directly onto watercolor paper with waterproof ink. Or scan your sketches or drawings into a computer design program, remove any color, and convert the image to a line-only sketch. Buy watercolor paper that fits your printer, or cut your paper to size, and output the image.

Add your favorite acrylic color to a batch of freshly mixed art paste. Paint the mixture over your paintable paper and drag a wide-tooth comb, or a notch tool, through it. Next add acrylic paint (any color) to a bit of clear tar gel, load a generous amount onto your brush, and then dribble the mixture here and there. Use this simple technique for a spectacular tactile and visual effect.

Field Notes

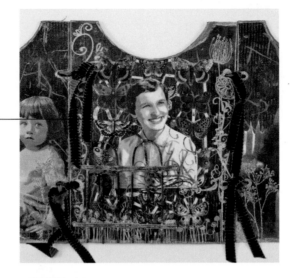

Leaving the connectors on a German-scrap sheet create a lattice effect.

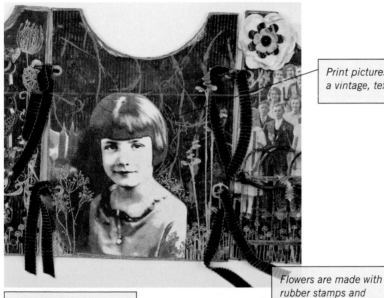

Print pictures on canvas for a vintage, textural look.

A photograph is mounted on book board, and then mounted onto the main panel.

Flowers are made with rubber stamps and embossing powder.

Glitter adds sparkle to these flowers.

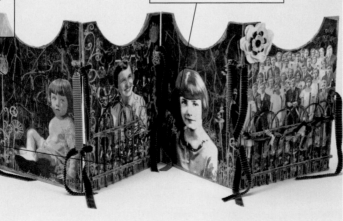

Dandelion: faithfulness, happiness, love's oracle

Zen Garden

letting the warm summer breeze
refresh my senses

tiny buds and tightly
furled leaves and their promise
of new growth

brown, crunchy, and big old growth

the randomness of
blooming weeds and wildflowers

a tomato plucked from the vine
and eaten on the spot

musky wildflowers mixed with the
sweet scent of proper flowers

rearranging the rocks of
my waterfall

Dig It!

Experiment with different
papers when printing images.
Try printing on paper from old
books, magazines, wrapping paper,
and manila envelopes—
almost anything! Cut the paper
to size, and then print on it
with color or black and white.
To print on thin paper, tape it
to a sheet of copy paper for
added body; remove when the
printing is complete.

Susie LaFond

CHAPTER 9

THE FOUR RUSTED HEARTS GARDEN

Susie LaFond's *The Four Rusted Hearts Garden* is a veritable tour de force of materials and elements! Susie truly believes in the serendipitous accumulation of bits and pieces that form her art. In addition to art supplies; text fragments, random words, lines of poetry, and lyrics provide precious seedlings to inspire the narrative of her finished garden plot.

From the moss-covered front gate of her painstakingly shaped and cut garden (its edges softened with a Dremel tool) we move consecutively through each corner, and marvel at the rich details Susie has incorporated to tell her various tales.

To suggest a deliberate harmony and cohesiveness, Susie used a light base color on each garden wall and corner. Onto that base she incorporated a plethora of painted effects that evolved from hours of experimentation on sample boards. Susie then embellished with numerous tactile elements for additional texture, including rust, other metallic materials, wire, glass, fabric, and beads.

The Four Rusted Hearts Garden is a bit like a fairy-tale enclosure in the middle of perennially enchanted woods. By the time we traverse the labyrinthine perimeter we find we have fallen under the spell of an apparently old, and richly planted plot, filled with timeworn stories and secrets—just waiting to be explored.

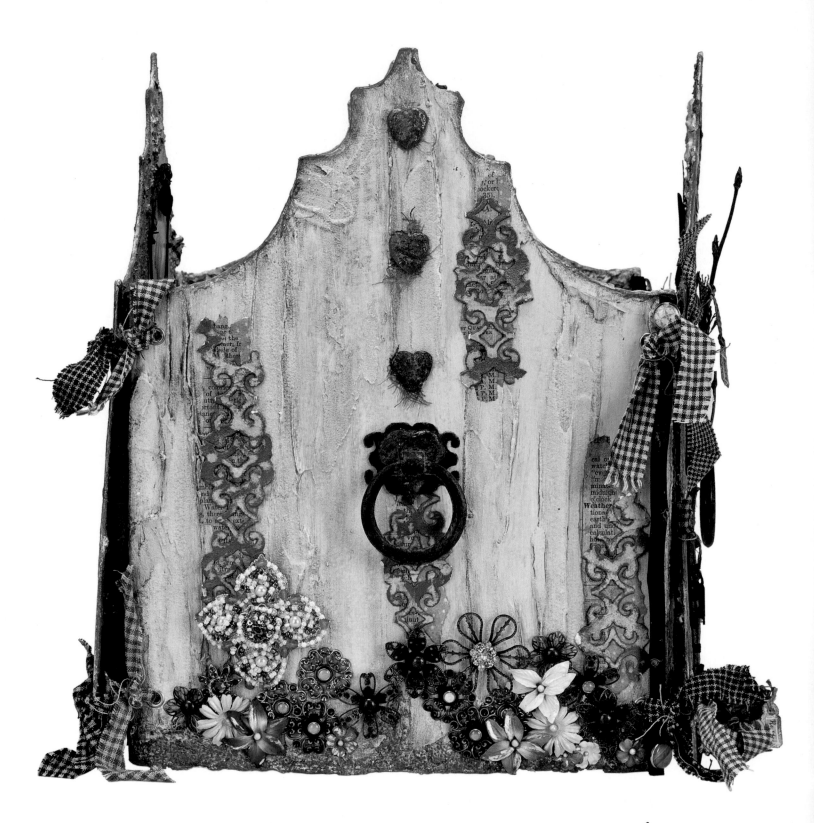

THE FOUR RUSTED HEARTS GARDEN

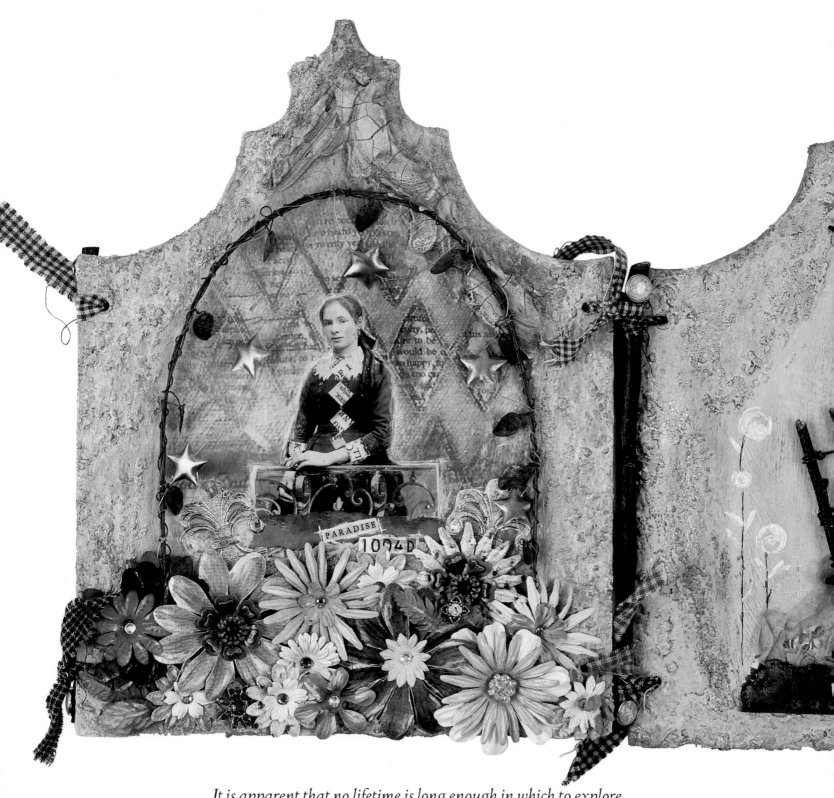

It is apparent that no lifetime is long enough in which to explore
the resources of a few square yards of ground.
ALICE M. COATS

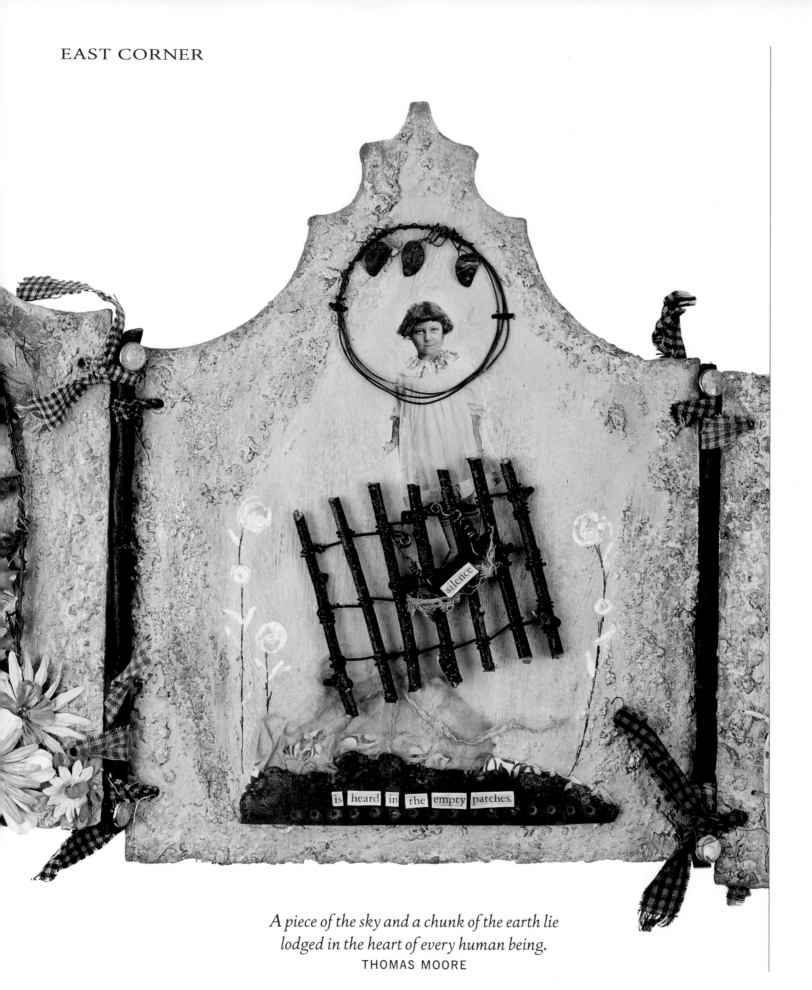

silence

is heard in the empty patches.

A piece of the sky and a chunk of the earth lie
lodged in the heart of every human being.
THOMAS MOORE

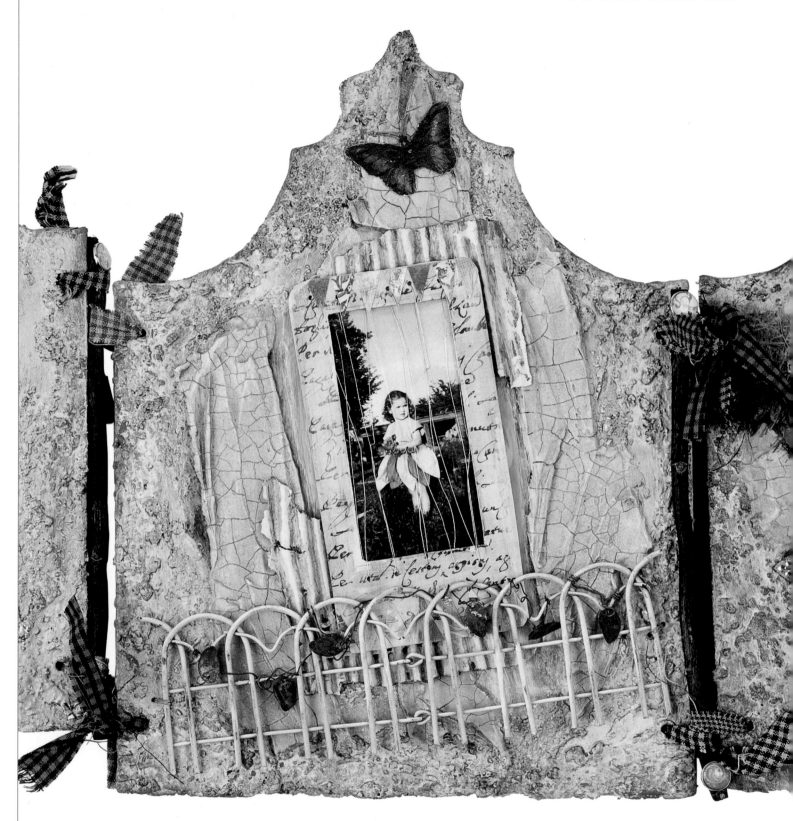

A garden is a delight to the eye and a solace for the soul.

SADI

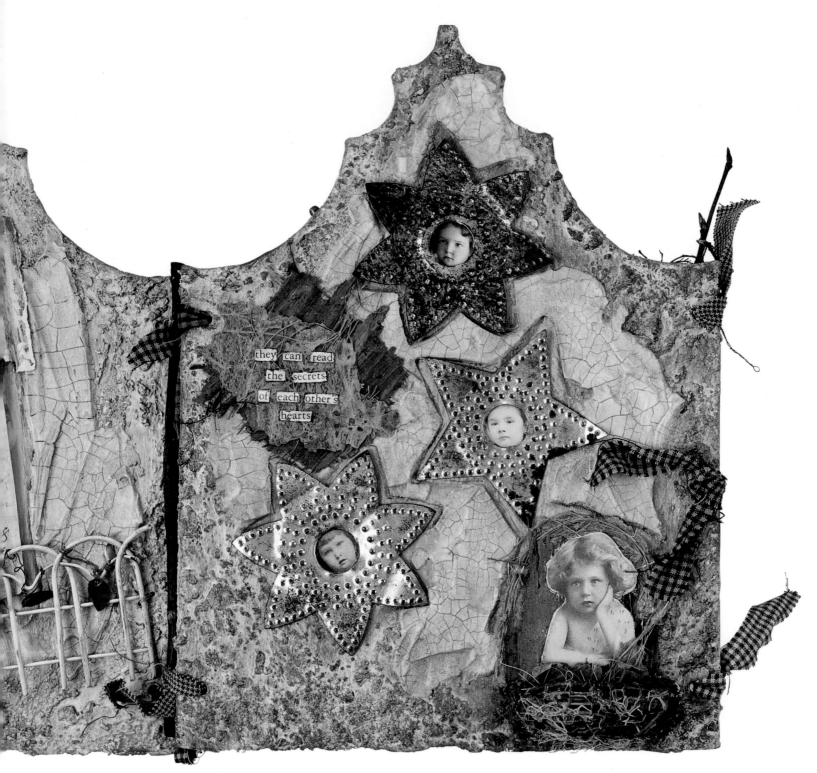

they can read
the secrets
of each other's
hearts

I am writing in the garden. To write as one should of a garden
one must write not outside it
or merely somewhere near it, but in the garden.

FRANCES HODGSON BURNETT

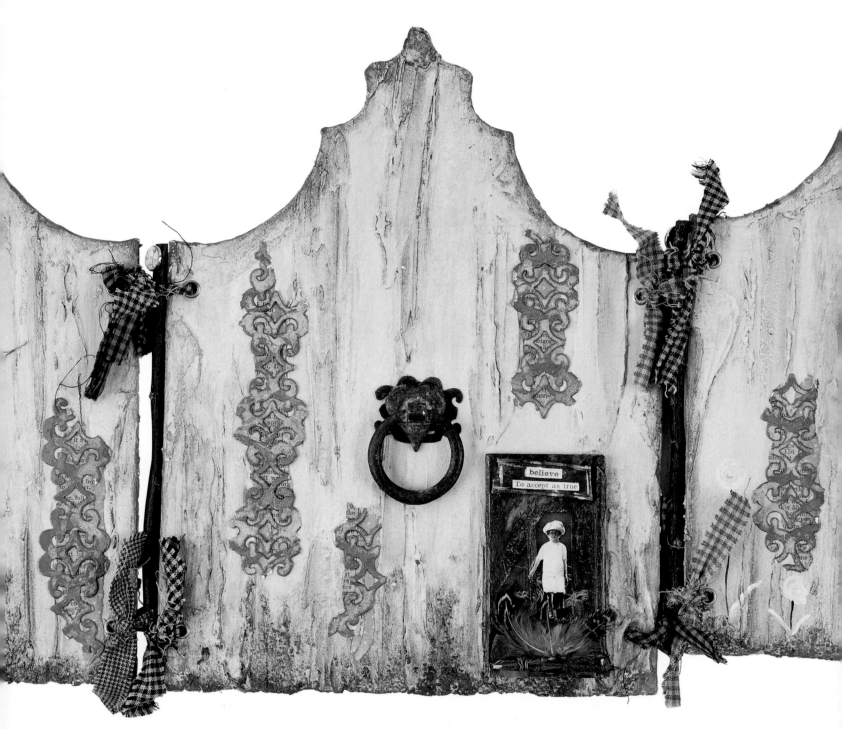

*To me a lush carpet of pine needles or spongy grass is more welcome
than the most luxurious Persian rug.*

HELEN KELLER

Garden Notebook

Climbing plants may clamber over a support (climbing rose), twine up a slender support (honeysuckle), or grasp the support by aerial roots (English ivy) or tendrils. Climbers are found in nearly every plant group, twining their stems around any available support. Curiously, each plant twines in a direction distinctive to their species—either clockwise or counterclockwise.

Outdoor ivies can be transplanted. Dig up several stems, and make sure to get the roots. Excavate a planting hole just deep and wide enough to hold the roots, or transplant them into a pot. Water thoroughly for several days—the ivy will quickly re-establish itself.

Cachepot

acrylic paint, gels and pastes, hardware, cabinet cards, vintage photos, collage images, vintage photo frames, wire items, vintage text, corrugated cardboard, tiny tags, fabric ties, natural elements, soldered glass slide

is heard in the empty patches.

How Does Your Garden Grow?

Thingamabobs and 3-D Collage

Because Susie works with so many dimensional and/or heavy elements, she finds it essential to thoroughly preplan. When constructing *The Four Rusted Hearts Garden*, she created faux panels on which to arrange and try out her designs. The constant back and forth between the faux and real wood panels, and making exact placement marks each step of the way, was a lengthy process. Susie laughs as she says, "So, ya want to know how I managed to get it all on the panels without seeing holes or wires or thingamabobs? Well, it wasn't easy, but to my delight it did work!" Along the way, she also documented her experiments with pigments and texturing techniques on additional panels, which she quickly referred to throughout her entire construction process.

Once her backgrounds were complete, the challenge for Susie was to create secure fastenings for the 3-D elements of various size, thickness, and weight. Items ranged from hard metal embellishments to beaded and fabric flowers, and from sturdy wire gates to the little nest in the West Corner.

Susie also wanted to make the flat elements three-dimensional. Most of the flowers had preattached brads. By measuring and marking carefully, she made sure each brad was camouflaged by the petals of other blooms. Susie then drilled holes through the wood panel to accommodate the brads. The overlapping flowers create a seemingly effortless floral floor. The little tree, nest, and gate pieces were secured with a combination of glue and waxed linen, which was tied through the drilled holes. Susie used dried moss to cover up the waxed linen holding the nest in place. Heavy gel medium kept metal elements, such as the decorative metal pieces from old wooden milk crates as seen on the outer walls, securely in place.

Use this easy method for creating a 3-D appearance when working with photographs or flat paper scraps: Cut small pieces of chipboard, and then sandwich the pieces between the background and the photograph. For even more depth, glue several chipboard pieces together before sandwiching them.

Field Notes

Patinaed metal pieces adorn the outer walls.

Tiny price tags with handwritten words hang from the branches.

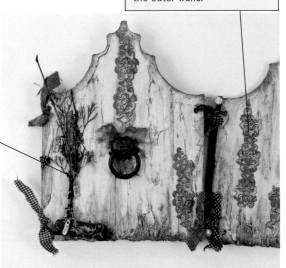

A soldered piece frames a vintage photograph.

Rusty heart-shaped drawer pulls found in a hardware store provide the theme for this garden.

Textured mediums and sand-texture paint add a decrepit look to the garden walls.

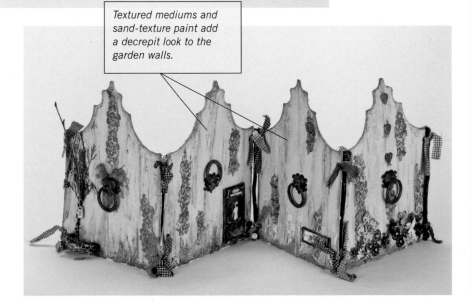

Black-eyed Susan: encouragement

Zen Garden

the colors and texture of the natural world

a walk on a crisp fall evening

looking for falling stars in the wee hours of the night

good gardening music

a storm washing away all the dust and bringing forth new growth

a walk after a heavy snowfall when the world goes very quiet

Dig It!

Create a series of test boards to experiment with different applications, paints, mediums, and elements before making them permanent on a substrate. When using many different textured mediums, these test boards allow for free experimentation. Audition the elements before committing, and then approach the final composition with confidence.

YES

DEB TROTTER

I thank you Go
for this most amazi
for the leaping gr
spirits of tree
and for the blu
dream of sky
and for everyth
which is natur
which is infini
which is yes.

e.e. cummings

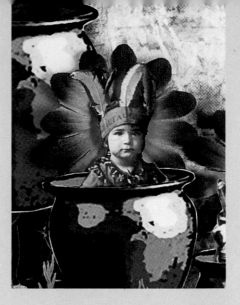

CHAPTER 10

THE PRAIRIE ROSE & SAGEBRUSH GARDEN

After a long, hard dawn-to-dusk workday at the ranch, what trail-weary cowgirl could resist settling down for a little sweet repose in Deb Trotter's *Prairie Rose & Sagebrush Garden*? As comfortable as an old hat, and twice as pretty, why, it's downright delightful to kick off dusty boots and curl up on a rustic weather-worn bench with the favorite ranch cat to watch a passel of butterflies as they flit so dang gracefully from blossom to blossom.

This garden seems to be located dead center in rugged relics, remnants, and ruins of the old barn. (The new barn has yet to acquire the proper patina of everyday use, and the flourishing, overgrown tumbles of verdant and flowering plant life necessary to be a chosen hangout—but hope does spring eternal in a cowgirl's heart.)

In the meantime, from the decorative cornices and rusted eaves with which Deb crowned every wall and corner, to the wood-burned-by-the-campfire welcome sign hung above the front gate, from the pots of sun-dried flowers to the pots of grinning kids playing a lively game in the western corner, the *Prairie Rose & Sagebrush Garden* truly exudes the fabulous spirit of the American West.

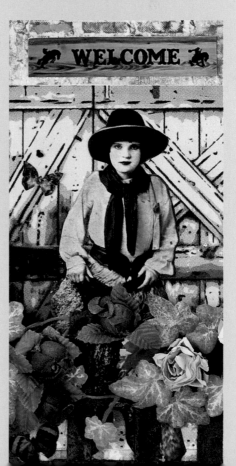

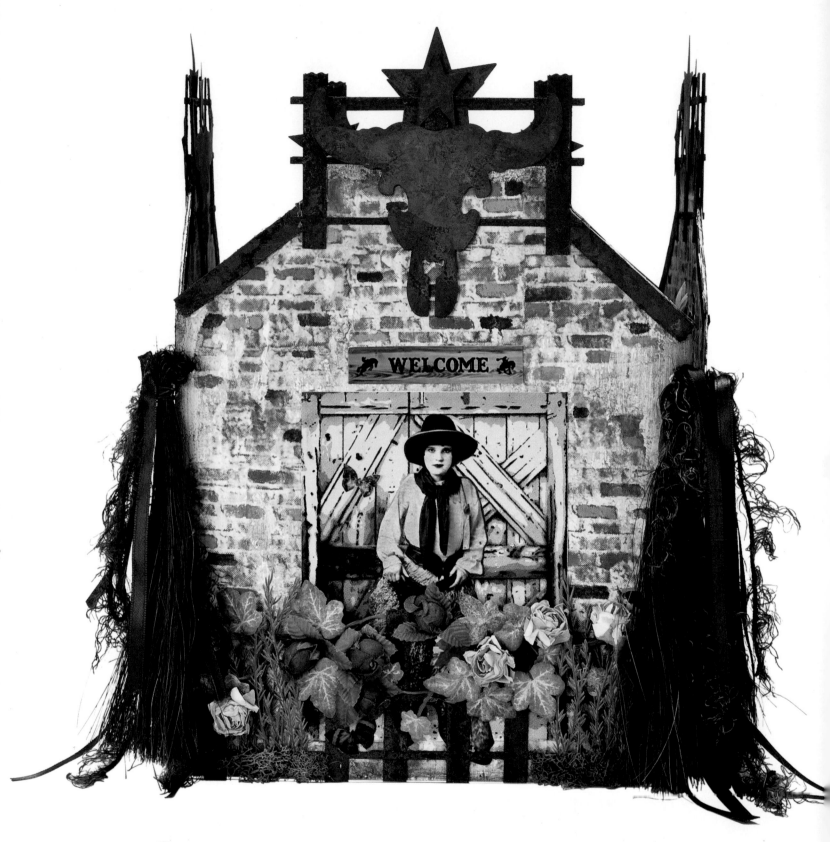

PRAIRIE ROSE & SAGEBRUSH GARDEN

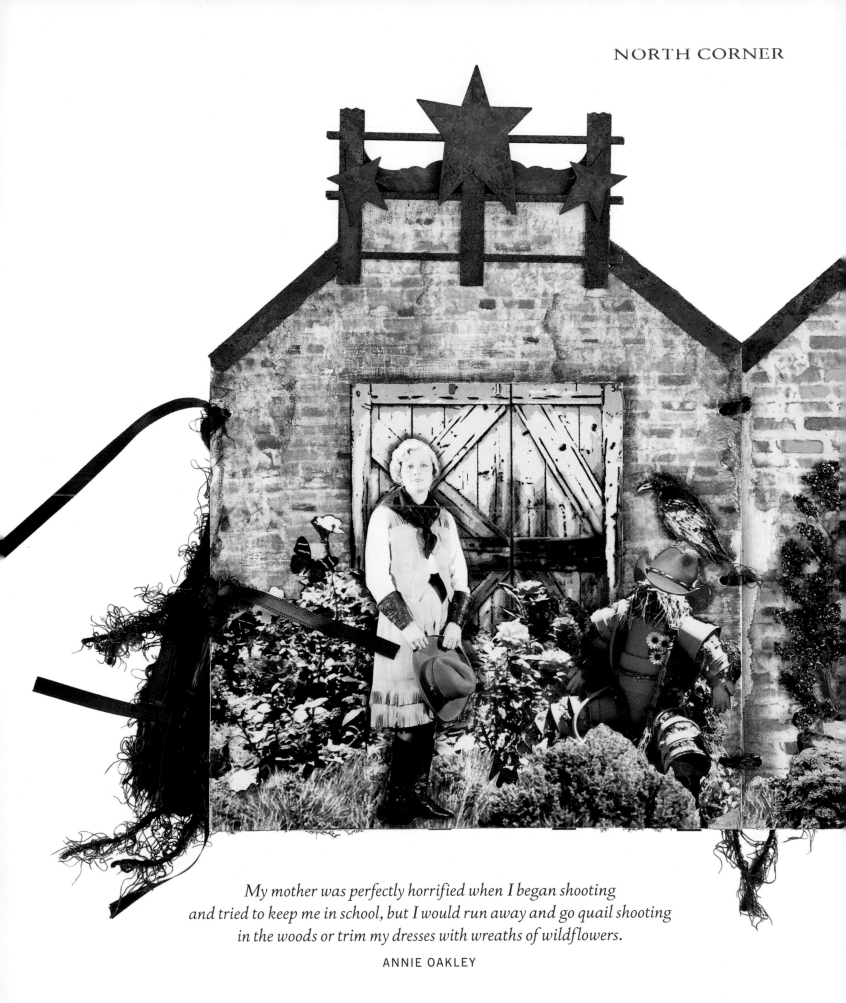

*My mother was perfectly horrified when I began shooting
and tried to keep me in school, but I would run away and go quail shooting
in the woods or trim my dresses with wreaths of wildflowers.*

ANNIE OAKLEY

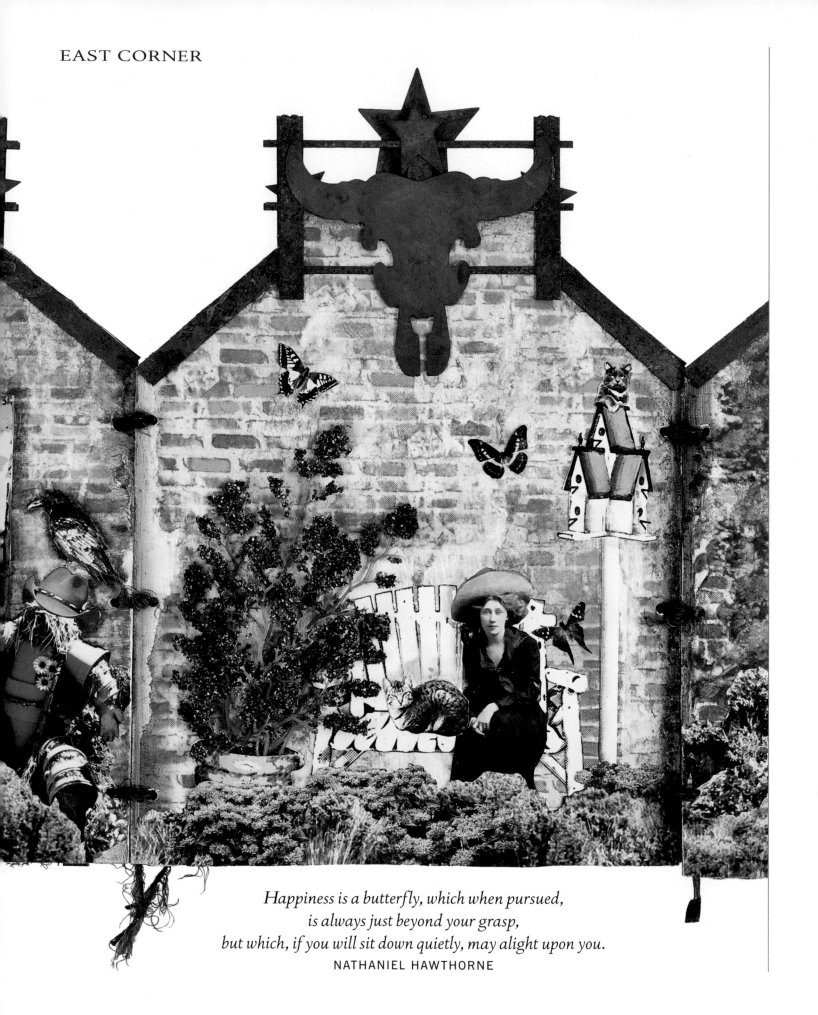

Happiness is a butterfly, which when pursued,
is always just beyond your grasp,
but which, if you will sit down quietly, may alight upon you.
NATHANIEL HAWTHORNE

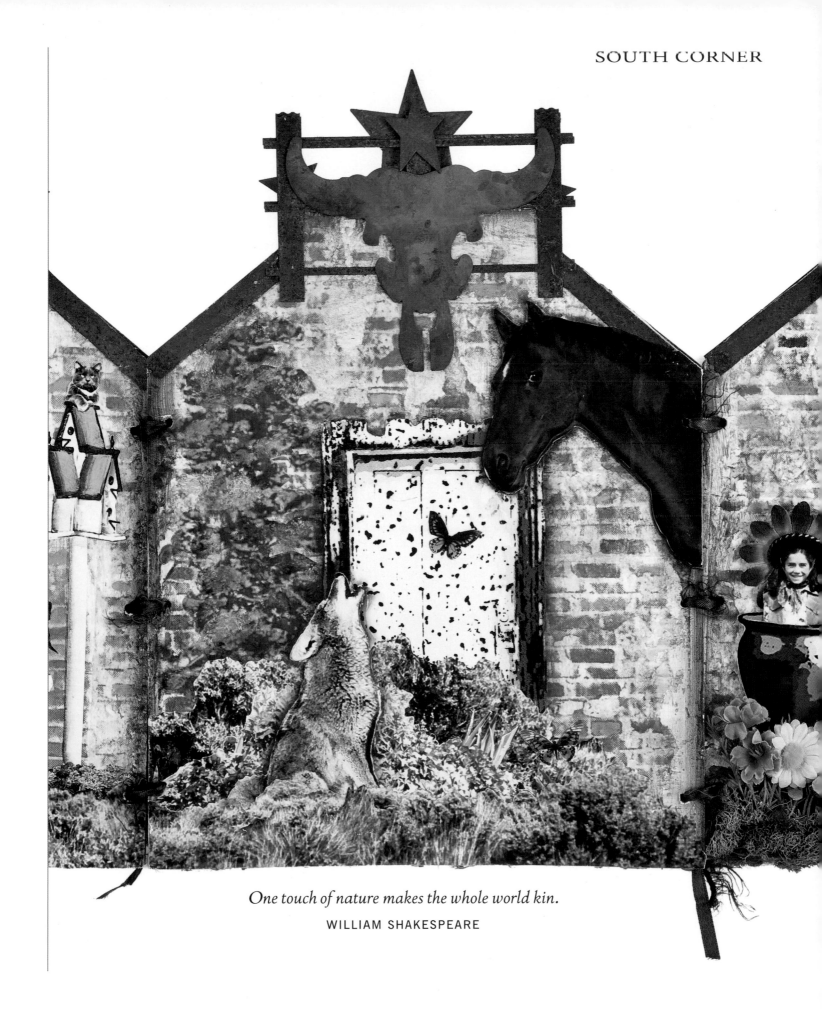

One touch of nature makes the whole world kin.
WILLIAM SHAKESPEARE

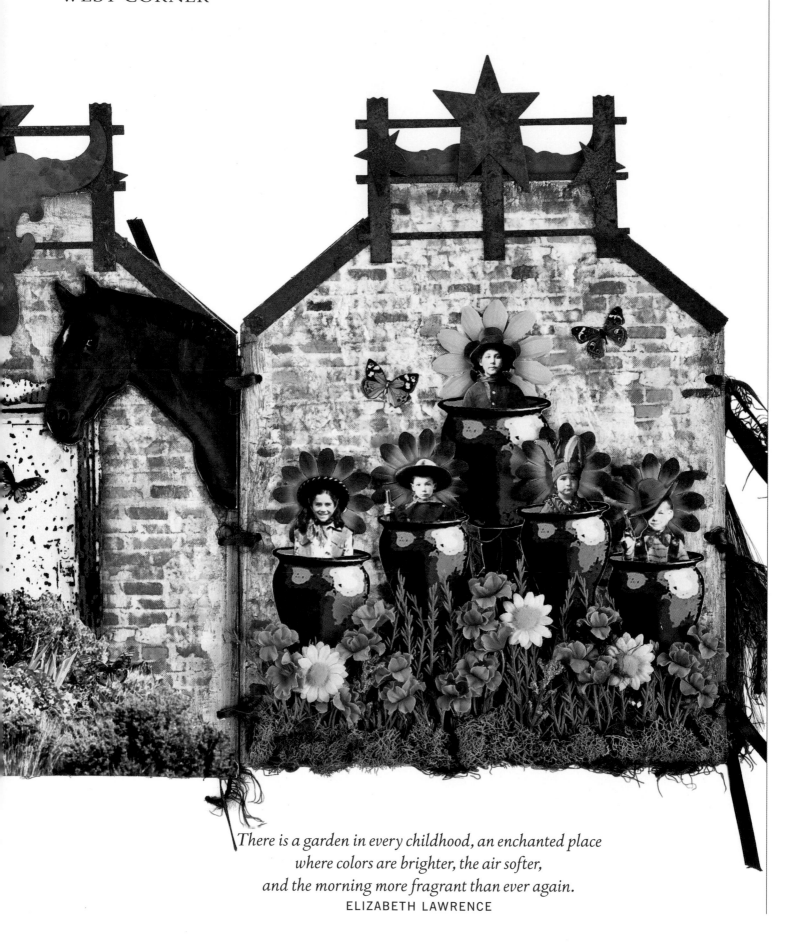

There is a garden in every childhood, an enchanted place
where colors are brighter, the air softer,
and the morning more fragrant than ever again.
ELIZABETH LAWRENCE

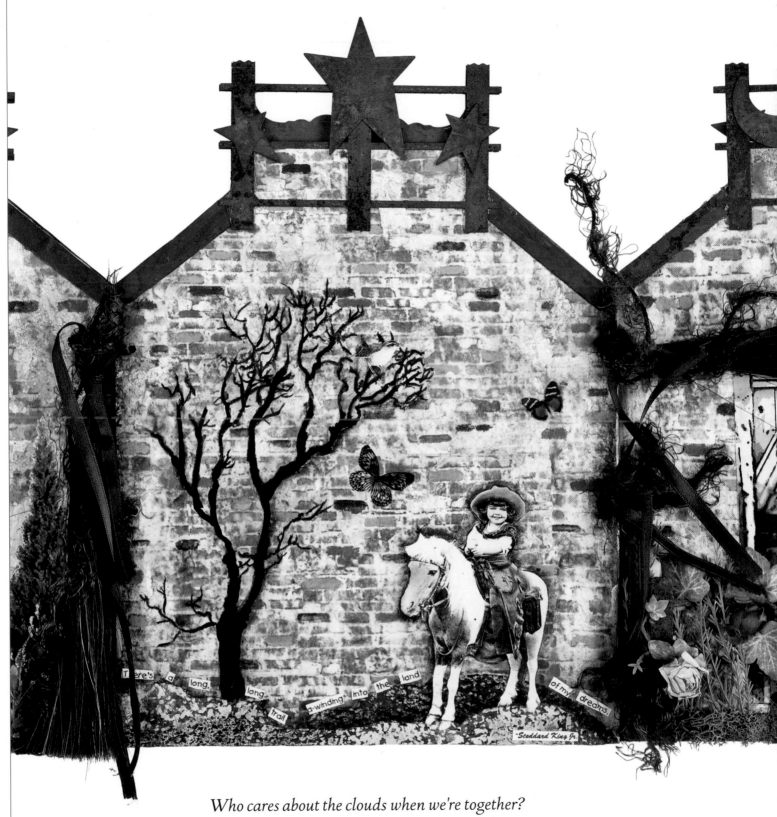

There's a long, long, trail a-winding into the land of my dreams.

—Stoddard King Jr.

Who cares about the clouds when we're together?
Just sing a song and bring the sunny weather.
DALE EVANS

Garden Notebook

For dried-flower bouquets, pick flowers late in the morning after the dew has evaporated, and the plants are dry but not yet wilted from the sun. Select flowers at different stages of development, from buds to open blossoms, and keep in mind the buds will open further as they fully dry. Pink, orange, and blue blooms will retain the best color. It's very easy to air-dry flowers. Simply tie the flowers into small bunches and hang them upside down in a place with low humidity, good airflow, and—here's the secret to rich color—in the dark away from the tiniest ray of sunlight!

Cachepot

photographs, clip art, transparencies, acrylic paint, handmade paper, colored chalk, metal embellishments, fence, artificial flowers, stickers, ribbon, fibers, horsehair

How Does Your Garden Grow?

Savvy Shading

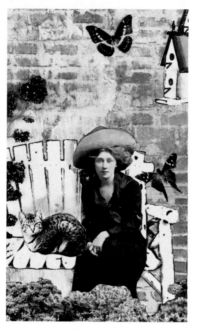

Many artists draw around their subjects with a pencil, art crayon, or even permanent markers. Deb prefers shading with paint and glaze medium. She shades around the photos or drawings in her art with a technique she refers to as "side-loading" the brush. As she explains, "It softens the artwork, adds depth, and appears more natural." Side-loading is ubiquitous in *The Prairie Rose & Sagebrush Garden*. It can be seen adeptly applied around the cowgirl in the North Corner and the little cowgirl and her pony on the back wall of the South East Corner.

Wet a ¾" (1.9 cm) angled brush with water, and then press it firmly onto a thick paper towel to remove most of the moisture. Squeeze some glaze medium and burnt umber paint onto a palette, a paper plate, or a sheet of waxed paper. To side-load, dip the brush edge into the glaze and then into the paint. Move the brush back and forth (towards and away from you) three to four times to gradually blend the paint into the brush. The result will be a brush that has more paint concentrated on the tip with a gradual blend of paint further down the bristles. Carefully paint around the edges of the chosen photo or drawing by letting just the brush tip go into the photo, and then brush outward to create a shadow effect. The thin line of paint/glaze will be darker at the image's cut edge and be gradually lighter farther away until it disappears completely, producing a shadow that looks more natural than if you used a pencil or loaded the paint normally onto a brush.

The secret of a smoothly graded shadow is all in the blending, the brush dampness, and the paint/glaze combination. That's the art of side-loading for perfect shading every time.

Field Notes

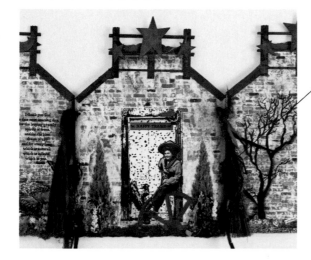

Unusual accents, such as these horsehair ties, hit the target.

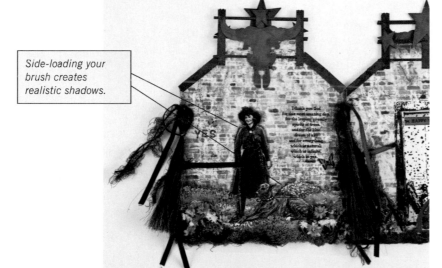

Side-loading your brush creates realistic shadows.

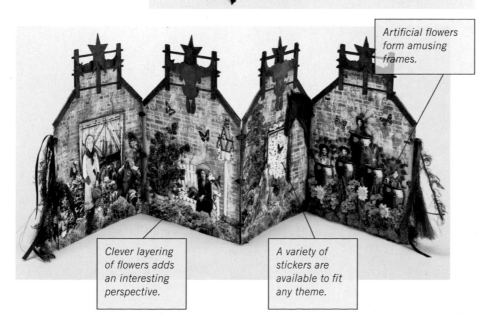

Artificial flowers form amusing frames.

Clever layering of flowers adds an interesting perspective.

A variety of stickers are available to fit any theme.

Daisy: innocence, loyal love, "I'll never tell"

Zen Garden

the memory of pink gladiolas
in my grandmother's garden

bobwhites calling in the early mists
of the Blue Ridge Mountains

red chile lights hanging in my studio

the sight and smell of Wyoming
sagebrush in the early summer

yellow roses and a Navajo weaving
on my kitchen table

dried Indian corn hanging on
a front door in the fall

cotton from the cottonwood trees
blowing in the May wind

my "yard-art people" holding ivy
and begonias

Dig It!

Horsehair bundles dangling from the corners, repetitive brick patterns, rusty tin shapes, photos of sagebrush and flowers, colorful butterflies, and repeating colors, objects, and patterns throughout help to unify a piece of cowgirl art. Experiment with one or all of these ideas, and keep the eye moving.

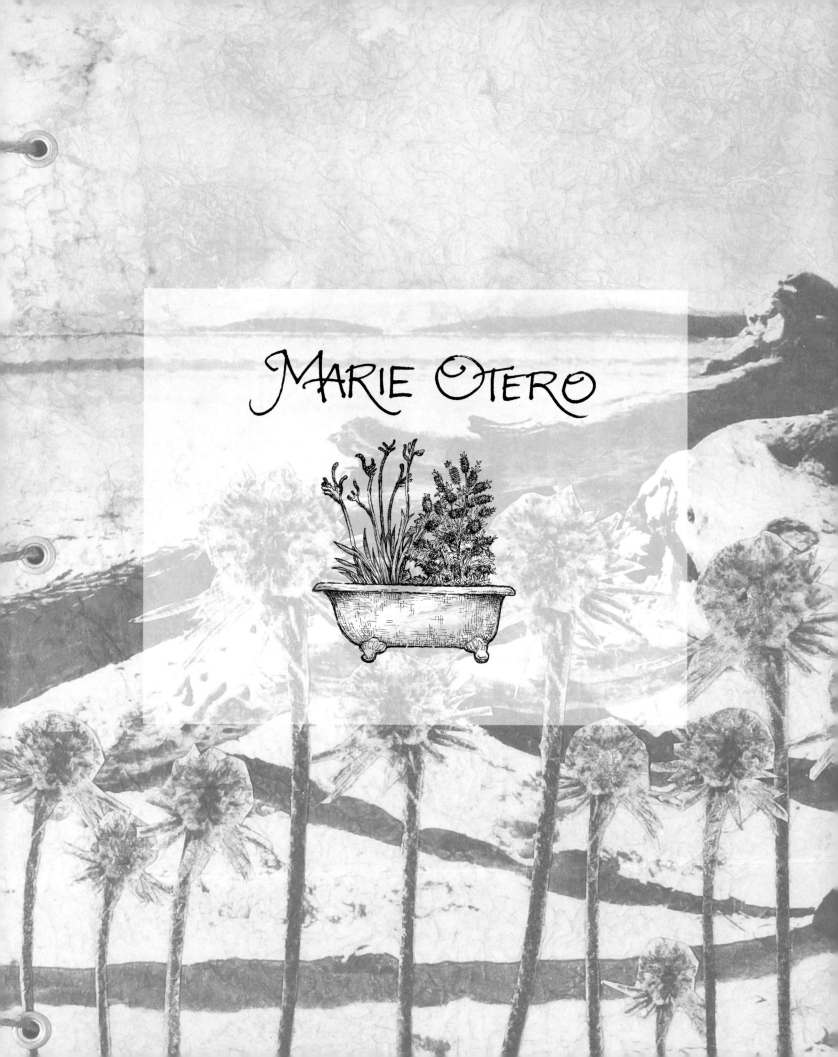

Marie Otero

CHAPTER 11

DOWN UNDER DREAMTIME

Marie Otero aimed for a "wide, brown land feel with no boundaries—just endless beauty," in her *Down Under Dreamtime* garden. Always inspired by the incredible vistas seen from the windows of her half-the-year Australian home, she incorporated an original art and coloring technique with some traditional mixed-media collage throughout her walls and garden corners.

The concept of *Dreamtime* describes how the universe came to be. It embraces that which occurred in the past, that which is happening in the present, and that which will happen in the future. *Dreamtime* encompasses all things—every human, animal, plant, stone, and river that ever was or ever will be. *Dreamtime* influences all Aboriginal life, from the structure of society and rules of behavior, to stories and ceremonies handed from one generation to the next.

In Marie's capable hands, a rich, color saturated panorama sprang to life with nods to aspects of indigenous culture, traditional bush gardens, and the four cardinal directions of each corner. Marie's photograph of the spectacular sandstone rock formation, Uluru, at the heart of *Dreamtime* tradition, runs along the entire back wall of the garden. A padlocked miniature fence traverses the length and is symbolic of the rabbit-proof fence that runs across Australia from north to south.

Each garden corner is suffused with the most fantastic, deep colors seen under the Australian sun and is embellished with eye-catching photographic images of kangaroos, gum trees, beach grass, pom-pom flowers, and an abandoned shed. Each carefully selected photograph contributes something of significance to the whole. Each nuance contributes to a complete and splendid visual interpretation of her *Down Under Dreamtime.*

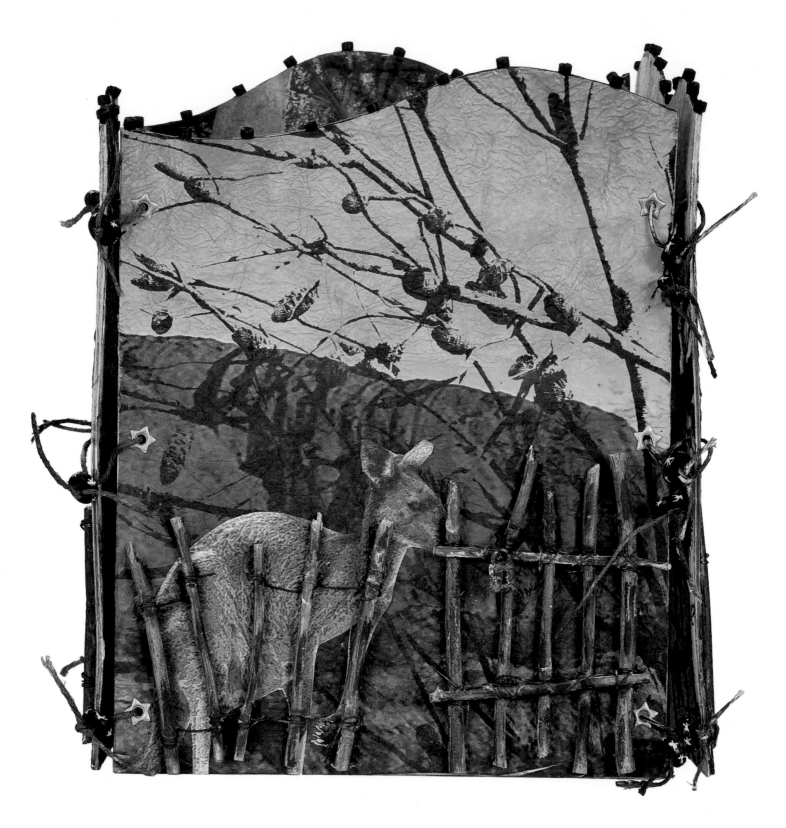

DOWN UNDER DREAMTIME

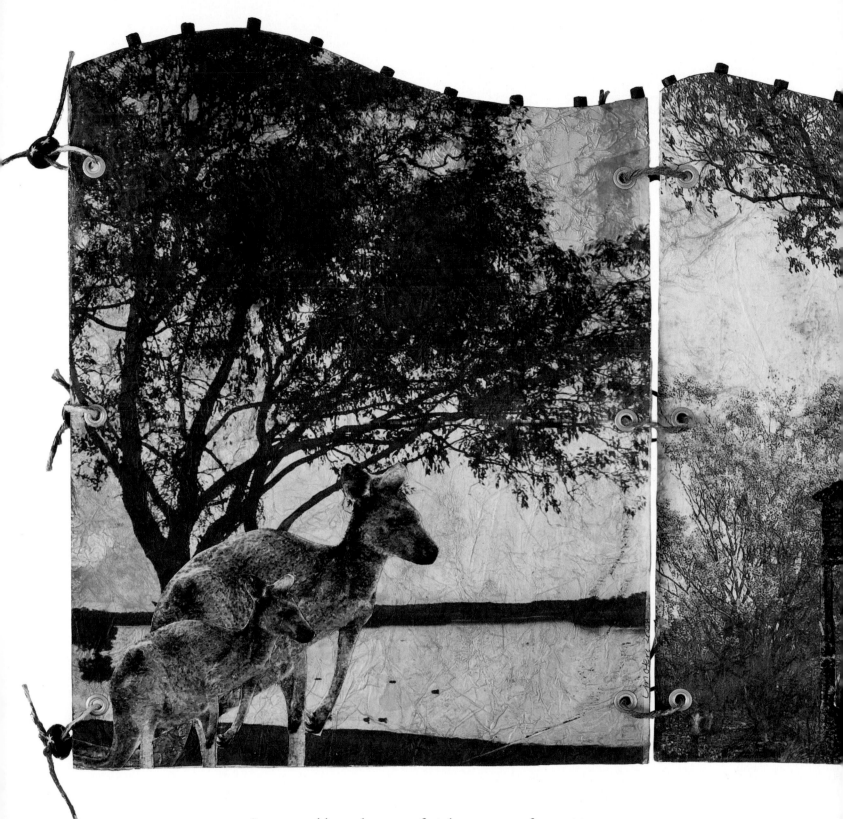

Innumerable as the stars of night, or stars of morning,
dewdrops which the sun impearls on every leaf and every flower.
JOHN MILTON

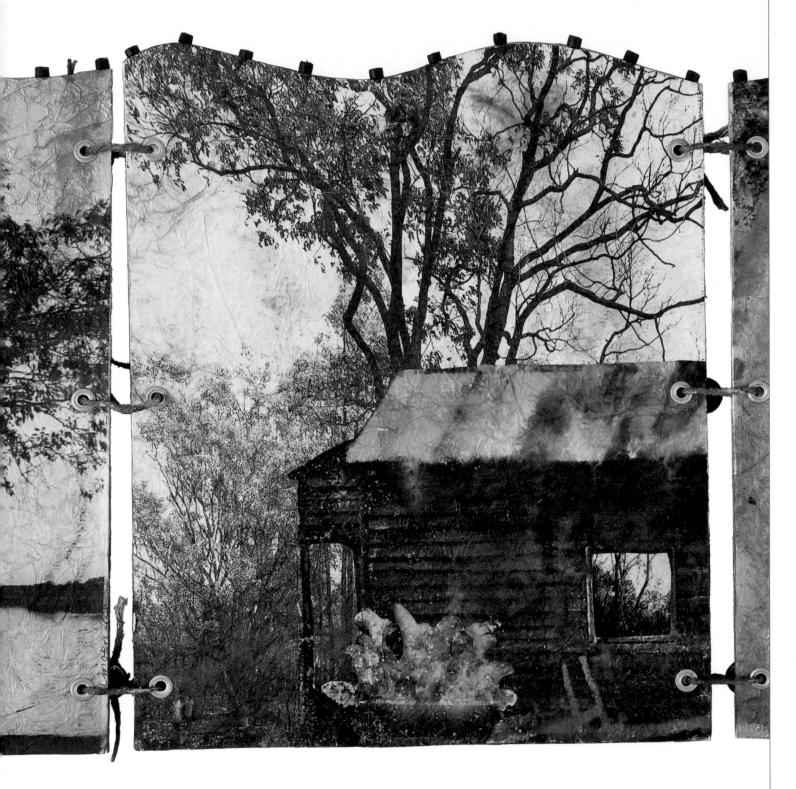

Gardening is the art that uses flowers and plants as paint, and the soil and sky as canvas.
ELIZABETH MURRAY

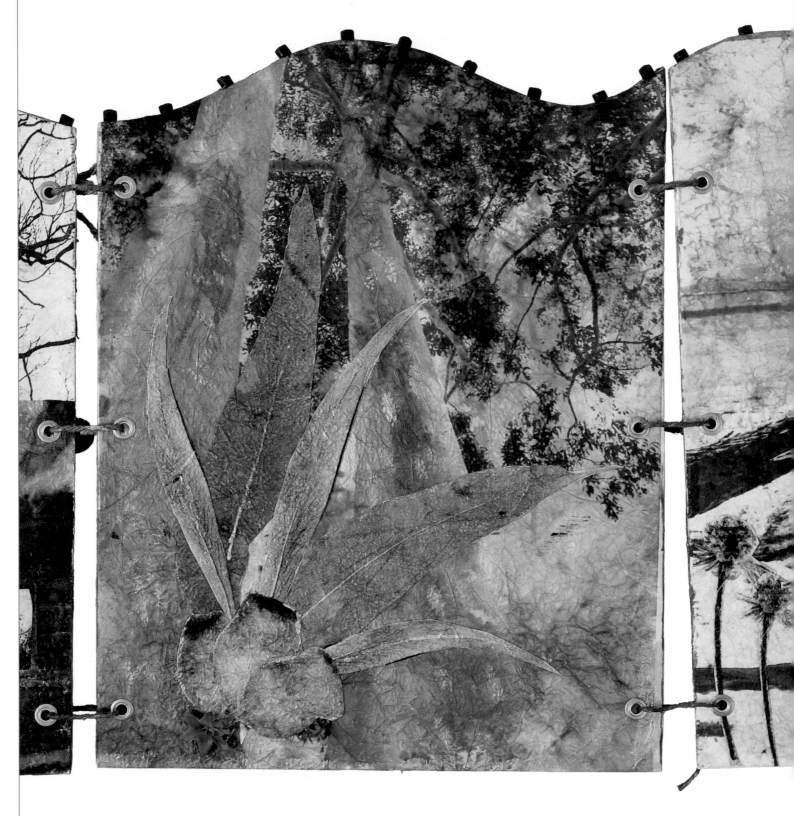

I do not understand how anyone can live
without one small place of enchantment to turn to.
MARJORIE KINNAN RAWLINGS

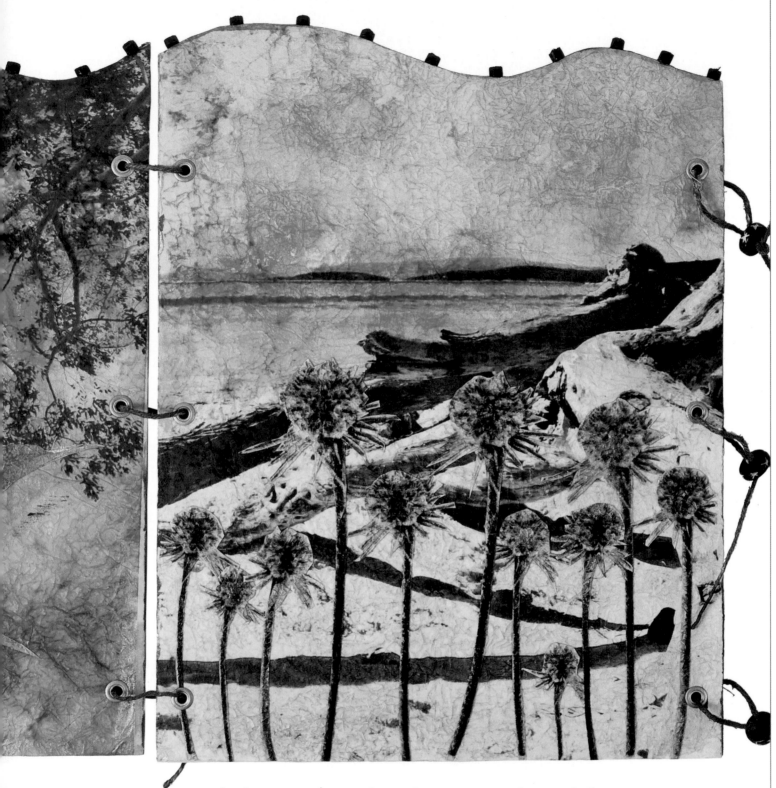

The three great elemental sounds in nature are the sound of rain,
the sound of wind in a primeval wood,
and the sound of outer ocean on a beach.
HENRY BESTON

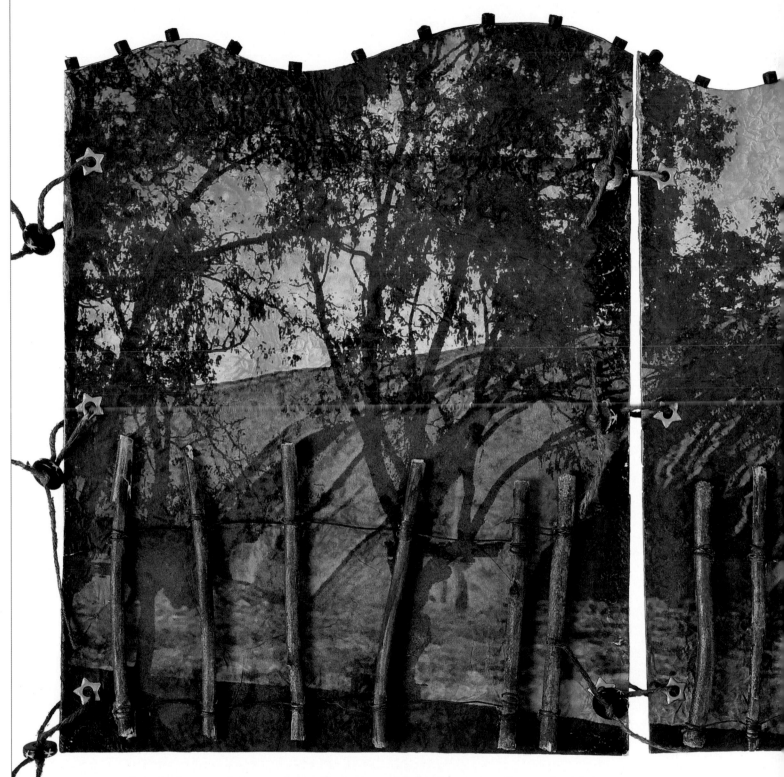

*People from a planet without flowers would think we must be mad with joy
the whole time to have such things about us.*
IRIS MURDOCH

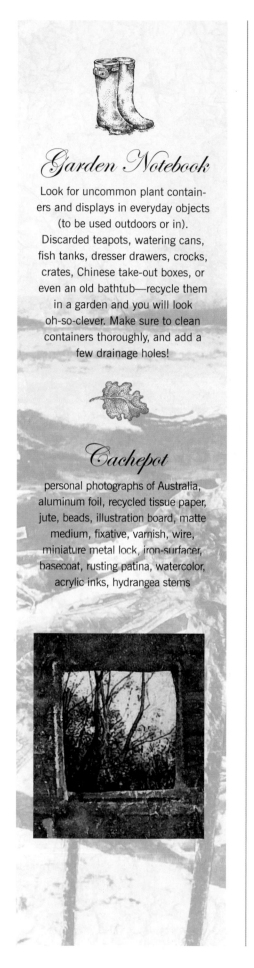
How Does Your Garden Grow?

Tin Tactics and Tissue Tricks

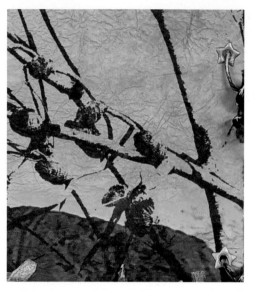

To evoke the feeling of the spacious, almost endless Australian landscape, and yet present it in human terms was Marie's challenge as she imagined the *Down Under Dreamtime* garden. An accomplished photographer, she always has a vast source file of images at her fingertips. Having a myriad of personal images is especially helpful for artists working in collage and mixed-media artwork. Creating with your own photographs is satisfying!

Marie was able to select particular photographs to exemplify the compass points of north, east, south, and west. Kangaroos, beach plants, an abandoned shed, and even a bathtub—each small image contributes significantly to the whole.

To re-create this look, import selected photographs into a digital-photo program and alter them. The black contrast should be high, and desaturate the colors to give the photographs an abstract appearance. Print the altered photographs onto tissue paper. Print additional sheets of tissue with altered images from which to extract smaller elements.

Next, scrunch up large sheets of aluminum foil, and then flatten the foil back out to create a fair amount of texture. Using the unaltered copies of the chosen photographs as a guide, paint wide swaths of colored ink onto the foil; the color need not be exact and the painting may be exaggerated. Once the ink has thoroughly dried, these are the backgrounds onto which the pictorial elements are collaged.

The tissue-printed images will be transparent when collaged onto the backgrounds, and the ink-colored foil will shine through from below. Add an illusion of further depth by placing cutouts of unaltered images onto the collaged tissue (such as the large leaves shown in the South Corner). For a divided panoramic effect with the look of a single landscape, simply use a wide photograph cut and collaged onto separate panels.

Field Notes

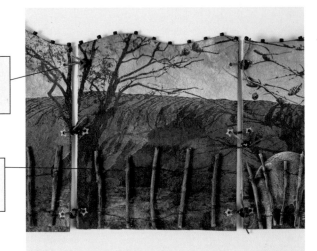

Eyelets are available in various shapes and colors.

Use elements indigenous to your area.

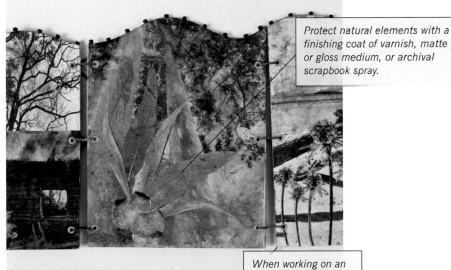

Protect natural elements with a finishing coat of varnish, matte or gloss medium, or archival scrapbook spray.

Beads create a tactile edging along the border of the wall.

When working on an accordion format, extend images from one panel to the next.

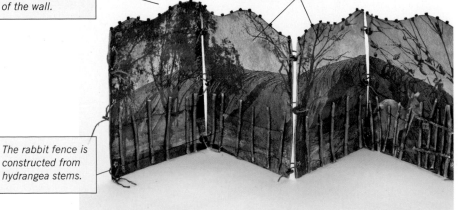

The rabbit fence is constructed from hydrangea stems.

Bottlebrush: great beauty

Zen Garden

magpies darting around and underneath the trees looking for treasures to take to their nests

fresh strawberries and tomatoes straight off the vine

the scent of roses from my mother's garden

the kookaburra's call

cicadas chirping on a hot summer night

the smell of gum trees in the warm evening air—a sure sign I am home

the first shoots of daffodils heralding spring, and the first red leaf of autumn

pressing petals, leaves, and other bits of nature to use in my artwork

Dig It!

Think outside the box when considering possibilities for printing images to be used in collage and mixed-media art. You might be surprised at what can safely go through your printer—anything from tissue paper and tinfoil to fabric and leather. Just be sure to change the printer settings to allow for moderately thick materials and hand-feed if necessary.

ERIKA TYSSE

grow [grō]
v. 1. To incr...
in size by a natural
process. To expand
gain.

SPRI

CHAPTER 12
A YEAR IN THE GARDEN

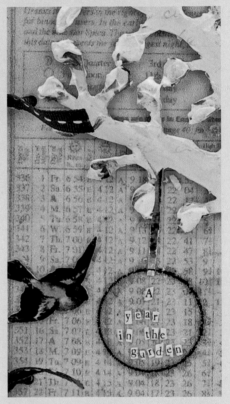

The passage of time through the four seasons is the focus of *A Year in the Garden*. Working in a paint/collage style favored by the Symbolists in the late nineteenth century and the Fauvists and Surrealists of the twentieth century, Erika Tysse breathes fresh life into iconic images. The negative space surrounding each cutout is as crucial to the composition's rhythm as the cutouts themselves. The artist's subdued palette, consisting of shades of blue, brown, cream, and white, is accented with occasional vibrant splashes of pink or red.

Almost as much forest as garden, every corner is filled with branches—bare, flowering, or going to seed. The hands of the gardener are ubiquitous as well, from small hands that measure the North Corner with a clever snowflake banner, to an oversized hand conveying a note on the perfection of the month of June. Words are an integral design detail in the hands of this artist; they appear in some form on each panel. Almanac pages are splendid backgrounds for additional words and messages that are handwritten, stamped, or applied as rub-on transfers.

A Year in the Garden successfully incorporates common garden imagery, such as branches, flowers, leaves, and roots, and some less common items, such as hands and a Madonna, to fabricate a remarkably abstract canvas. Each element is essential in Erika's enchantingly stylized poetic reality.

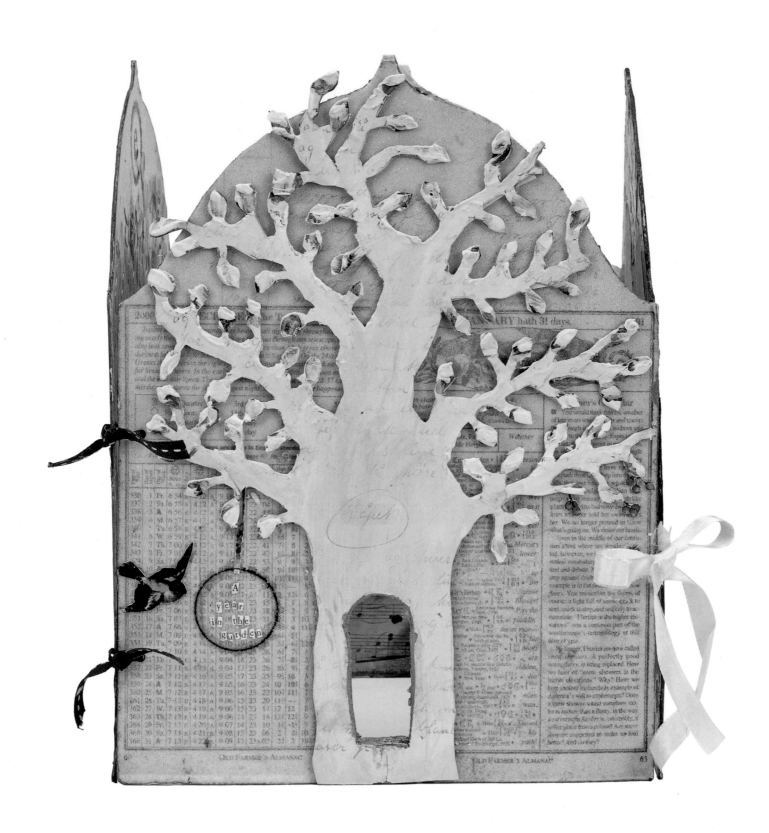

A YEAR IN THE GARDEN

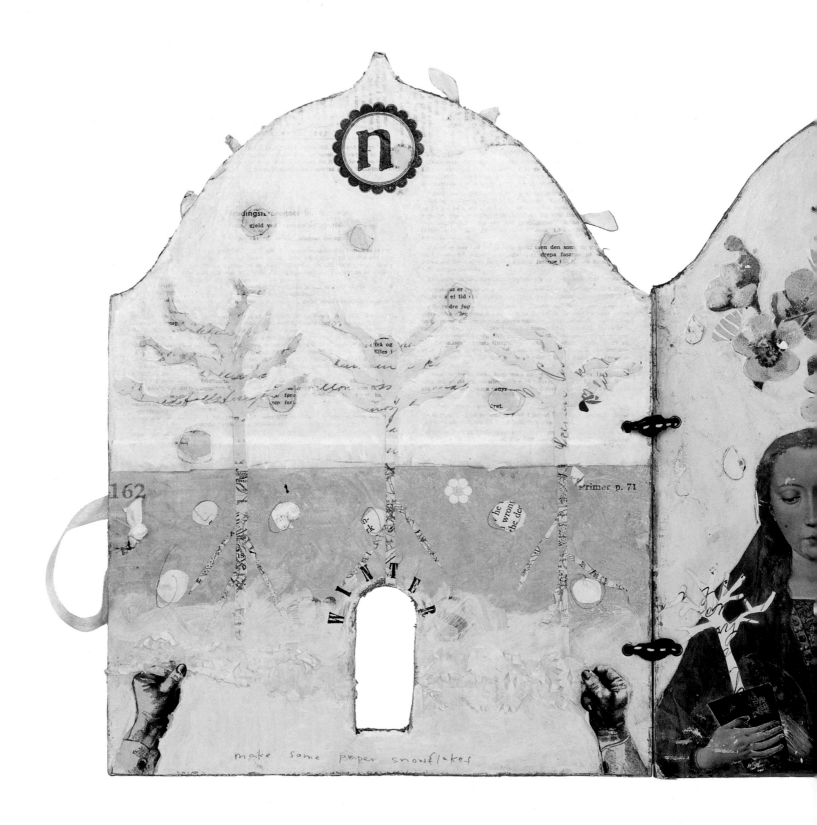

*I value my garden more for being full of blackbirds than of cherries,
and very frankly give them fruit for their songs.*
JOSEPH ADDISON

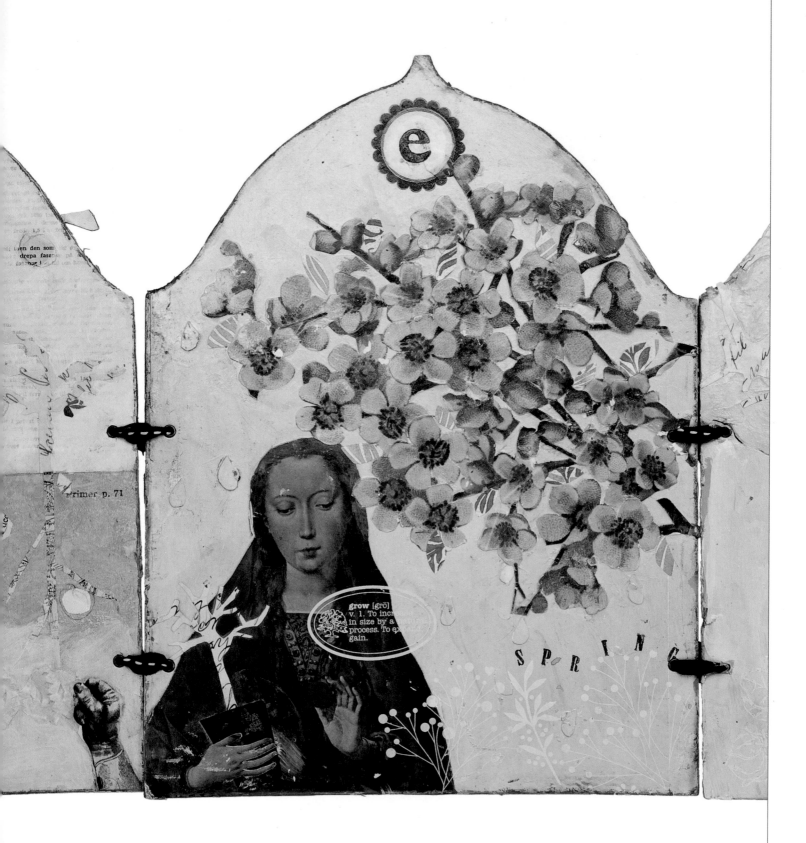

*There came a time when the risk to remain tight in the bud
was more painful than the risk it took to blossom.*
ANAÏS NIN

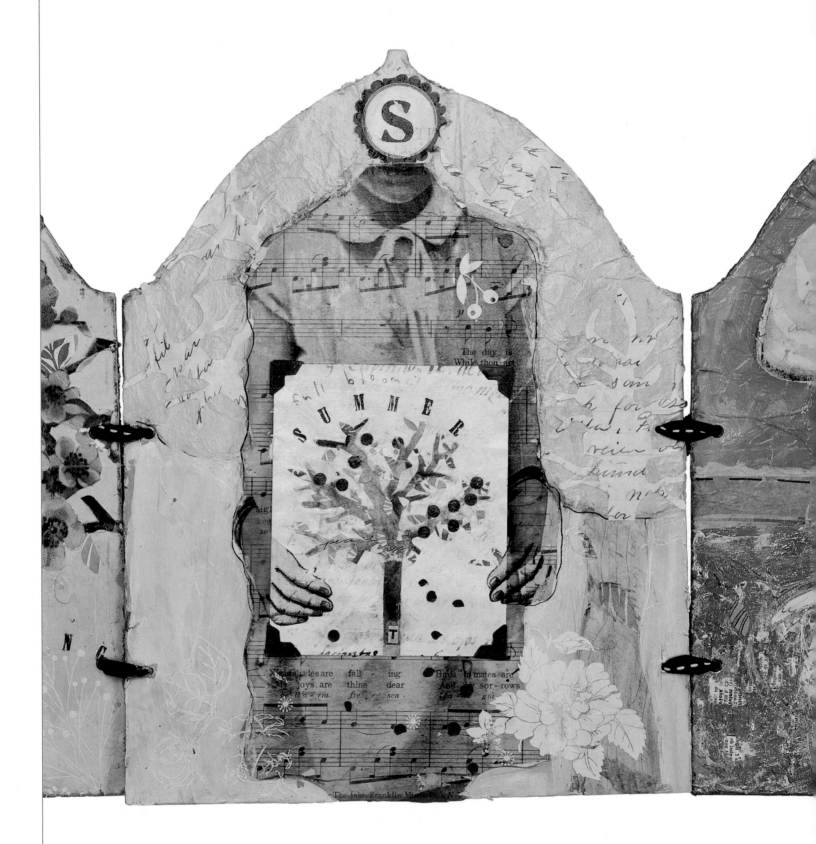

Earth laughs in flowers!
RALPH WALDO EMERSON

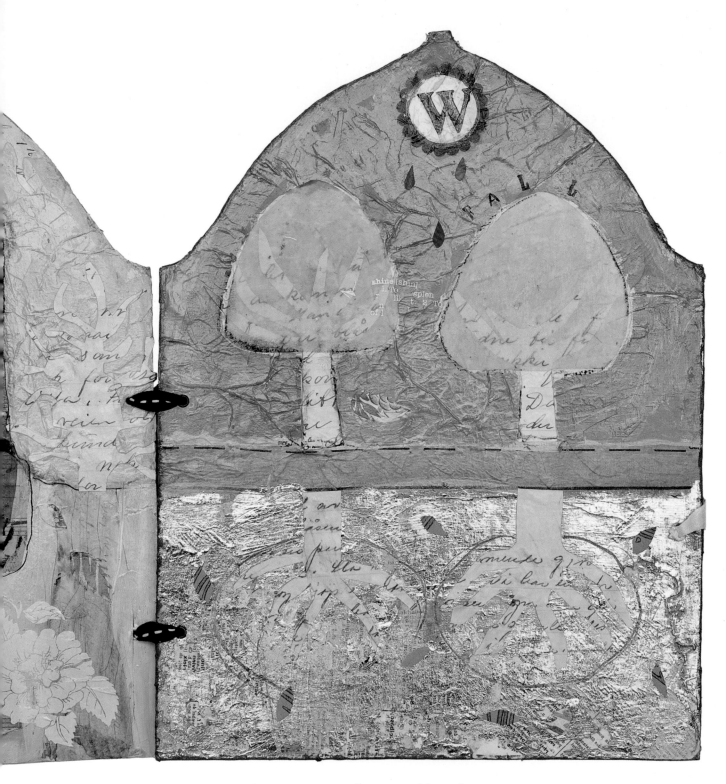

Sometimes our fate resembles a fruit tree in winter.
Who would think that those branches
would turn green again and blossom, but we hope it, we know it.
WOLFGANG VON GOETHE

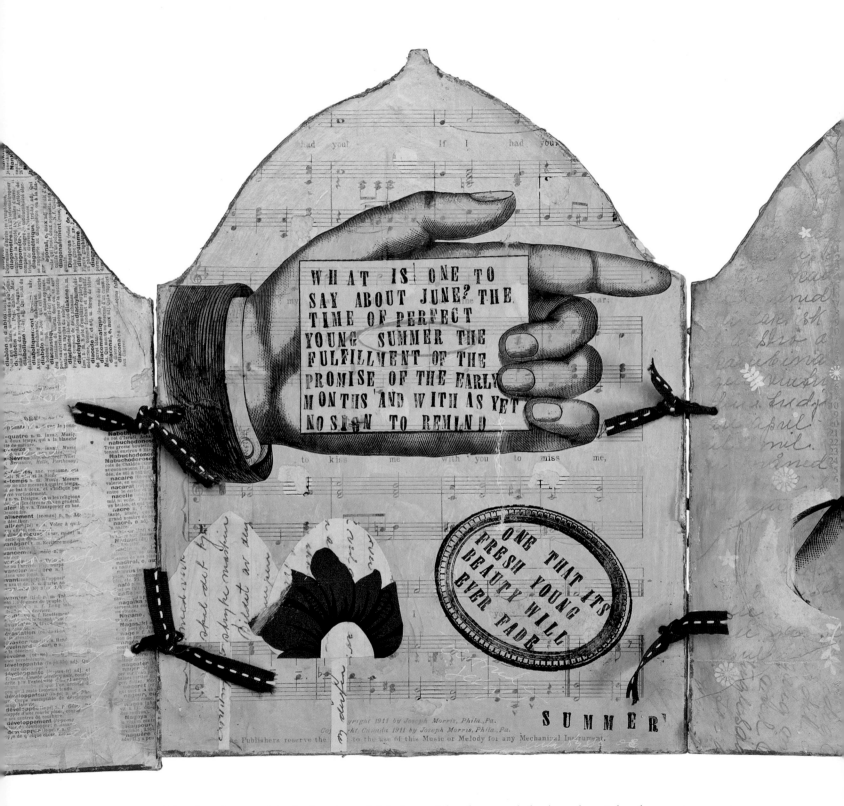

Earth is here so kind, that just tickle her with a hoe and she laughs with a harvest.
DOUGLAS JERROLD

How Does Your Garden Grow?

Rub it, Scrub it Revelations

make some paper snowflakes

The techniques, which Erika used profusely on her garden, are the same she's currently using on very large commissioned canvases. Whether working small or large, the look is reminiscent of old-fashioned whitewashing, though oddly, the procedure to achieve it is almost opposite! Though time-consuming, the method is quite easy when taken step by step and the results are well worth the time spent.

Begin with an acrylic base using a fairly neutral color, which works very well for this application. Don't add a medium to thin the paint—just use a really wet brush to make the paint more fluid. Add several additional color layers, and then rub off bits on random areas to expose the different underlying surfaces. If the paint is still somewhat wet, rub it with a damp paper towel. If there are several layers to rub through, or if the paint has begun to dry, use water and a durable cloth, or try acetone. Rubbing or even scratching off varying amounts of paint is an easy method for adding textural interest and is a fabulous way to expose layers of text and other imagery. Rubbing can also be used to soften the surface by getting rid of unwanted paint strokes and smoothing uneven background areas. When using acetone make sure the work area is well ventilated!

As Erika collages, she brushes a thin layer of water on the paper that's being adhered to the base layer. This makes it easier for her to add to the background and also circumvents uneven drying and bubbles. If gel medium is the adhesive, she brushes it onto both the base layer and her chosen imagery to avoid unwanted bubbles.

To add to the soft, somewhat aged quality of her overall garden palette, Erika applied gold foil in several places. Gold foil is somewhat thicker than gold leaf but easier to work with. It comes in a long sheet, can be cut with scissors, and is readily applied with an adhesive.

Field Notes

Old letters, music, dictionary, ledger, or Farmers' Almanac pages create a terrific layer to build upon.

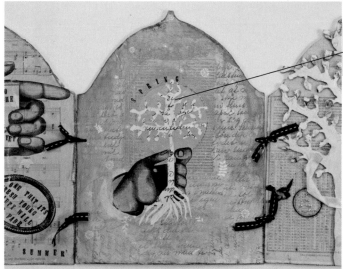

Handwriting lends a personal touch.

Rub-on transfers can be found for every style and subject.

Pieces of gold foil cover the writing beneath.

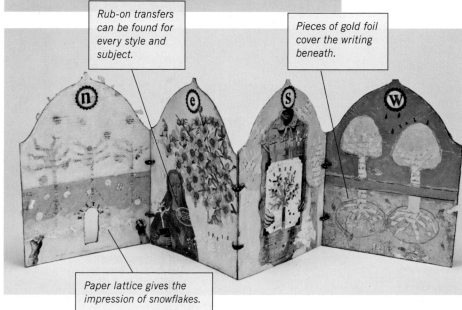

Paper lattice gives the impression of snowflakes.

Cherry blossom: spiritual beauty

Zen Garden

waking up to birdsong
from the garden

ice tea brewing in the sun

my purple and white clematis
in full bloom

my blue hydrangea with flowers
larger than a grapefruit

the smell of newly oiled
lawn furniture

catching bugs with the kiddies
to examine in their "bug barn"

picking herbs from my garden
at suppertime

the midnight sun
(I live in Norway you know!)

Dig It!

grow [grō] v. 1. To increase in size by a process of natural growth and development. It's often said, "Any project worth doing is worth doing well." Have pride in your work, and cut with precision! Take the time to clip around the details in your imagery. Follow the exact curvature of a curl or outlines of a blossom. A sharp pair of scissors, a steady hand, and patience will elicit fantastic results. An X-Acto or craft knife works for cutting fine details in leaves or defining small twigs.

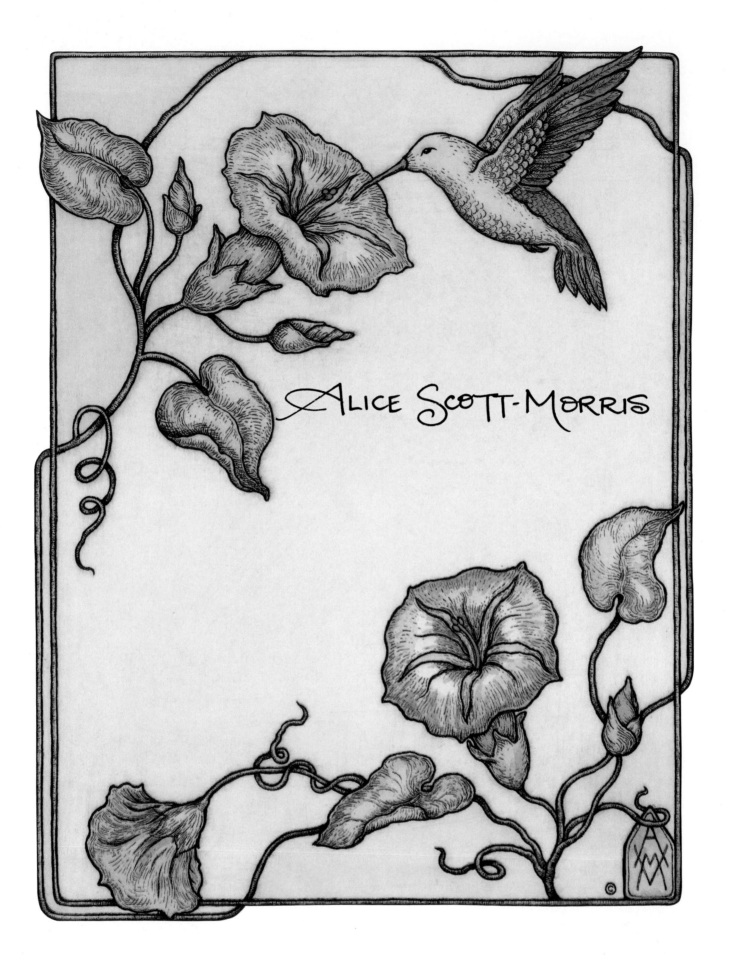

Alice Scott-Morris

SKETCHING THE INK

Alice Scott-Morris is the accomplished artist whose detailed drawings, sketches, and illustrations have woven a common strand through the flora and fauna of the diverse gardens blooming throughout these pages. Her precisely inked interpretations of plants, containers, tools, and other practical items found in a garden shed, have carefully and cleverly distilled and refined the essence of each planted plot. Her intricate illustration of the entire scenic landscape allows our imaginations to run wild on a fantastic and far-flung garden tour taking us from New Orleans to Australia, from England and France to Japan, and from the Wild West and beyond.

Whether working in black and white or employing the delicate watercolors she prefers, it's clear this artist is a connoisseur of the fragile and fleeting gifts of the garden which she has been abundantly portraying since she first began her artistic career several decades ago. Alice is matter-of-fact in her simple yet eloquent explanation, "The perfect balance and gentle lines of nature seen in every plant and flower can be the inspiration for a lifetime of art."

Establish a backyard bird sanctuary and start a journal of your observations. A notebook, pen, and a bird book are the only necessary equipment—though a pair of binoculars, and some artist colors are wonderful!

The Audubon Backyard Bird Watchers: Bird Feeders, and Bird Gardens recommends setting up birdhouses in late summer before breeding season, so local birds can find them. Leaving birdhouses up year-round encourages migratory birds to shelter as they travel. With a little ingenuity, whether you live in a city, suburb, or miles from nowhere, you can establish baths, feeders, or houses. If you don't have room for a birdbath, a humble pie plate filled with water on a windowsill will appeal to species such as juncos and tree sparrows. Birds are attracted to the sound of water so fountains and sprinklers will also prove alluring.

Cachepot

ink, pencil, rapidograph pen, Micron pens, 400 lb. hot-press watercolor-paper block, artist tape, light box

How Does Your Garden Grow?

Illustration 101

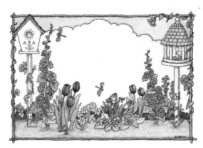

"When you paint what you love, your inspiration is bound to show through your work." Alice clearly draws acres of inspiration from her love of flowers and plants. Her garden-themed illustrations practically burst from the page with lively color and careful detail.

Alice uses only three types of pens for all her drawings and illustrations. She uses a Rotring brand rapidograph pen for her ink drawings. It gives a consistent, crisp, almost mechanical line, and there are superfine to heavy drawing tips available. Alice did all of the handwriting for *In This Garden* with Sakura Pigma Micron pens, which are available in various widths. She feels nothing matches their quality when a thicker, looser line is desired. She also loves using an old-fashioned quill pen with an inkwell. A thin tip is perfect for sketching an irregular, more sensitive line. Flat pen nibs are traditionally used for calligraphy.

Although she loves the look of her india-inked work, Alice employs several techniques when she needs to add color. The illustration shown above was colored with pencils; she also frequently uses gouache and watercolors.

If you haven't kept up with your journal sketches and drawings and find you need to work on a project from scratch, try an Internet image search. Old-school artists had to check out dozens of library books to glean even a few images, and reference books often can't leave the premises.

Alice sometimes incorporates a portion of a completed drawing into something new. She will place tracing paper over the previous drawing, which is placed on a light-box, and then traces the general outlines. Using her copier she may enlarge, reduce, or mirror image the tracing. Once it's the desired size and alignment, she returns to the light-box to trace the image onto watercolor paper for the new piece.

Alice also suggests experimenting with this alternative image-transfer process. Make a tracing with a soft pencil, turn the tracing paper over and redraw the lines on the reverse side. Then place the tracing right side up over watercolor paper and redraw the image. Just enough graphite transfers to the watercolor paper to see the outlines. Use small pieces of artist tape to secure the papers together so they don't shift during the process. If pressed for time, you can use carbon paper made from tracing paper with graphite preapplied to one side.

Field Notes

Depending on the intended use, sometimes a black illustration can have just as much impact as the same image when colored.

A detailed black-ink sketch is reminiscent of vintage garden maps.

A rapidograph is the perfect tool for creating dot sketches with an open, airy, outdoorsy feel.

Simple iconography suggests rich and complex stories.

Morning Glory: affection

Zen Garden

daffodils and tulips popping out of the ground after a long cold winter

seeing a fence completely smothered by mounds of purple morning glories

pansy faces, soft as velvet

an explosion of Million Bells petunias cascading from hanging pots, attracting hummingbirds

looking over at my prayer plant to see that it has opened its "hands" today

being amazed at the stages of a rose as it slowly opens its petals

the surreal colors of my coleus plants

Dig It!

To find images such as blue morning glories in California, try an Internet image search. Type "morning glory blue California," hit the search-image button and *voila*, over 200,000 photos and sketches will appear on the screen in a few seconds. You're sure to find a few visuals to get you started. The Internet is a fabulous repository for source material for sketches—any time of the day or night!

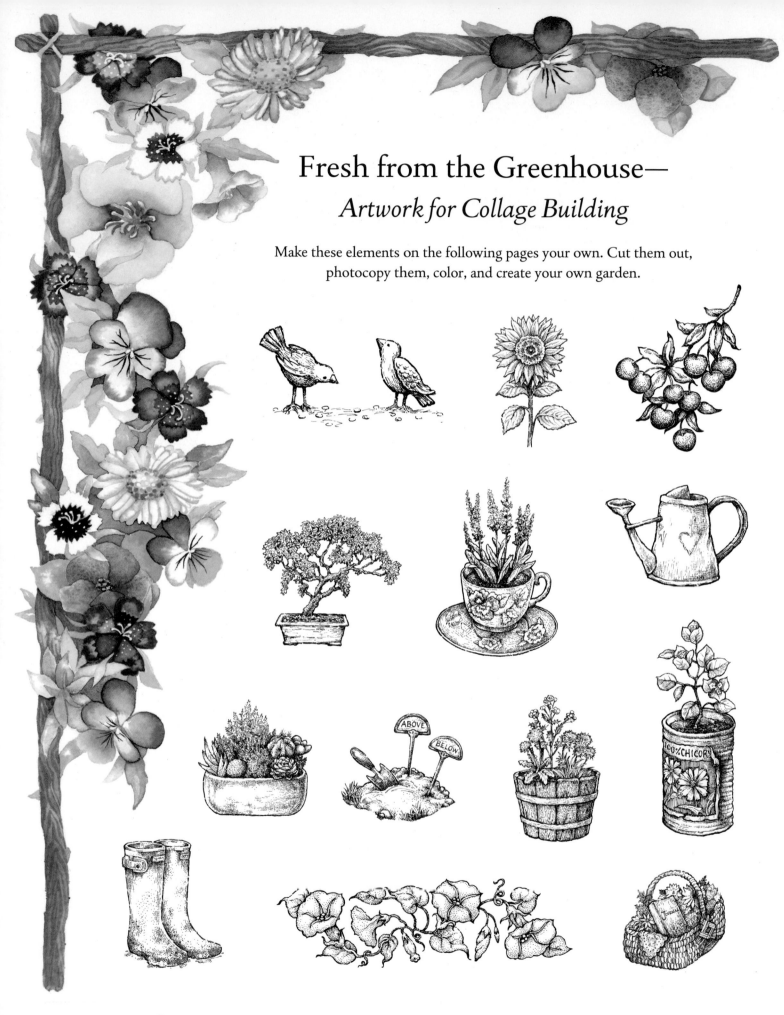

Fresh from the Greenhouse—
Artwork for Collage Building

Make these elements on the following pages your own. Cut them out, photocopy them, color, and create your own garden.

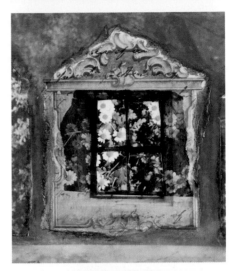

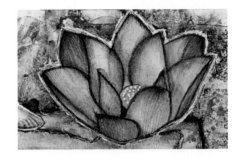

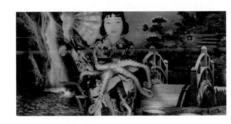

GARDEN

JUNKYARD

COMMUNITY

WAYFARER

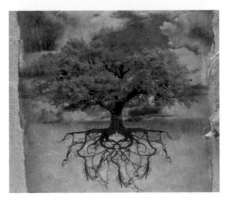

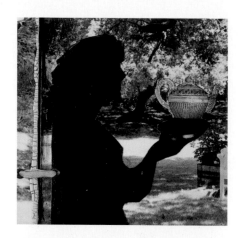
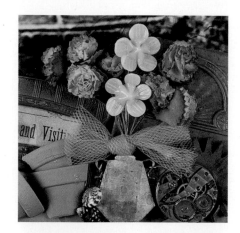

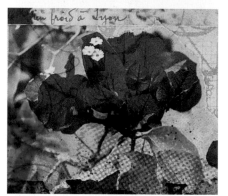
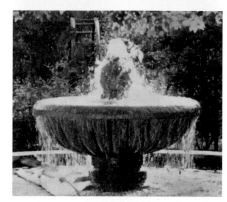

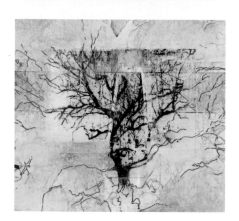

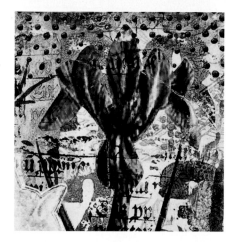
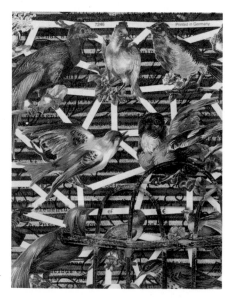

ABOVE

BELOW

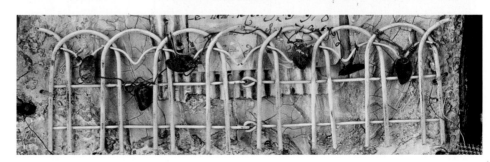

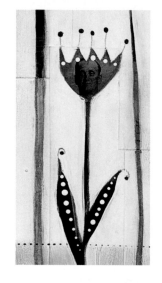

WHAT IS ONE TO SAY ABOUT JUNE? THE TIME OF PERFECT YOUNG SUMMER THE FULFILLMENT OF THE PROMISE OF THE EARLY MONTHS AND WITH AS YET NO SIGN TO REMIND

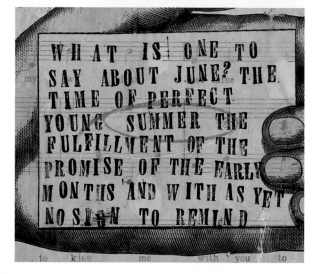

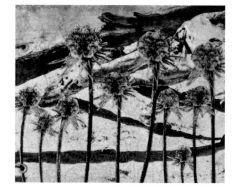

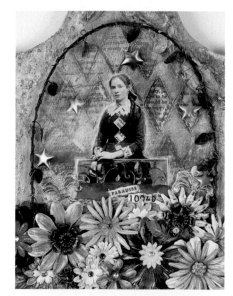

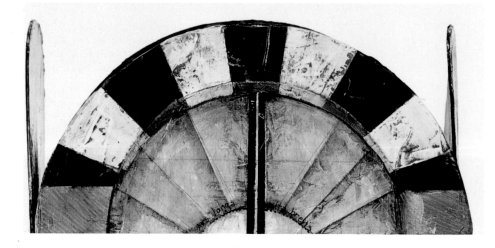

BOTANY 101—*Glossary*

book board: A sturdy board similar to mat board, used in bookbinding to make covers and slipcases.

brad: A thin wire nail with a small head and prongs on the back that are bent back when attaching it.

cabinet card: A photographic print mounted on cardboard approximately 4 ¼" x 6 ½" (10.8 x 16.5 cm). Introduced in the 1860s, the cards were common until about 1900. The photograph is smaller than the card to which it is attached. The name of the photographer or studio was often printed at the bottom or on the back.

cartes-de-visite: Photographic calling cards measuring 2 x 4 ½" (5.1 x 11.4 cm). These cards were mostly replaced by cabinet cards in the late 1860s.

DPI: Printing lingo for "dots per inch."

dye ink pad: Designed for rubber stamping. Colorful dye ink affords added versatility when photo tinting and color layering.

embellishment: A small element such as a button or charm used for decoration.

emboss: To mold or carve in relief; to create a raised design.

embossing powder: Fine plastic-based clear or tinted powder, which is sprinkled on wet ink or adhesive, and then melted with heat to create a raised area. The texture may be rough, smooth, glossy, or matte.

ephemera: Printed matter usually discarded after use, such as a ticket stub.

eyelets: Available in a variety of shapes, sizes, and colors, eyelets are used to attach embellishments to paper and canvas, add metallic texture, or thread ribbon and other fibers to artwork.

fiber paper: Hand- or machine-made paper that incorporates a plant fiber that gives it character. Cotton is the most common example, but many fiber papers include more exotic materials.

fibers: Slender, threadlike cellulose structures that cohere to form a sheet of paper.

fine pumice medium: A pure volcanic pumice, which is combined with an acrylic polymer emulsion, and is used to build a durable textured surface.

fluid acrylic: An acrylic paint with a saturated color and a thin consistency.

fluid matte medium: A liquid medium useful for extending colors, decreasing gloss, and increasing film integrity.

German scrap: Colorful embossed relief pictures, originally used in German bakeries for cake decoration. The forerunner to modern stickers, scrap is still available in its original form, sometimes called Victorian scrap.

gesso: Gypsum or plaster of paris prepared with glue for use as a painting surface or texture techniques.

glaze: A medium used alone or mixed with paint for a smooth, glossy finish.

gold leaf: Gold in the form of very thin foil used for gilding.

iconic: Relating to, or having the character of an icon, an important and enduring symbol.

india ink: A bottled black ink used in drawing, calligraphy, and by watercolorists.

juxtaposition: Occurs when two or more things are placed side by side.

light-box: A light-box is a backlit piece of acrylic or frosted glass, sometimes in the form of a small table. Many artists use light boxes for looking at photographic negatives, tracing, etc.

metallic or luster rub-ons: Metallic pigments in a cream form used for accents and embellishments.

monochromatic: Having, or appearing to have, only one color.

monoprint: A method of creating decorative paper with pigments or inks resulting in a one-off—a distinct print which can never be repeated.

nicho: a small carved-out wall space for the display of art and other curios or valuables. Originally, nichos served as shrines for *santos* (carved religious objects).

notch tool: A tool for laying tile that makes indentations in the adhesive so the tile adheres better. Use it to create designs in pastes and gels.

oil sticks: Rich, creamy, vibrant pigments in stick form that can be applied directly to any substrate.

patina: The sheen on any surface produced by age, use, or chemical reaction.

Pellon: A fabriclike backing used by seamstresses to add body and stabilize fabrics; also used behind embroidered areas.

potager: French for "vegetable garden."

RC paper: Resin-coated photographic paper.

rice paper: A thin delicate material resembling paper; made from the rice-paper tree.

Rigid Wrap: Plaster-impregnated gauze used for crafts.

rub-on: A dry-transfer decal, which comes on a backing material. The decal is placed facedown onto a surface, and the image is transferred by rubbing the backing with a stylus or bone folder.

spray fixative: Similar to varnish, sprayed over a finished piece of artwork to better preserve it and prevent smudging and fading.

stencil: A sheet of Mylar, plastic, or cardboard from which a design or lettering has been cut. When ink or paint is applied, the cut-out image is reproduced on the surface beneath.

tooth: A rough surface on paper that grabs graphite, paint, computer ink, or other pigment.

transparency: Any transparent sheet, including photographic slides and overhead-projector sheets.

varnish: A liquid coating used as a final step to protect art; available in matte, shiny, or satin finishes.

vellum: A heavy, translucent paper that resembles parchment.

walnut ink: A dark, finely pigmented water-based ink that adds an aged look to paper.

water-soluble wax pastels: Bright, semi-opaque color-sticks of exceptional purity and intensity; excellent for watercolor techniques as they break down easily when water is applied.

X-Acto or craft knife: A small, sharp knife with replaceable blades of different sizes and used for fine cutting purposes, such as creating stencils.

Zephyrus: The Greek god of the West Wind. He abducted the goddess Chloris and gave her dominion over flowers.

THE ARBORETUM—*Materials and Other Resources*

Adhesives and Glues
E6000 glue: ceramicsource.com
Glue stick: saunders-usa.com/uhu
Hot-glue gun: michaels.com
Matte medium: goldenpaint.com
Pop-Up Glue Dots: uline.com
PVA adhesive: artsuppliesonline.com

Chalk, Ink, Markers, Paints, Pastels, Pencils, Pens, and Powders
Acrylic paint:
 Americana: decoart.com
 Ceramcoat: deltacreative.com
 CraftSmart: plaidonline.com
 Golden: goldenpaint.com
 Liquitex: liquitex.com
 Lukas: lukas.eu
 Nova paints: novapaint.com
 Ranger: rangerink.com
 Stewart Gill: artistcellar.com
 stewartgill.com
Blending chalks: inkadinkado.com
Brushes, Sceptre Gold Round, Winsor & Newton: dickblick.com
Colored pencils, Stablio: archivalsuppliers.com
Distress Ink: rangerink.com
Embossing powder:
 Judikins: judikins.com
 Stewart Gill: artistcellar.com
 Ranger: rangerinks.com
Eraser, Staedtler Mars soft white plastic eraser: dickblick.com
Glaze: goldenpaint.com
Gouache, Winsor & Newton Designers Colors: dickblick.com
Inks:
 Daler-Rowney FW: rexart.com/fwinks.html
 Encore pigment inks: paperrocks.com
 FW Acrylic Ink: dickblick.com
 Higgins Calligraphy Ink: dickblick.com
 Pebeo Colorex Watercolor Inks: pebeo.com
 Ranger Adirondack: rangerinks.com
 Winsor & Newton: dickblick.com

Markers
Tombo: dickblick.com
Sharpie: sharpie.com
Metallic paints: modernmasters.com
Sophisticated Finishes: modernoptions.com, michaels.com
Oil pastels, Sennelier: dickblick.com
Paint stiks: quiltingarts.com
Patina, iron surfacer, rusting patina: modernmastersinc.com
 modernoptions.com

Pencils:
 Sanford turquoise drawing pencil 3B lead: dickblick.com
 Mechanical Staedtler or Pentel 0.5 mm pencil and 2B lead: dickblick.com
Pens:
 Koh-I-Noor rapidograph: jerrysartarama.com
 Paint pen: elmers.com
 Pigma Micron pen: jetpens.com
 Rotring rapidograph: dickblick.com
 Sakura Glaze Gel Ink Pen: jetpens.com
 Sakura Pigma Micron: aaronbrothers.com
 White pen, Signo Uniball: jetpens.com
Photographic oil paints, Marshalls: dickblick.com
Rigid Wrap: michaels.com
Spray paint: acehardware.com

Gels, Gesso, Mediums, Pastes, and Varnish
Art paste: elmers.com
Caulk, Red Devil quickpaint: reddevil.com
Clear tar gel: goldenpaint.com
Crackle accent medium: rangerink.com
Crackle paint: rangerink.com
Crackle paste: goldenpaint.com
Fiber paste: goldenpaint.com
Gloss medium varnish: liquitex.com
Green patina: modernmastersinc.com
High Solid Gel matte: goldenpaint.com
Gesso: goldenpaint.com, liquitex.com
Gold gesso: danielsmith.com
Matte fixative, Grumbacher: pearlpaint.com
Metallic paints: modernmastersinc.com
Molding pastes: goldenpaint.com
Plaster: michaels.com
Pumice gel: goldenpaint.com
Resin sand texture gel: liquitex.com
Stucco patch, Dap: acehardware.com
Tar gel: goldenpaint.com
Texture paste: novapaint.com
White opaque flakes: liquitex.com
Varnish, Grumbacher: pearlpaint.com

Papers, Tissues, Transparencies, Vellums, and More
Art prints: sarahfishburn.etsy.com
Canvas printable paper: mcgpaper.com
Canvas pad: dickblick.com
Clipart: clipart.com, doverpublications.com
Collage papers:
 Angela Cartwright Collection, Stampington & Co.: acartwrightstudio.com/vendibles.htm
 basicgrey.com

cratepaper.com
characterconstructions.com
mymindseye.com
sarahfishburn.etsy.com
sevengypsies.com
Embossed foil: lklight.etsy.com
Gold-foil letters: NicholasKniel.com
Grungeboard: timholtz.com
Handmade paper, The Paper Studio: paperstudio.com
Hot-press paper, 120 lb. Arches Aquarelle: dickblick.com
Illustration board: crescent-cardboard.com
 Kristen Robinson: kristenrobinson.etsy.com
 K&Company: kandcompany.com
 Traci Roos: alphastamps.com
Lutradur: shoppellon.com, joggles.com
Paintable paper, Prema: paperrocks.com
Paper lattice, Pop Culture KI: kimemories.com, paper-source.com
Pellon: joann.com
Photographs/images: dotcalmvillage.net, lauriezuckerman.blogspot.com, Cre8it.com
Fiber photographs, Franks Custom Lab: astudiogallery.com/frankscustomlab.htm
Plexiglas: homedepot.com
 Scrap, Doodlets: 505-983-3771
Stencils, Coffee Break Designs: coffeebreakdesign.com
 Stewart Gill: artistcellar.com
Stock photographs: dreamstime.com
 The European Collection: tweetyjill.com
T-shirt transfers: avery.com
Tin foil (aluminum foil): supermarket, kitchen supply
Tissue paper: recycled
Transparency,
 Angela Cartwright Collection, Stampington & Co.: acartwrightstudio.com/vendibles.htm
 Avery: avery.com
Vellum paper: Angela Cartwright Collection, Stampington & Co.: acartwrightstudio.com/vendibles.htm
Vintage images: frenchkissed.etsy.com, sarahfishburn.etsy.com
Watercolor paper, 400 lb. cold press Arches Aquarelle: dickblick.com
Wallpaper: homedepot.com

Rubber Stamps

Alice Scott-Morris stamps: stampusa.com/
 alice.htm
Character Constructions:
 characterconstructions.com
Christine Adolph: christineadolph.typepad
 .com
Clearly Impressed: stampington.com
Foam stamps, Making Memories:
 makingmemories.com
Green Pepper Press: greenpepperpress.com
Invoke Arts: invokearts.com
Ma Vinci Reliquary:
 reliquary.cyberstampers.com
Paper Candy: papercandy.com
Paper Bag Studios: paperbagstudios.com
Sassafraslass: sassafraslass.com
Stampington & Company: stampington.com
Stampsmith: stampsmith.net
Technique Tuesday: techniquetuesday.com
Unruly Girls Club: acartwrightstudio.com/
 vendibles.htm

Embellishments, Beads, Fibers, and Ribbons

Artificial flowers: joann.com
 michaels.com
Beads: eebeads.com
 firemountaingems.com
 greengirlstudios.com
Brads, Basic Grey: basicgrey.com
 Making Memories: makingmemories.com
 Archivers: archiversonline.com
Craft wire: acehardware.com
 michaels.com
Eyelets: makingmemories.com
Faux-ivory embellishment: zinnia.biz
Gem flower brads: creativeimaginations.us
Gem stones: heroarts.com
Glitter: artglitter.com
Heart charms: makingmemories.com
Horsehair: ebay.com
Jute string: michaels.com
Lightbox, Gagne Porta-Trace: dickblick.com
Mardi Gras beads: neworleansonline.com
Metal findings: michaels.com
 Rusty Tin-tiques: joann.com
Metal flowers: archiversonline.com
 imaginisce.com
Metal locket, Scrapbook Designs:
 scrapbookscrapbook.com
Miniature hangers: characterconstructions.
 com
Miniature metal gate: michaels.com
Nest: paper-source.com
Paper florals: pulpfashionmn.com
 Prima: scrappopotamus.com
Rhinestone picks: paperwhimsy.com

Ribbon and fibers:
 NicholasKniel.com
 walmart.com
 vvrouleaux.com
 coatsandclark.com
Rusty bottle caps: paperwhimsy.com
Sculptural angel: michaels.com
Star garland: paper-source.com
Stencil masks: heidiswapp.com
Swarovski crystals:
 pulpfashionmn.com, ejoyce.com
Velvet flowers: paperrocks.com
Wire fence: kathymcelroy.typepad.com
 127sale.com

Tools

Cutter Bees scissors: eksuccess.com
X-acto knives/blades: dickblick.com
Epson 7800 printer: officemax.com
Epson Ultrachrome K3 Inks:
 inkjetart.com
Versa Tool: michaels.com

Gardening Suppliers, Plants, and Seeds

The Antique Rose Emporium:
 antiqueroseemporium.com
Baker Creek Heirloom Seeds:
 rareseeds.com/seeds
Botanical Paperworks:
 botanicalpaperworks.com
Brecks: brecks.com
Burpee: burpee.com
Climbing roses: climbingroses.com
Cooks Garden: cooksgarden.com
Dutch Gardens: dutchgardens.com
Forest Farm: forestfarm.com
French Garden House:
 frenchgardenhouse.com
Gardeners Supply Company: gardeners.com
Grow Organic: groworganic.com
Heirloom Roses: heirloomroses.com
Hydranagea Plus: hydrangeasplus.com
Michigan Bulb: michiganbulb.com
Oakes Daylilies: oakesdaylilies.com
Prairie Nursery: prairienursery.com
Smith and Hawken: smithandhawken.com
Super Seeds: superseeds.com
Territorial Seed: terrritorial-seed.com
Wayside Gardens: waysidegardens.com
White Flower Farm: whiteflowerfarm.com
Vermont Wild Flower Farm:
 vermontwildflowerfarm.com

Top-Notch Publications
Books

Alphabetica by Lynne Perrella (Quarry,
 2006)
*Altered Books, Collaborative Journals and Other
 Adventures in Bookmaking* by Holly
 Harrison (Rockport Publishers 2003)
The Altered Book Scrapbook by Susan Ure
 (Sterling/Chapelle 2006)
*Artist Trading Cards Workshop: Create, Collect,
 Swap* by Bernie Berlin (North Light
 2007)
*In This House: A Collection of Altered Art
 Imagery and Collage Techniques* by Angela
 Cartwright and Sarah Fishburn (Quarry,
 2007)
*Mixed Emulsions: Altered Art Techniques
 for Photographic Imagery* by Angela
 Cartwright (Quarry 2007)
The Scrapbooker's Color Palette by Kerry
 Arquette and Andrea Zocchi (Lark
 Books, 2007)
Transparent Art, stampington.com

Magazines

Cloth, Paper, Scissors: clothpaperscissors.com
Domino: the guide to living with style:
 dominomag.com
Pasticcio Quartz: lulu.com/cartwrightand-
 fishburn
Somerset Studio: stampington.com
Sunset Magazine: sunset.com

THE MASTER GARDENERS—*The Authors*

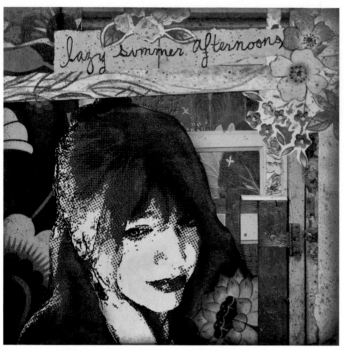

Sarah Fishburn

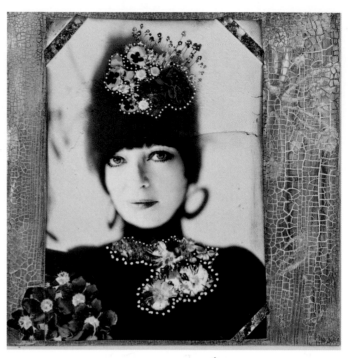

Angela Cartwright

Sarah Fishburn describes her work as mixed-media narrative. Internationally recognized for unexpected yet elegant juxtaposition of images, spray paint, transparencies, and words, Sarah's art has been featured in art and scrapbooking magazines, and in a shelf full of books, including *In This House—A Collection of Altered Art Imagery and Collage Techniques,* her first collaboration with Angela. They also collaborate on *Pasticcio Quartz*—a multifaceted art publication. Sarah lives and cultivates a madcap garden in the foothills of the Colorado Rockies.

website: sarahfishburn.com
blog: ragtagsf.blogspot.com

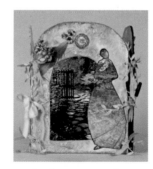

Angela Cartwright has been a photographer and artist for more than four decades, and her work is exhibited and collected internationally. Unique techniques for interpreting her hand-painted photographic art with acrylic and oil paints, inks, written word, and ephemera are explored in her book *Mixed Emulsions: Altered Art Techniques for Photographic Imagery.* Known for her acting roles in *Make Room for Daddy, The Sound of Music,* and *Lost In Space,* Angela now photographs, writes, and curates A Studio Gallery in Los Angeles, where she makes her home and garden.

website: acartwrightstudio.com
blog: acartwrightstudio.blogspot.com

THE GARDENERS—*Contributing Artists*

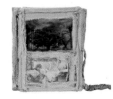 **TIFFINI ELEKTRA X**
website: tartx.com
blog: tartx.com/blog

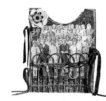 **DENISE LOMBARDOZZI**
website: firstbornstudio.com
blog: firstbornstudio.blogspot.com

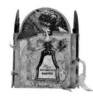 **CATHERINE MOORE**
website: characterconstructions.com

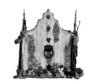 **SUSIE LAFOND**
blog: latwmn.typepad.com/
susiesmuse

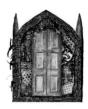 **C. W. SLADE**
website: cwslade.com

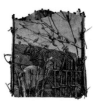 **DEB TROTTER**
website: cowboyssweetheart.net
blog: cowboyssweetheart.typepad.com

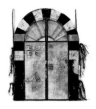 **PILAR ISABEL POLLACK**
blog: pipnotes.typepad.com

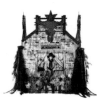 **MARIE OTERO**
website: lostaussie.com
blog: lostaussie.typepad.com

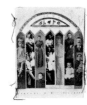 **LYNN WHIPPLE**
website: whippleart.com
blog: freshyfresh-lynnie.blogspot.com

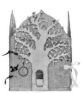 **ERIKA TYSSE**
website: erikatysse.com
blog: erikatysse.blogspot.com

 ALICE SCOTT-MORRIS
website: aliceandcompany.net

Acknowledgments

A garden is only as plentiful as the gardeners who put their tools to the earth and dig for artistic expression. Bushels of words can't convey our gratitude to Alice, Catherine, C. W., Deb, Denise, Erika, Lynn, Marie, Pilar, Susie, and Tiffini.

To our families who grow, bloom, and range from our garden gates ...

Steve, Becca, and Jesse: Your constant encouragement whenever I go out on a limb makes my life blossom. (ac)

My ever-growing and generally good-natured family; thank you for your patience, especially Sebastian, who helped me by gathering seeds, and Dante, who always makes me laugh. (sf)

We thank Winnie Prentiss for continuing to encourage and support our sometimes outlandish offerings. To Marla Stefanelli, our dashing editor, we are grateful for your insight and careful attention to detail. Thanks also to Mary Aarons, Betsy Gammons, John Gettings, Regina Grenier, Meg Sniegoski, Mary Ann Hall, Cora Hawks, Tiffany Hill, Susan Hershberg, and the rest of the Quarry crew.

And finally, to all artists, photographers, filmmakers, poets, and gardeners; we want to thank you for your continuing visual steampunk and unruliness that always propel us beyond the norm.

IF YOU WANT TO BE HAPPY FOR A SHORT TIME, GET DRUNK;
HAPPY FOR A LONG TIME, FALL IN LOVE;
HAPPY FOREVER, TAKE UP GARDENING.

~ ARTHUR SMITH ~